Art Povera

ART POVERA

germano celant

PRAEGER PUBLISHERS

New York • Washington

BOOKS THAT MATTER

Published in the United States of America in 1969
by Praeger Publishers, *INC.*
111 Fourth Avenue, New York, N.Y. 10003

© 1969 Gabriele Mazzotta Publishers, Milan

Library of Congress Catalog Card Number: 70-84095

Printed in Italy

STATING THAT

This book does not aim at being an objective and general analysis of the phenomenon of art or life, but is rather an attempt to flank (both life and art) as accomplices of the changes and attitudes in the development of their daily becoming.

The book does not attempt to be objective since the awareness of objectivity is false consciousness.

The book, made up of photographs and written documents, bases its critical and editorial assumptions on the knowledge that criticism and iconographic documents give limited vision and partial perception of artistic work.

The book, when it reproduces the documentation of artistic work, refutes the linguistic mediation of photography.

The book, even though it wants to avoid the logic of consumption, is a consumer's item.

The book inevitably transforms the work of the artist into consumer goods and cultural goods, a means of satisfying the cultural frustrations of the reader.

The book proposes a way for the public to take part in artistic events, but does not impose it upon them.

The book narrows and deforms, given its literary and visual oneness, the work of the artist.

The book is a precarious and contingent document and lives hazardously in an uncertain artistic-social situation.

The book is offered only as an instrument for further experience in regard to art and life.

The book does not aim at establishing what has happened in art, but what is happening.

The book gives documentary evidence of individual authors.

The book transforms real life into information.

The book is entitled « art povera ». This critical definition makes the type of material collected understandable to the public and places itself as work among other works; it does not aspire to be a unique definition of works of art, realizing that it furnishes only a special aspect of the infinite charge that can be found in the same works. There are other critical definitions, the best known being: conceptual art, earthworks, raw materialist microemotive art, antiform.

The book remains within the limits of the collection of the material; tomorrow there could be another book by the same authors.

The book has not been designed a priori, but has grown, constructed in a quantitatively fortuitous way — in the same way that the artists have collaborated to bring it about.

The book produces a collection of already old material.

The book coagulates a fluid and continuously becoming state that is exactly that of the work of art.

In this book there is no need to reflect in order to seek a unitary and reassuring value, immediately refuted by the authors themselves, rather there is the necessity to look into it for the changes, limits, precariousness and instability of artistic work.

CONTENTS

61 MICHAEL HEIZER (New York).
62 Circumflex, 120' long, Massacre Creek Dry Lake, 1968.
63 Abstraction / dissipate, 6' x 6' x 6'.
64 Gesture, five 12" x 12" depressions, 16" deep, 12"-24" apart, with one off set, Mojave desert, April 1968.
65 Double compression, two 12" x 12" x 12" long lines compressed in center, 30° gradient in hill side, boulder measures 18' square approx., August 1968.
66 Two stage line, 4' x 4' x 4', Sierra Mountains, December 1967.

67 GER VAN ELK (Holland).
68 To a first stone to be first, 1968.
69 Piece made in one hour, with assistance, 1968.
70 Untitled (street scene), 1968.
71 Cords, 1967-68.
72 Some sparetime floor enjoyment, 1968.

73 JANNIS KOUNELLIS (Rome).
74 Cotoniera, 1967. Steel and cotton.
75 Pappagallo, 1967. Live parrot, steel.
76-77 Cavalli, (Show at the Galleria L'Attico, Rome, 1969).
78 Carboniera, 1967-68.

79 LAWRENCE WEINER (New York).
80 Windham College, Putney, Vermont. Staples, stakes, twine and turf, 1968, 70' x 100'.
81 An amount of bleach poured upon a rug and allowed to bleach, 1968.
82 Two minutes of paint sprayed directly upon the floor from standard aerosol spray can, 1968.
83 A 36" x 36" removal of wallboard from the lathing or wall support of plaster, from wall, 1968.

84 LUCIANO FABRO (Milan).
85 Italia, 1968. Map and wood.
86 Felce, 1968. Glass, fern, lead.
87 Il pupo, 1969. Swaddling-bands and light.
88 Lenzuola, 1968.
89 Lenzuola, 1968.

90 BRUCE NAUMAN (Southampton).
91 My last name exaggerated fourteen times vertically, 1967. Pale purple neon tubing, 63" x 33".
92 Dead centre, 1969. Steel, 3" x 15" x 15".
93 Wedge piece, 1968. Engraved painted steel.
94 From hand to mouth, 1967. Wax over cloth, 30" x 10" x 4".
95 Untitled, 1967. Rope, wax over plaster, 17" x 26" x 4 1/2".
96-97 My name as though it were written on the surface of the moon, 1968. Blue neon tubing, 11" x 204".

98 JOSEPH KOSUTH (New York).
99 Photograph of installation of exhibition at Gallery 669, Los Angeles, California.
100 Titled (Art as idea as idea), 1967. Photographic process, 4' x 4'.
101 Titled (Art as idea as idea), 1967, 5' x 5'.
102 (left): Existence (Art as idea as idea), 1968, (published in:) New York Times (January 5, 1969); Museum News (January 1, 1969); Artforum (January 1969); the Nation (December 23, 1968).
(right): Time (Art as idea as idea), 1968, (published in:) the London Times; the Daily Telegraph (London); the Financial Times (London); the Daily Express (London); the Observer (London) all in December, 1968 issues.

103 JAN DIBBETS (Amsterdam).
104 Grass Roll, 1967.
105 Sticks with neon, branches (green), 1968. Water (mud) puddle, 1968; grass roll, 1967. Show at Konrad Fisher Gallery.
106 Correction of perspective, 1968. Photograph on canvas as a work of art. Original size 59" x 47".
107 White line in the sea, 1968 (Amalfi).
108 Correction of perspective, 1967 (construction) 1968 (made), first pile 13", last one 29".

109 GIOVANNI ANSELMO (Turin).
110 Untitled, 1968. Granite and flesh.
111 Torsione, 1968. Fustian and iron.

112 Untitled, 1969. Cotton, water and plexiglass.
113 Torsione, 1968. Cow hide, cement and wood.
114 Untitled, 1968. Brick, chalk, steel and water.
114 Untitled, 1968. Cotton and water.

115 ROBERT BARRY (New York).
116 Photograph of the artist's studio being occupied by « 88 mc. Carrier Wave » (FM) 1968, 88 megacycles, 5 milliwatts, 9 volts DC battery.
117 Photograph of the artist's studio being occupied by « 1600 kc. Carrier Wave » (AM) 1968, 1600 kilocycles, 60 milliwatts, 110 volts AC/DC.
118 Photograph of the artist's studio being occupied by « 0,5 Microcurie Radiation Installation », January 1969, Uranium - 238, 4,5 x 100 years duration.
119 Photograph of the artist's studio being occupied by « 4,5 cm. Microwave Installation », December 1968, 4,5 centimeter microwaves.

120 PIER PAOLO CALZOLARI (Urbino).
121 Il filtro e Benvenuto all'angelo, 1966 (project for a public work) 244' x 244" x 118".
122 Il mio letto così come deve essere, 1967-1968. Banana leaf, musk and bronze.
123 Impazza angelo artista, 1968-1969. Synthetic ice.
124 2000 lunghi anni lontano da casa, 1968-1969. Tin and lead.
125 Anne (left), 1968. Ho cucito un vestito per la mia salita in paradiso (right), 1968.

126 DENNIS OPPENHEIM (Brooklyn, N. Y.).
127 Snow-fencing, grass, 1968. Near Hauburg Pa, 50' strips.
128 Vegor Spear, June 1968. Near Hauburg, oat field 9000' x 1000'.
129 New Haven, Conn. Piece, 1968, 175' x 200' contour lines, metal filing; cut by cycle mower.

130-131 Annual rings, 1968. Frozen River (St. John River at Ft. Kent, Maine) 150' x 200'.
132 I Hour Run, December 1968. Fort Kent, Maine, indentation 1' x 3' x 6 miles.

133 BARRY FLANAGAN (London).
134 Bundle, 1967. Hessian and paper, 2' x 3' x 2'6".
135 Pile, 1967. Hessian, 12" x 22" x 16".
136 Four rahbs, 1967. Resin, hessian, sand, 50" x 60" square.
137 3 ton sandbag. Cornwall, Easter, 1967.
138 2 space rope, 1967, 60' x 6" girth.
138 1 ton corner piece, 1967-1968.

139 ROBERT SMITHSON (New York).
140 20 shots of 5 sites of Franklin, N. J. Non-site, 1968, 18" x 18".
141 A non-site, 1968 (Franklin, N. J.). Aerial map.
142 A non-site, 1969. Steel and mica.
143 A non-site, 1968. Steel and mica.
144 Untitled.

145 GIULIO PAOLINI (Turin).
146 Qui, 1967. Transparent plastic.
147 Astrolabe (a F. P.), 1967. Printed metal and plexiglass. It is placed in a free space so that the real shadow coincides with the false one.
148 Primo appunto sul tempo (detail), 1968.
149 Averroé, 1967.
150 Raphael Urbinas MDIII. Photographic reproduction, in life-size, of the span of the temple's doorway painted by Raphael in « Lo sposalizio della Vergine », 1,5" x 1,8", 1968.

151 REINER RUTHENBECK (Düsseldorf).
152 Aschenhaufen IV, 1969. Dia. 59".
153 Aschenhaufen V, 1969. Dia. 59".
154 Stair II, 1967.
154 Mobel III, 1968. Wood, h. 137".
155 Tin Pyramid, 1968. H. 43".

156 ALIGHIERO BOETTI (Turin).
157 Non marsalarti, 1968. Photograph.
158 Legnetti colorati, 1968. Dia. 110".

159 Untitled, 1968. Paper and iron, 59" x 39".
160 Untitled, 1968. Stones, wood, paper and glass.
161 Untitled, 1968. Water.

162 KEITH SONNIER (New York).
163 Silk piece, 1968, 8' x 3'.
164 Screen-green putty, 1968, 12' x 12".
165 Lead-string, 1968, 4' x 3'.
166 Untitled, fabric and neon, 1968.
167 Untitled, fabric, 1968.

168 GIUSEPPE PENONE
169 16-20 December 1968.
I have grasped a tree; I will hold it tight with an iron hand. The tree will continue to grow except this part.
170 16-20 December 1968.
I have interlaced three saplings.
171 16-20 December 1968.
I have enclosed the top of a sapling in a cube of metal net (opened at the bottom) and on the net I leaned a cauliflower, a slice of pumpkin and two peppers that I then covered with chalk and cement; the growing tree will raise the net.
172 16-20 December 1968.
I got hold of a tree and then signed with nails and string my profile in the points of contact. The tree growing shall be compelled to keep my action.
173 16-20 December 1968.
I have chosen a tree on which I put my hand and I followed the profile with nails. Afterwards I put 22 plumblines (corresponding to my age) connected with each other by zinc wire and the branches, on the tree. Every year I will add another plumb, till my death. In my will I will leave a disposition that a lightning conductor should be installed. Lightning going down will perhaps melt all the plumbs.

174 FRANZ ERHARD WALTHER (New York).
175 PIECE OF SIMULTANEOUSNESS
The correspondence of the four persons under facilitated conditions. Combinations. The most various forms of opposition.

Developed possibilities from mediate influences for better use of the object. Not the object, but for example the desirable circumstances or the exposed inability. The at times changing conditions and relations of a person. The at times changing conditions of the other persons. The change of the entire climate. The change from parts of the surroundings.

MULTIPLICATION
Points, to find tendencies for presences. Give up the presence of the various conditions of origin for supporting sufficiencies: mutaul presumptions about intentions (completely unilateral and certainly dispensable).
Observation of the assumed movements. No thinking in directions.
Constant hindrance of the « wish-thinking » - to make decisions and exception possible.

SEPARABILITY
Proportions. Distances. Proportions through distances. Similarities don't complete. Reject importunities. Alleged importance is probably only a pretext and doubts. Overhanding taking up the matter of contributions. Keep from the previous approach without especial reasons. The effect of distinct specialties delays.
Exceptions:
Expressing silence
Objective explanation
Displayed monotony
Meaningless confrontation
Incidental events
Fundamentally only give in on the really accessible moments, don't let the « only-feeling » be determining.

176 OBJECT FOR SEVERAL
Sympathy on the question of the necessary time to get the processes going. Provisions and conditions of the users. Destruction of aims and answers that were here before. Decisions for or against the possible situation, don't loose the sums from here! Development of the origins as events. Occupation with certain (evidently not necessary) aspects show the presumptions

as projection. Temporary thoughts at- / situations through memories / Physical events from the day before / what has to be settled urgent tomorrow / Psychological conditions / Disturbances through events. Which influences therefore by using the object.

177 OBJECT OF CONTROVERSION
OPTIONAL
SPECIFICATION
It is obviously made for two persons. What happens by the utilization between the two persons? One certainly can relinquish all the Intention. (And surely remains a certain degree of resistance as unalterable assumption for the experiences.)
(THE DEVELOPMENT)
Naturally the specification doesn't mean anything when it is used. More the momentary sentimentalities. The steady present conditions can motivate to a « Working-against » (which means: meet the conditions of the object, leave what you wanted before). Strengthening of this peculiar reciprocation. Be-striking of the claims. Use according to the wishes.

178 THE OBJECT
What one anyhow knows from similar situations- for first-aid. The reciprocation of the two situated in there. This causes the distance. The obviously «being-united». Energy out of the knowledge of « being-involved », etc.

179 HANS HAACKE (New York).
180 Cast ice disk in frozen environment, December 16, 1968.
181 Wind in water: snow, December 15, 1968. Demonstration on studio roof, N. Y.
182 Live airborne system, 1964.
183 Grass, 1967.
184 Sky line, July 23, 1967. Central Park, N. Y. White helium-filled balloons on approx. 800 feet nylon string assembled over 4 hours, swinging in wind.

185 GILBERTO ZORIO (Turin).
186 Untitled, 1968. Copper sulphate, lead, hydrochloric acid, copper.

187 Untitled, 1968. Amiantus, white light, sound of burning gas.
188 Arco voltaico, 1968. Cow hide with electric arc.
189 Il letto, 1966. Rubber, lead, iron, 59'' x 59''.
190 Untitled, 1969. Fire, junk, glass and cement.
191 Torce, 1969.

192 ROBERT MORRIS (New York).
193 Untitled, 1968. Felt.
194 Untitled, 1968. Red felt.
195 Untitled, 1968. Black felt.
196 Untitled, 1968.
197 Untitled, 1968.

198 MARINUS BOEZEM (Gorincherm, Holland).
199 Windtable, 1968. Table and ventilator.
200 Aerodynamic object, 1967.
201 Iron profile with flying nylon, 1968, 59'' x 6'' x 6''.
202 Untitled.
203 Cortina di profumo evaporante, 1968.

204 CARL ANDRE (New York).
205 16 pieces of slate, 1967. Slate sculpture 5/8'' x 4' x 4' (5/8'' x 12'' x 12'').
206 21 pieces of aluminium, 1967, 1'' x 3'' x 11'7'' - 1' x 2 7/8'' x 6 1/2''.
207 Log piece, summer 1968. Aspen, Colorado. Approx. 100' long; 14'' - 16'' lengths.
208-209 Cuts, 1967. Concrete sculpture, 2'' x 30' x 45'.
210 Rock pile, summer 1968. Aspen, Colorado. Approx. 5'6''.

211 EMILIO PRINI (Genoa).
212 I punti di luce sull'Europa, 1967.
213 Ho preparato una serie di ipotesi di azione a punzoni su piombo del peso del mio braccio che scrive, 1967-1968.
214 Io, tu, Dioniso anche, 1968.
215-216 Il mondo è una stanza - Stati di simpatia con la tua stanza, 1968.
217-218 Il mondo è una stanza - Stati di simpatia con la tua stanza, 1968.

219 RICHARD SERRA (New York).
220 Lead, 1968, 29" x 6,6" x 39".
221 Rubber, 1967.
222 Untitled, 1968.
223 Object, 1968. Iron and lead, 99" x 17" x 10,2".
224 Show at the Ricke Gallery, Cologne - Oct. 1969.

225-231 GERMANO CELANT (Genoa).

232-240 ZOO.

We wish to give particular thanks to all the artists that have collaborated in this work and to Seth Siegelaub, Gian Enzo Sperone, Ileana Sonnabend, Leo Castelli, Konrad Fischer, Heiner Friedrich, Rolf Ricke, John Weber, John Gibson, Harald Szeemann, Wim Beeren and also to Carlo Giani that made it possible to realize this book.

Photographs by Claudio Abate, André Morain, Shunk-Kender, Piero Gilardi, Albertine Ooiman, Rudolph Burckhardt, Bressano, Peter Moore, Errol Jackson, John Webb, Bruno Marconi, Eric Pullitzer, Walter Russell, Eva Beuys, Ute Klophaus, Manfred Tischer and Barbara Brown.

Art yard

I have been thinking about an art yard I would like to build. It would be sort of a big hole in the ground. Actually it wouldn't be a hole to begin with. That would have to be dug. The digging of the hole would be part of the art. Luxurious stands would be made for the art lovers and spectators to sit in.

They would come to the making of the yard dressed in tuxedoes and clothes which would make them aware of the significance of the event they would see. Then in front of the stand of people a wonderful parade of steamshovels and bulldozers will pass. Pretty soon the steam shovels would start to dig. And small explosions would go off. What wonderful art will be produced. Inexperienced people like La Monte Young will run the steamshovels. From here on out what goes on can't easily be said. (It is hard to explain art). As the yard gets deeper and its significance grows, people will run into the yard, grab shovels, do their part, dodge explosions. This might be considered the first meaningful dance. People will yell « Get that bulldozer away from my child ». Bulldozers will be making wonderful pushes of dirt all around the yard. Sounds, words, music, poetry. (Am I too specific? optimistic?)

The whole action might last any amount of time. Maybe the machines will run out of gas. Or the people take over the machines. Or the holes might cave in. In any case I am sure there will be enough range of possibilities in the art to permit individual variation, and in time, style and acceptance.

« (The town of Pittsburg's recent Art Yard was interesting but followed a usual romantic machine crashing interpretation. Yet even with this interpretation not enough was done with the explosions and collisions to merit special notice, and obvious references to NEW YORK'S recent two acre festival did not go unnoticed.) » Alas.

I have just been thinking about this wonderful art, already it is being killed in my mind. Is nothing safe? Perhaps you haven't thought me serious? Actually I am. And if this paper should fall into the hands of someone who owns a construction company and who is interested in promoting art and my ideas, please get in touch with me immediately. Also if someone owns an acre or so of land (preferably in some large city... for art... thrives there) do not hesitate.

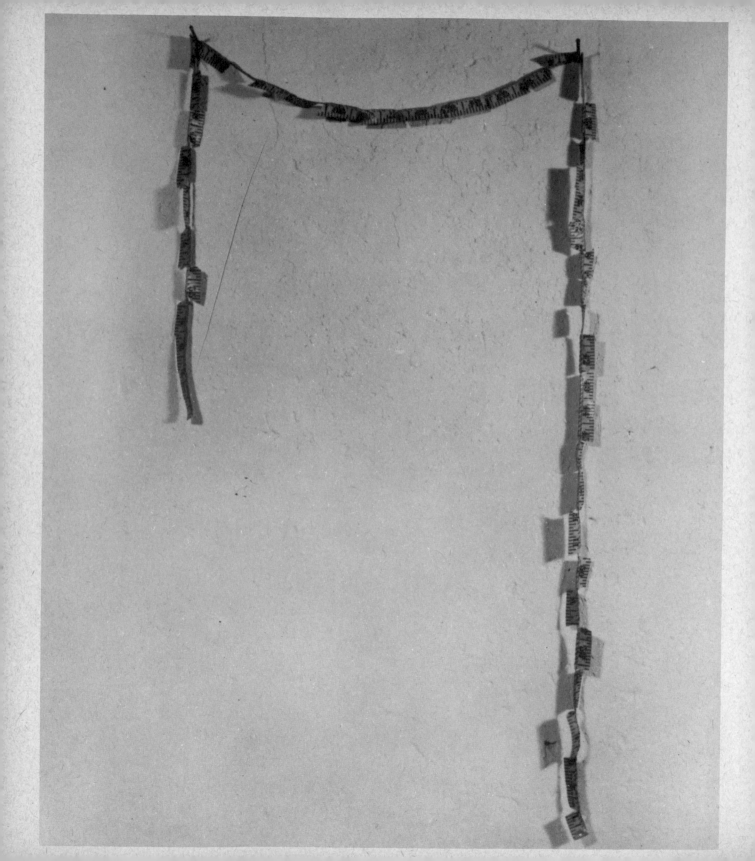

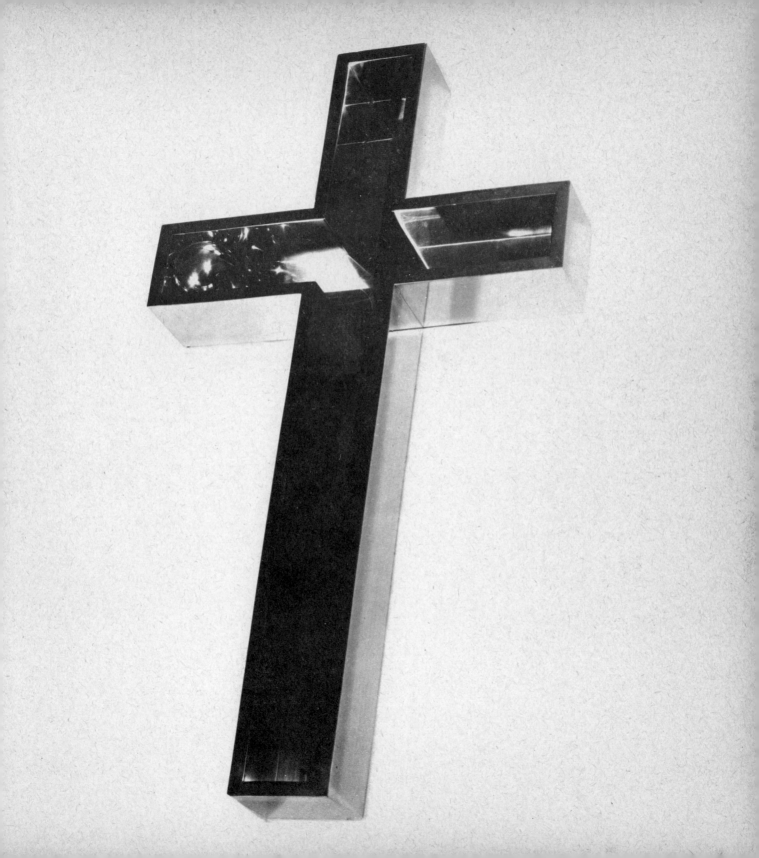

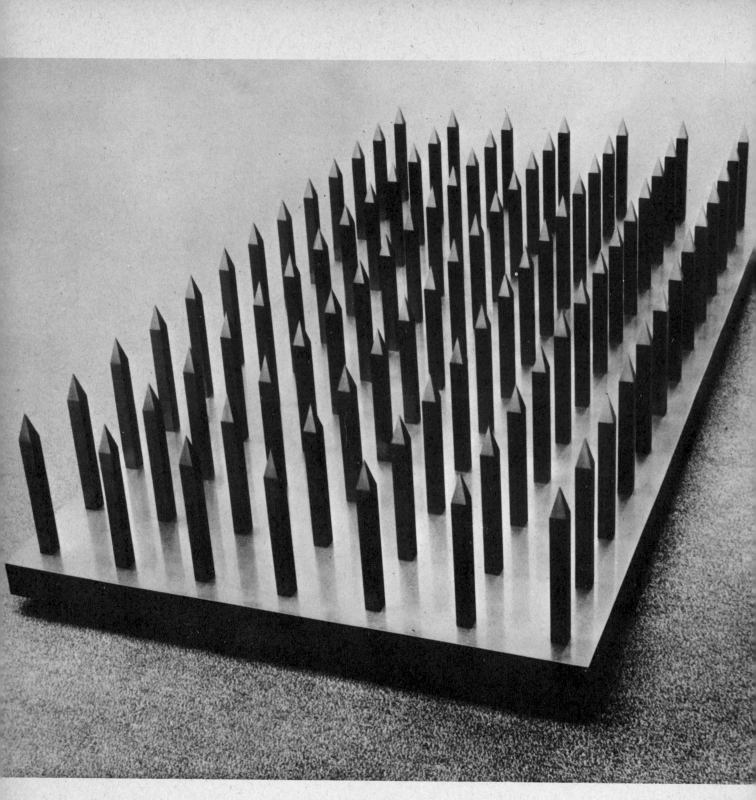

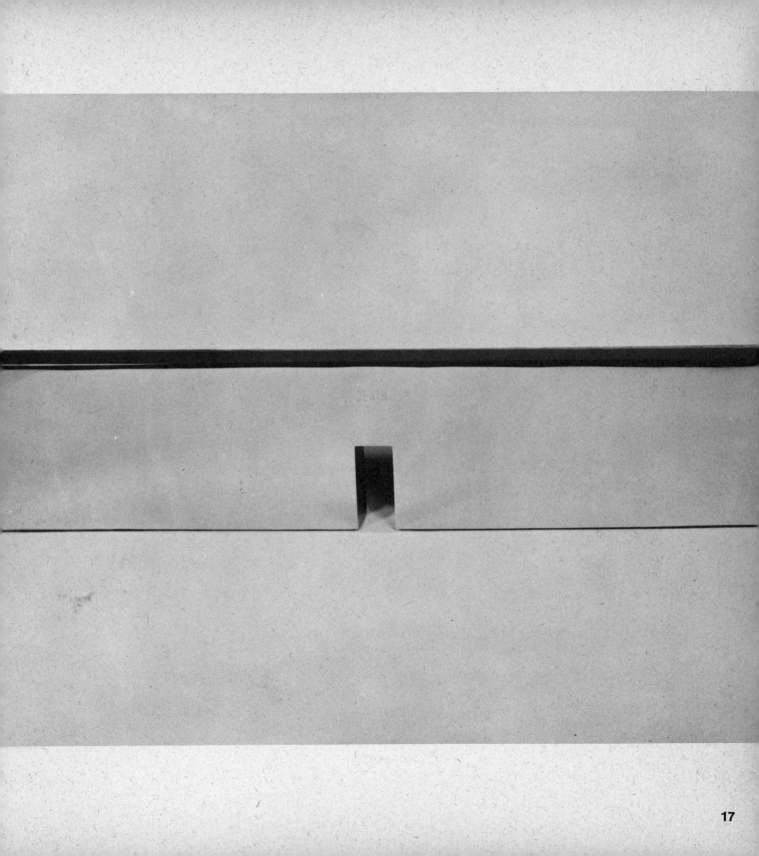

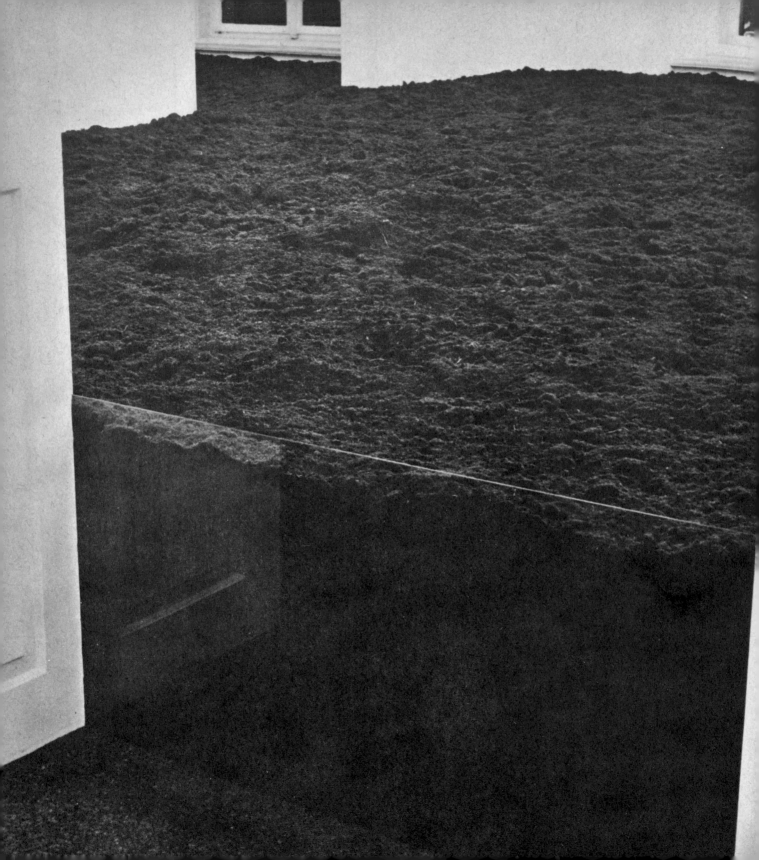

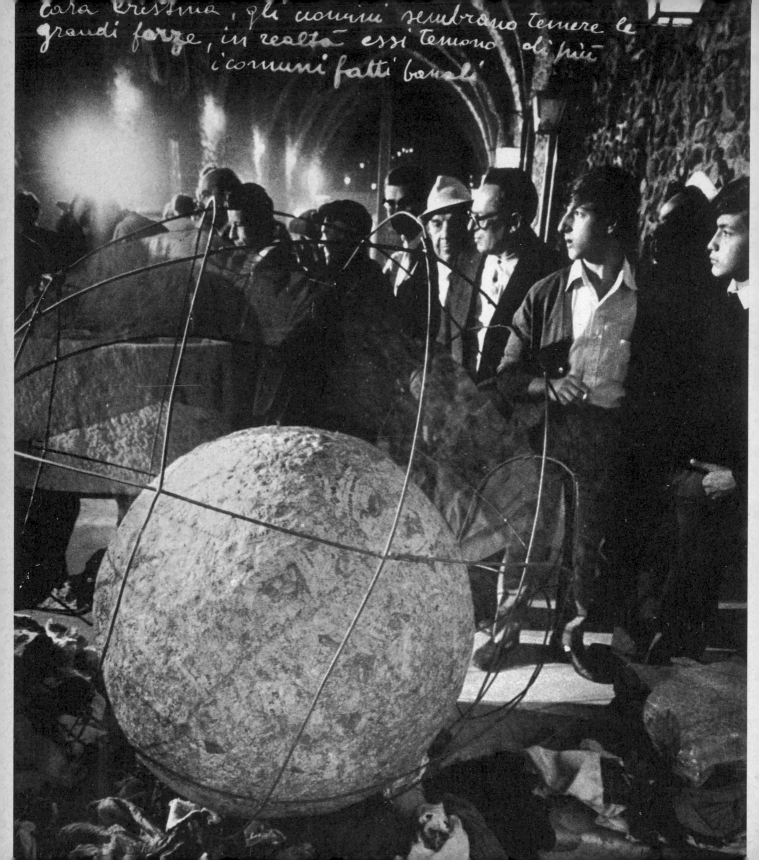

Cara Cristina, gli uomini sembrano temere le
grandi forze, in realtà essi temono di più
i comuni fatti banali

Caro Carlo, una volta un tale disse a
un'altro: io vorrei diventarti molto
molto amico, dopo un anno l'altro
gli rispose: anch'io vorrei diventarti
molto molto amico ma ora é
più difficile perché ci
conosciamo

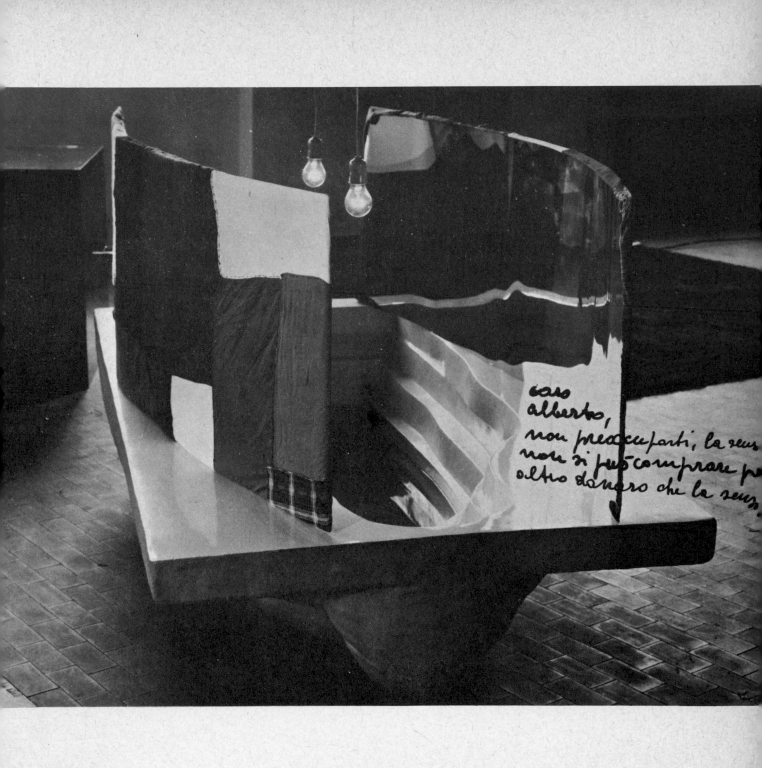

caro Pietro, se la politica é un quadrimotore
io viaggio su un aliante. Stia attenta la
maggioranza, qualsiasi essa sia, a tenere ben
chiusi i manicomi, se no....

Unannounced public Panam building spectrum lightshow.

In each room of the Panam building which has windows should be placed light bulbs of the major hues: Red, Orange, Yellow, Green, Blue, and Violet. The number of bulbs in each room should be determined by the size of the room and the number of windows so that each window emits the same amount of light.

The show will be given at dusk or after dark with the least amount of public announcement as is possible. Acceptable exceptions: Police and city officials and companies renting space in the building.

The lights are to be lit in the following order: Red for ten minutes, Orange for ten minutes, and so on through Violet. The show should last one hour.

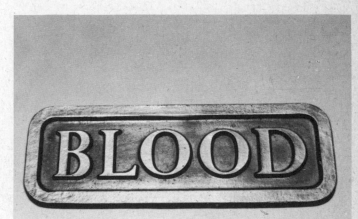

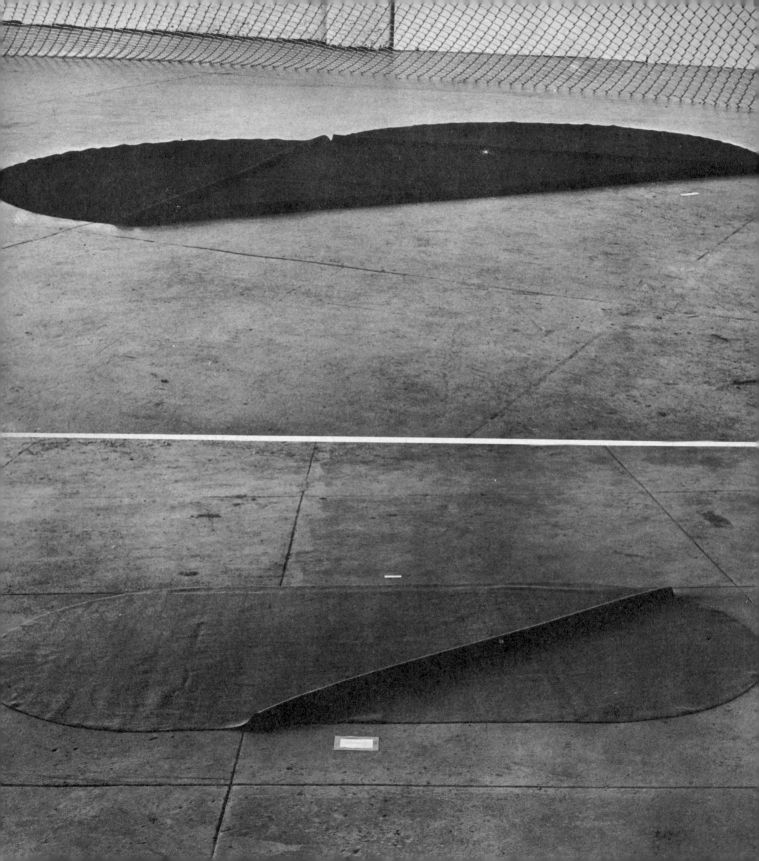

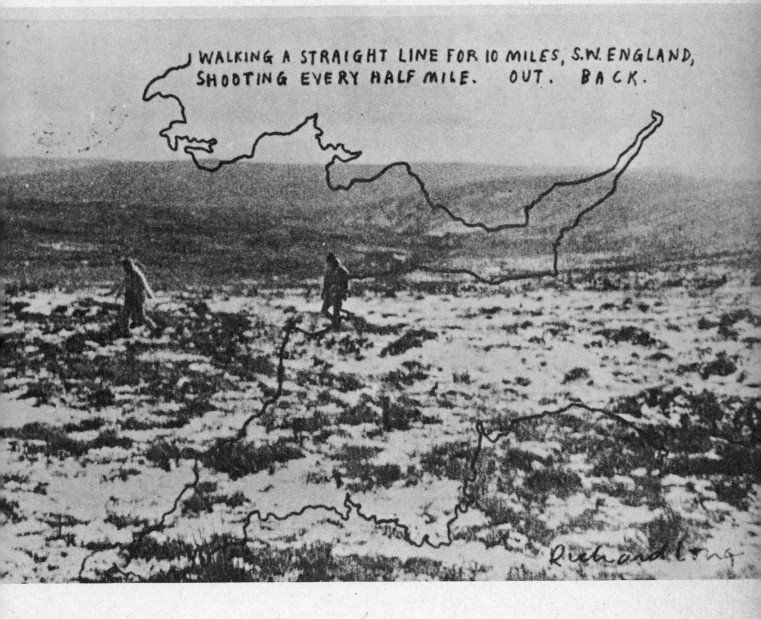

WALKING A STRAIGHT LINE FOR 10 MILES, S.W. ENGLAND, SHOOTING EVERY HALF MILE. OUT. BACK.

Richard Long

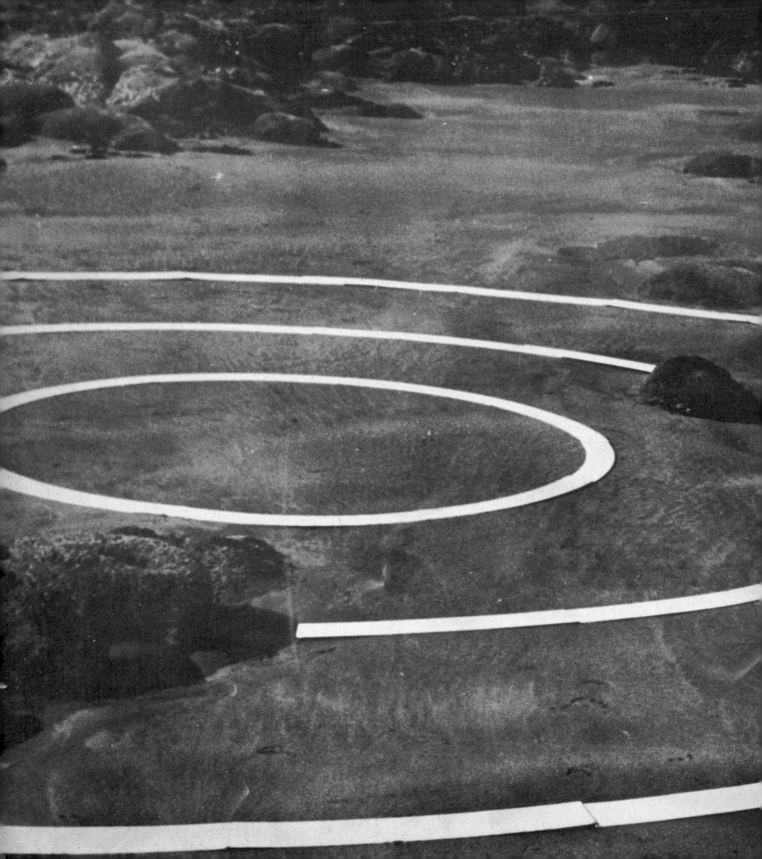

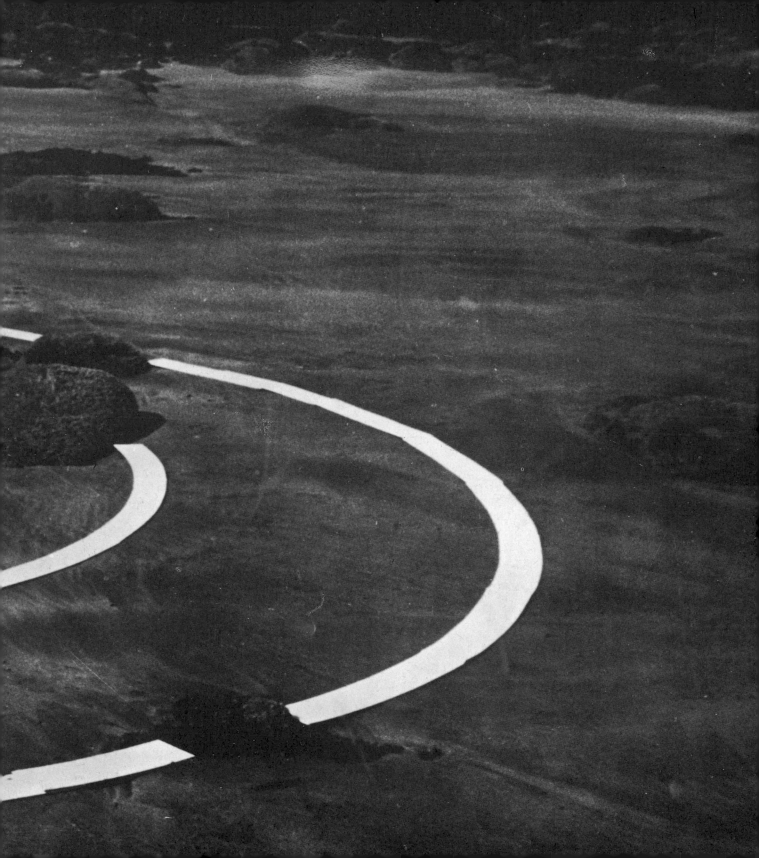

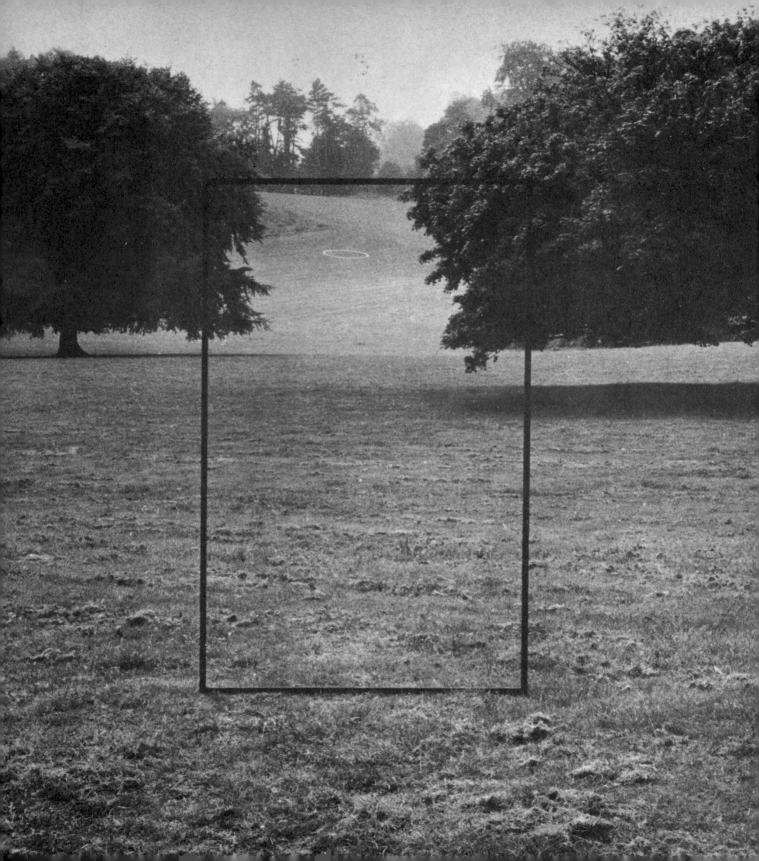

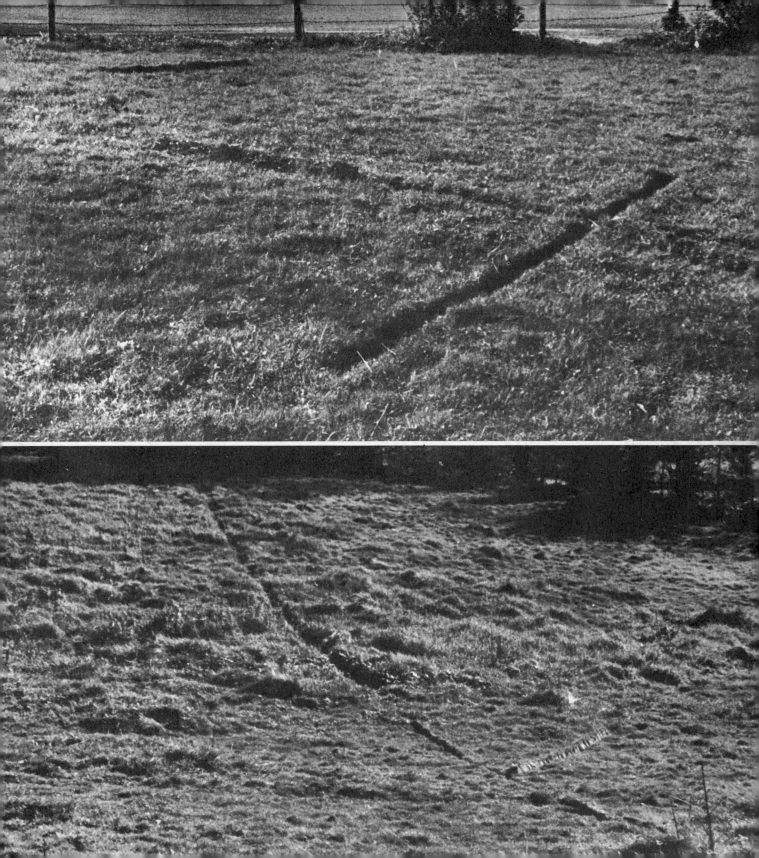

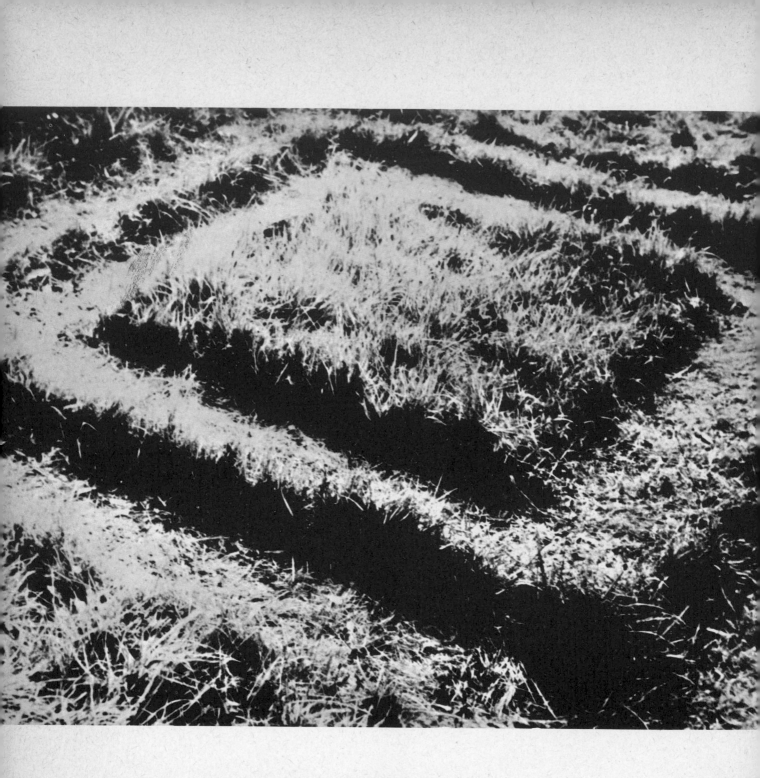

Thought for Celant. The broken glass is the violinists, the lances are the organ, the sticks have a wonderful sound, what more do you want. It certainly is necessary to believe that the streets and houses are crowded with people.

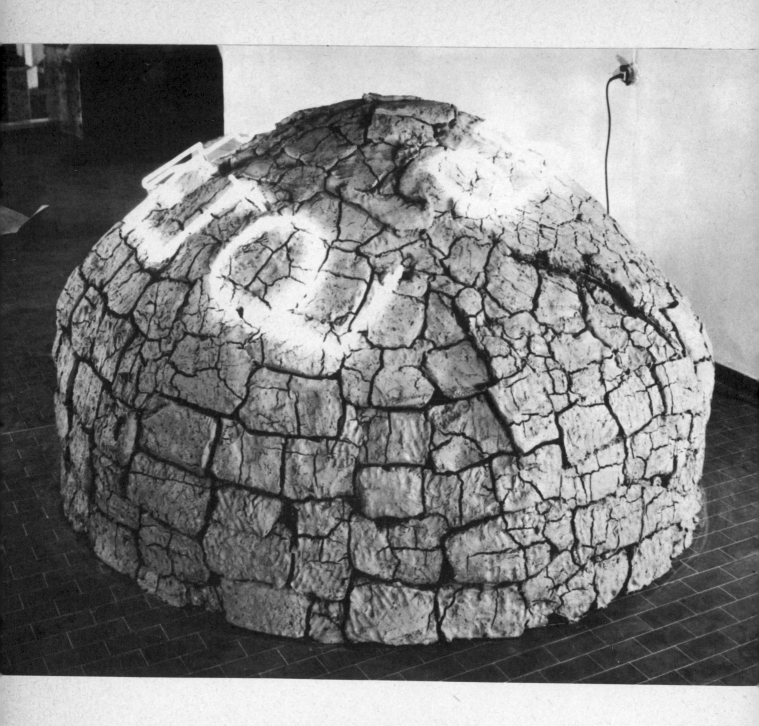

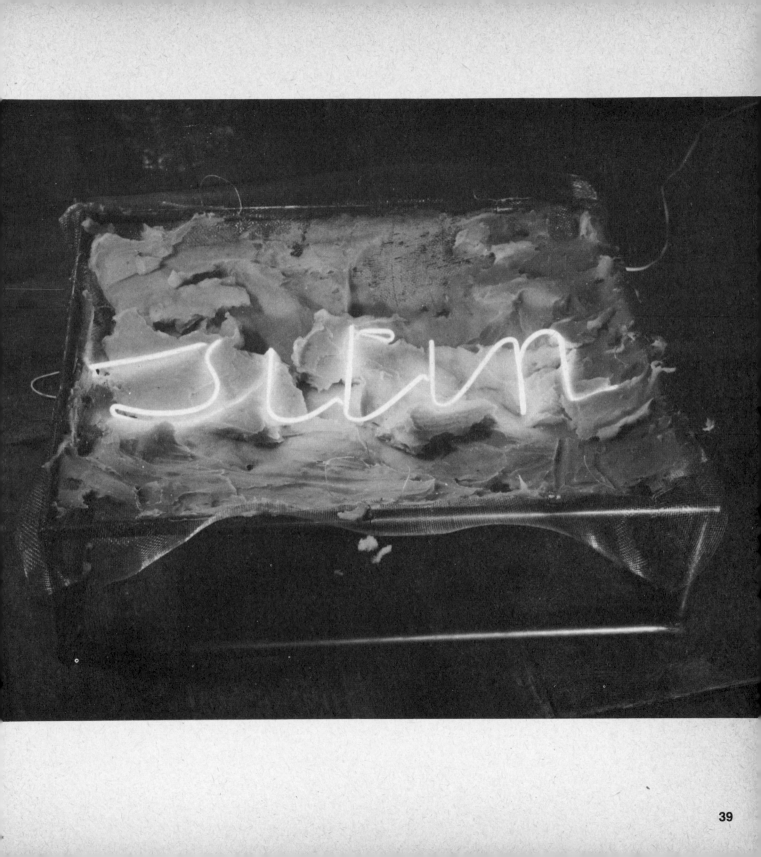

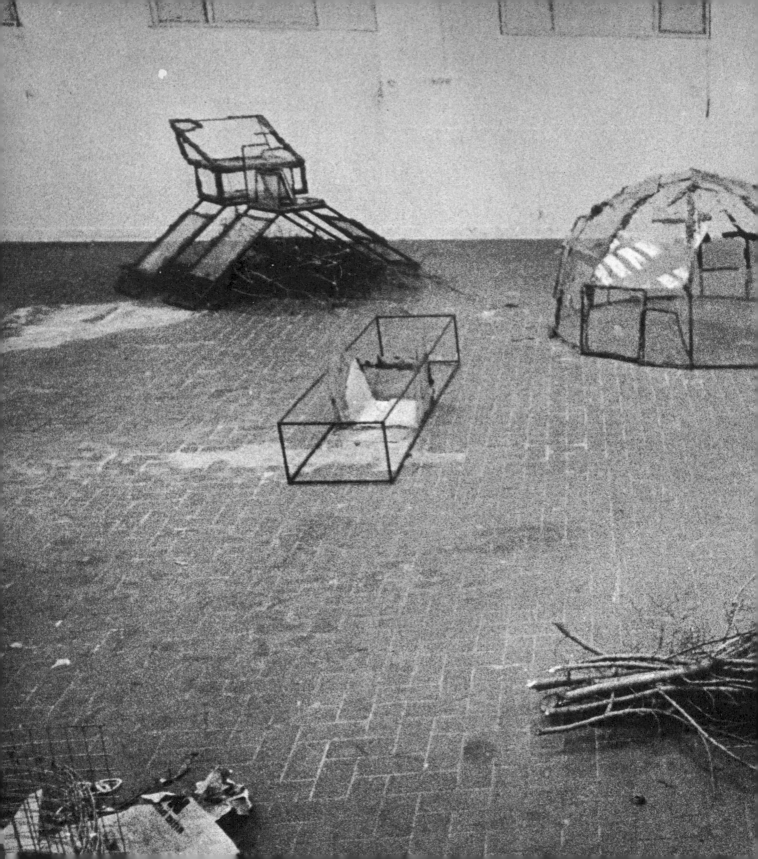

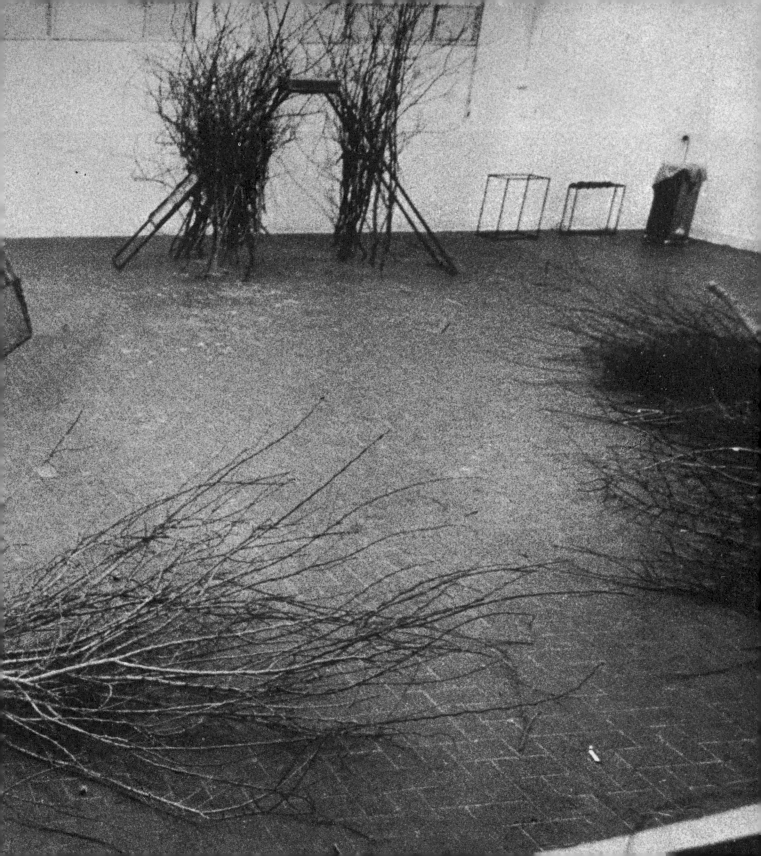

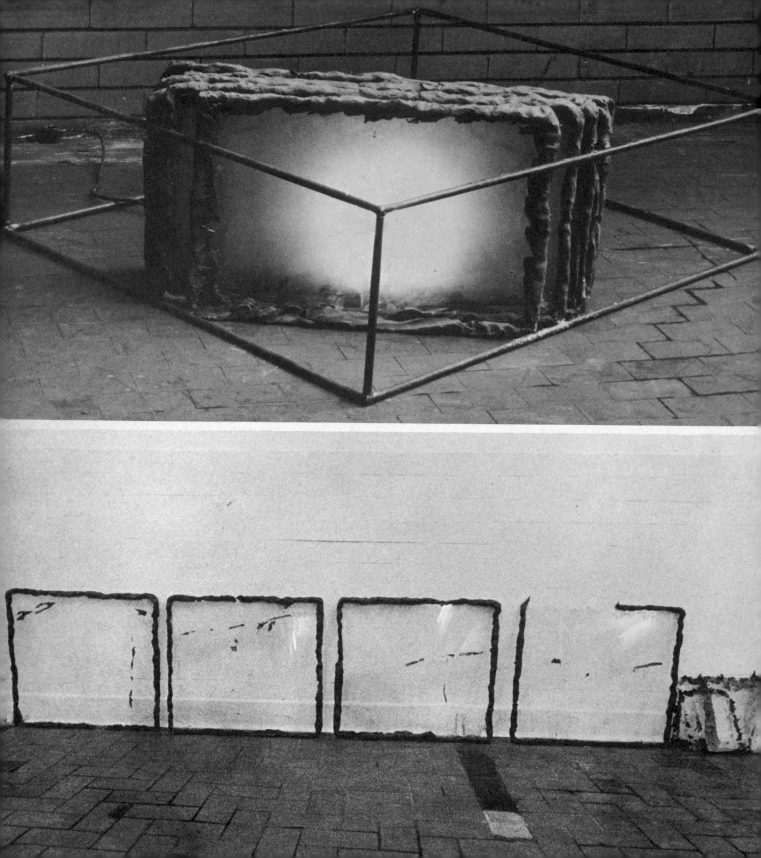

The world is full of objects, more or less interesting: I do not wish to add any more.
I prefer, simply, to state the existence of things in terms of time and/or place.
More specifically, the work concerns itself with things whose inter-relationship is beyond direct perceptual experience.

Because the work is beyond direct perceptual experience, awareness of the work depends on a system of documentation.

This documentation takes the form of photographs, maps, drawings and descriptive language.

December 1968

The existence of each sculpture is documented by its documentation.

The documentation takes the form of photographs, maps, drawings and descriptive language.

The marker « material » and the shape described by the location of the markers have no special significance, other than to demark the limits of the piece.

The permanence and destiny of the markers have no special significance.

The duration pieces exist only in the documentation of the marker's destiny within a selected period of time.

The proposed projects do not differ from the other pieces as idea, but do differ to the extent of their material substance.

September 1968

44

JOSEPH BEUYS

1961

Scene from the deer-hunt
fat yes
chemical processes yes
sculpture rough cast yes
ruin yes
deer's horns yes
of the deer (lady-rider) yes
medicaments yes
hare on motor-cycle yes
many - vehicles yes
soap yes
sugar sticks yes
ruin 2 yes
metric element yes
64 surrogates yes
feelers yes
filters yes
heating apparatus yes
ammunition yes
117 televisions yes
mass-media yes

1965

OSTEND

on the beach or in the dunes
a cubiform house
inside
« Samurai's sword is a blood-sausage »
pedestal

50

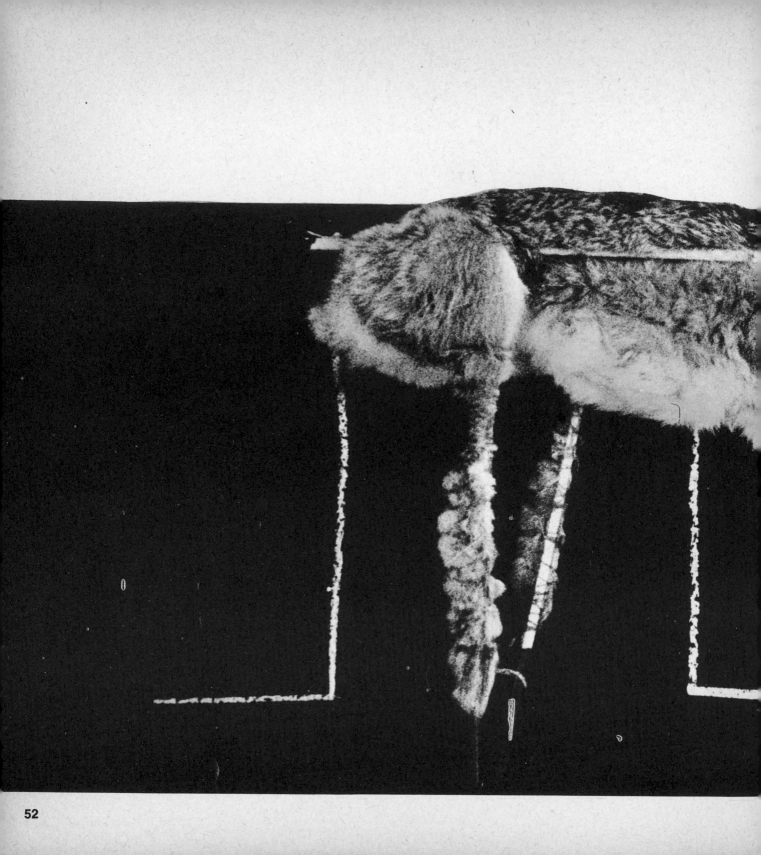

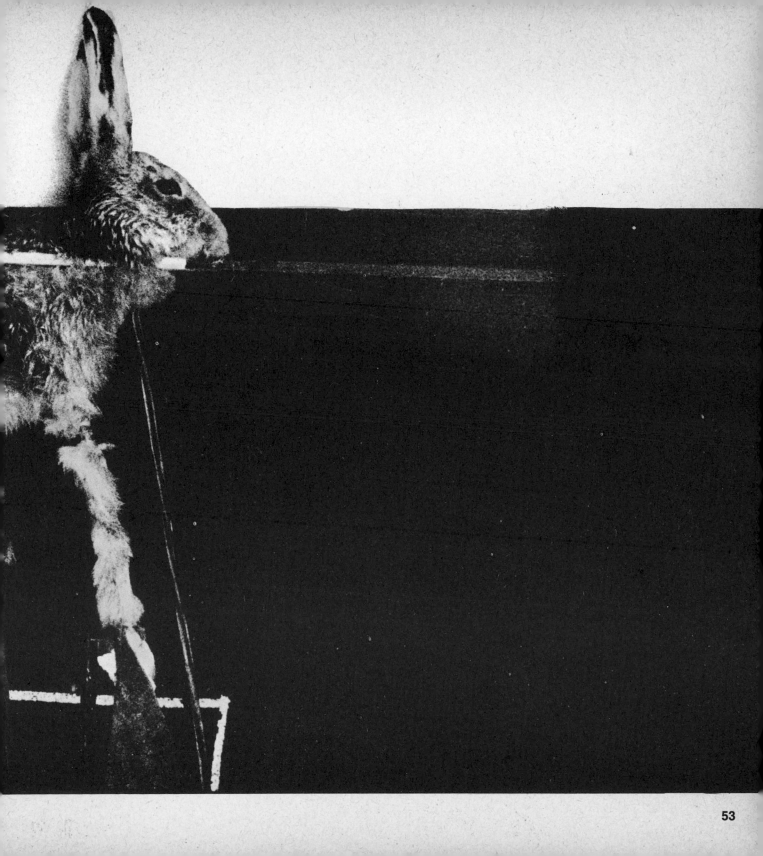

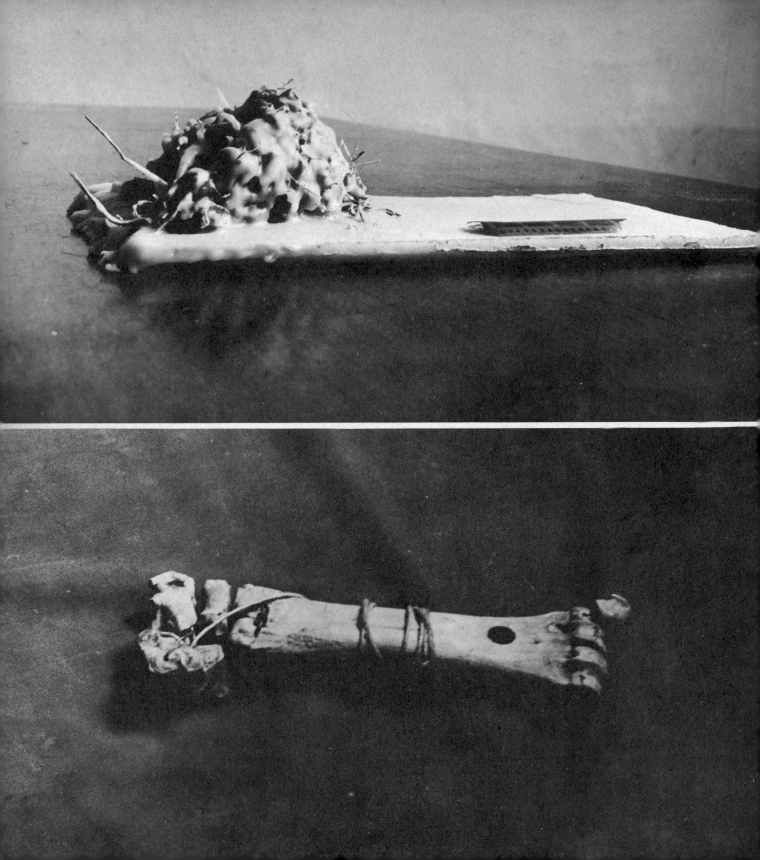

EVA HESSE

I would like the work to be non-work. This means that it would find its way beyond my preconceptions.

What I want of my art I can eventually find. The work must go beyond this.

It is my main concern to go beyond what I know and what I can know.

The formal principles are understandable and understood.

It is the unknown quantity from which and where I want to go.

As a thing, an object, it accedes its logical self.

It is something, it is nothing.

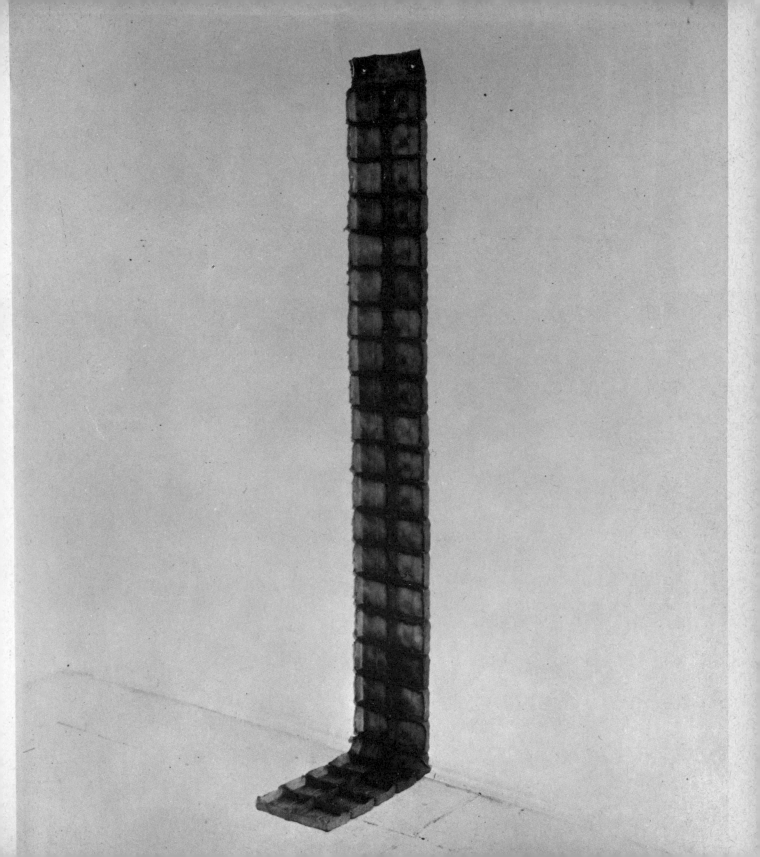

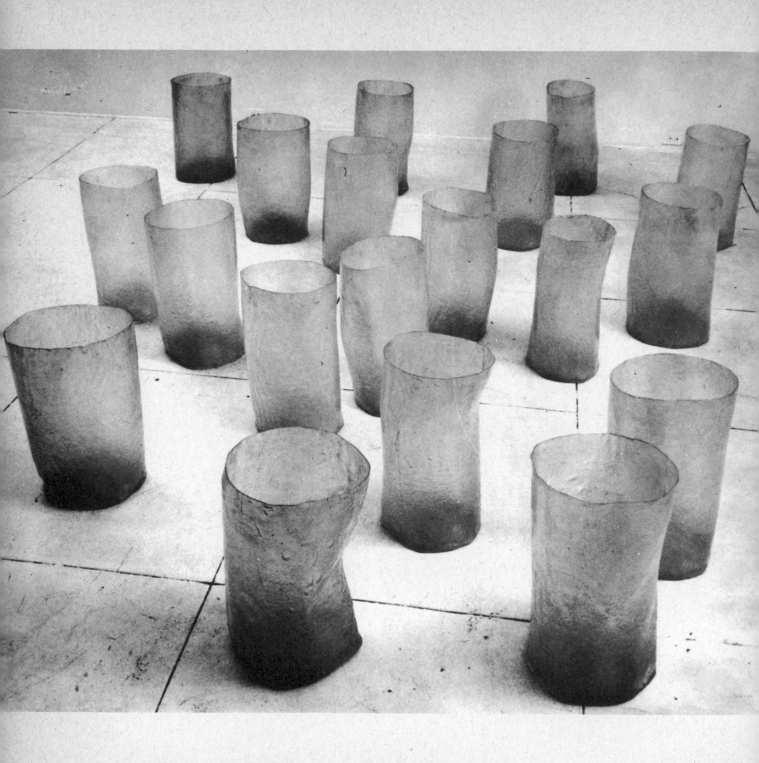

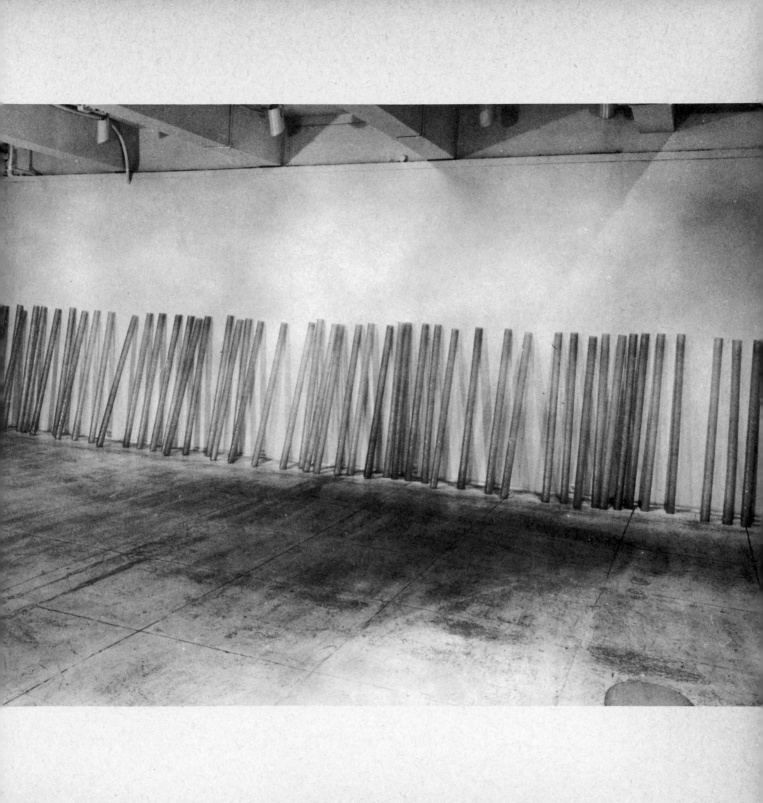

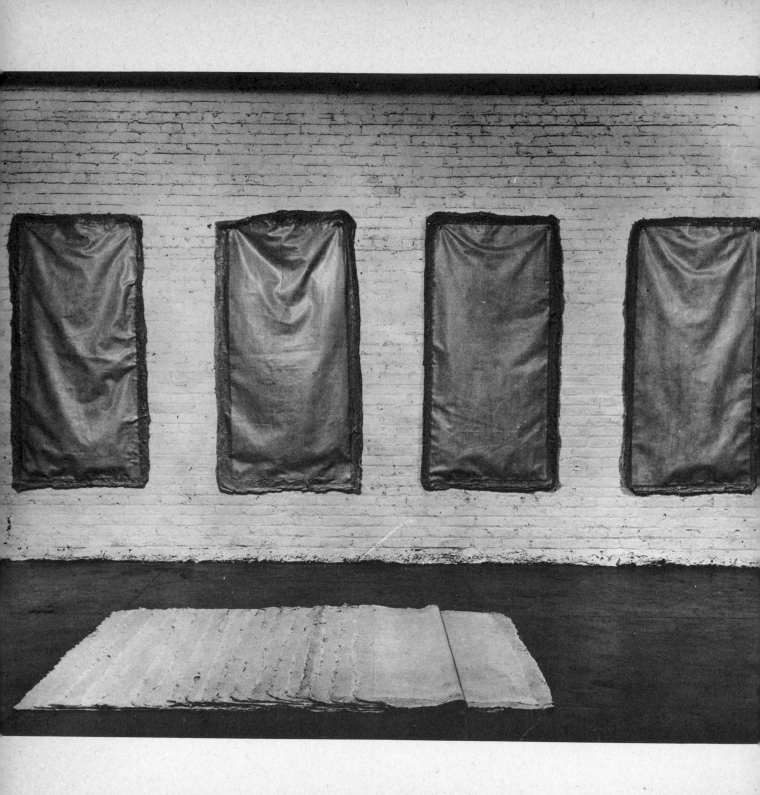

Mass can be a vacuum if it is pervaded by a universe.

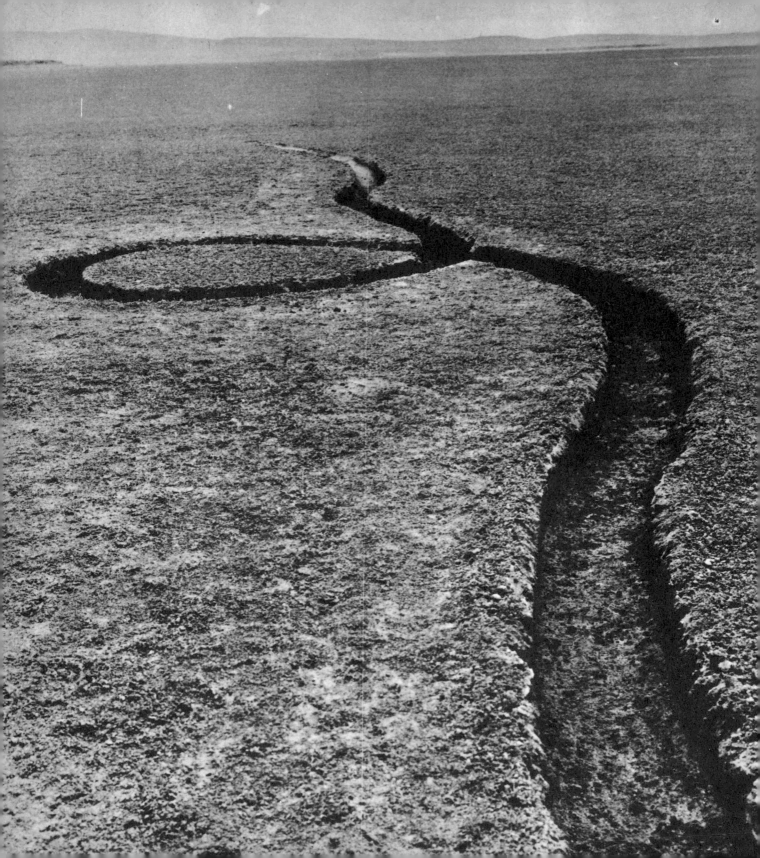

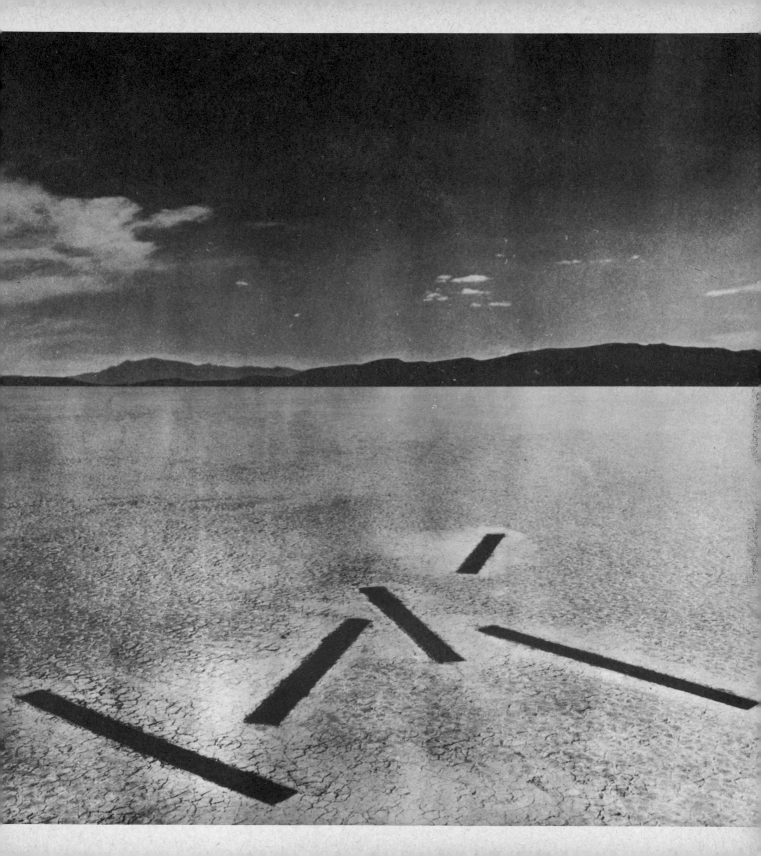

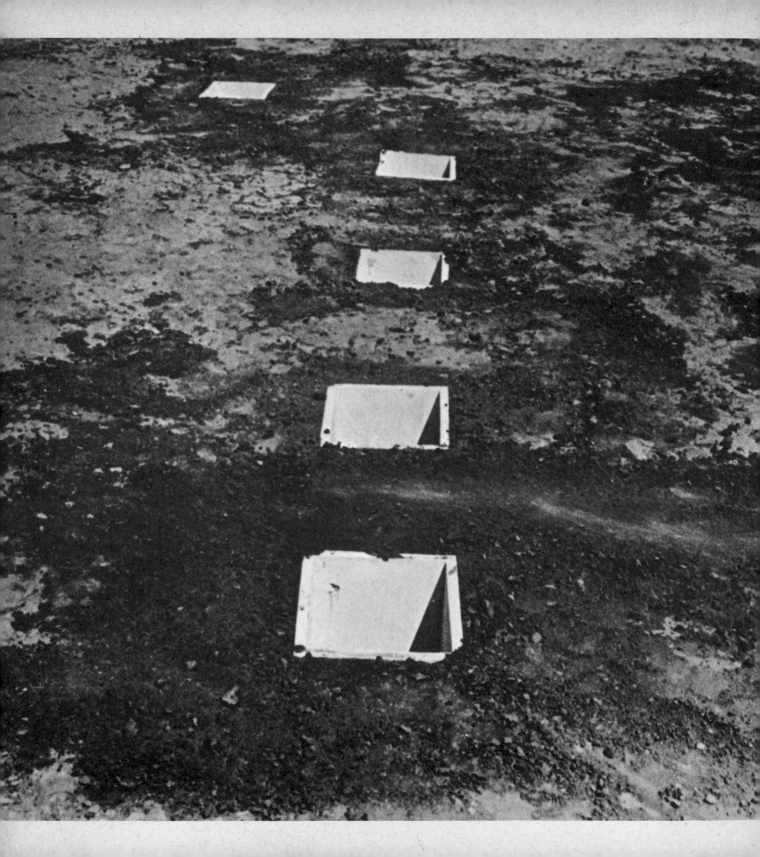

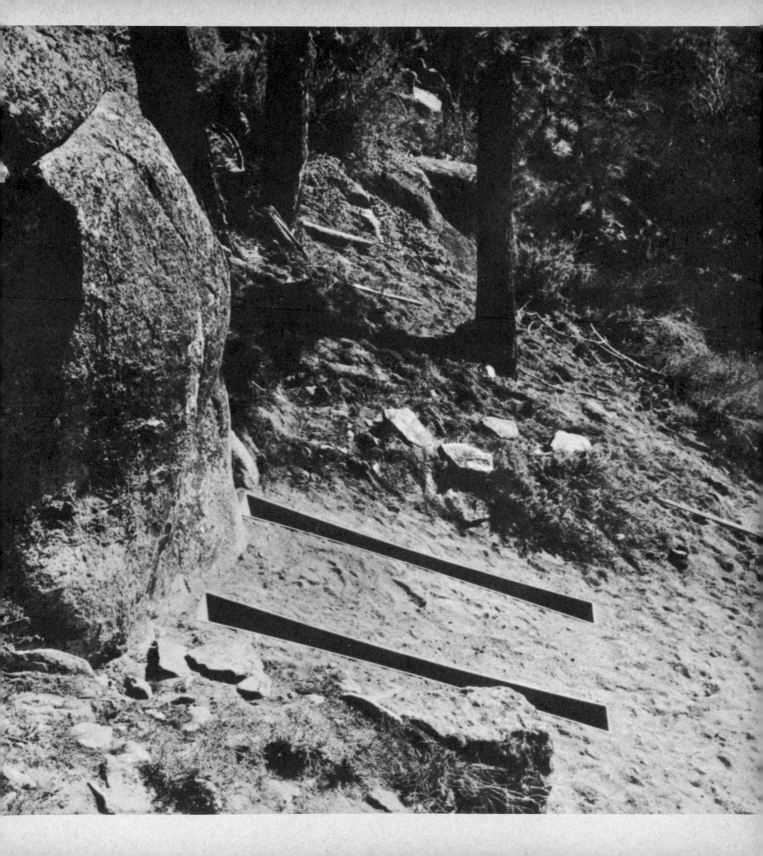

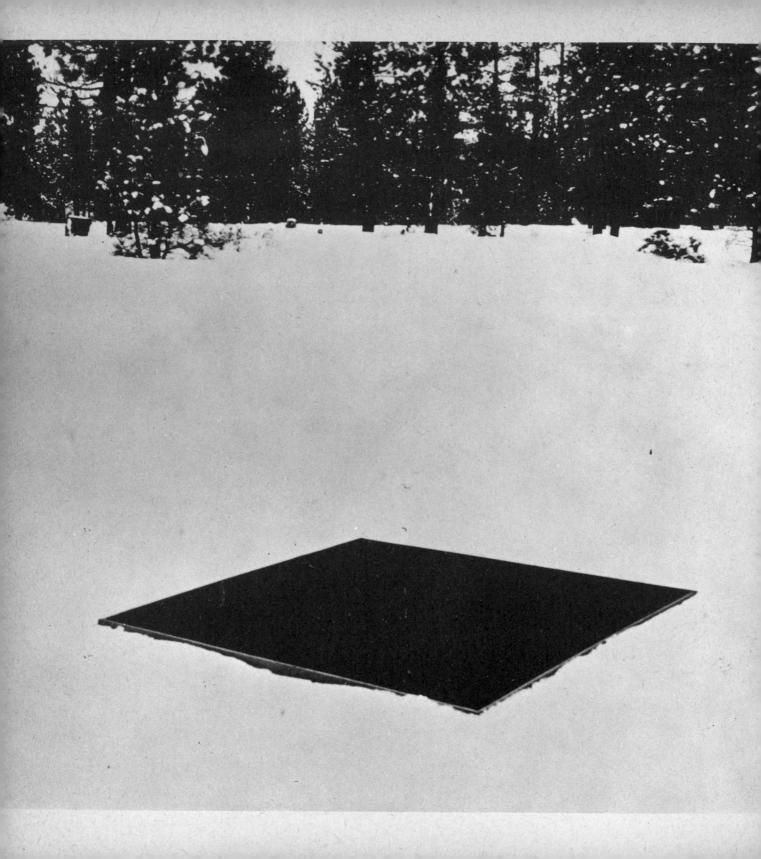

... I can say that I never have a clear and direct philosophy and never see any need to stay with a 'direction' or 'group'.

.

The changes in my work are the changes in the time around me or the given situation, and are the same changes comparable to when I for one week like cheese and the other week meat.

Yet, at the same time I do like old cheese or meat, but then with the consciousness of the fact that it isn't the same cheese or meat I'm using because it changed in time or situation. I call my works rather materialized actions of passing-by and coincidental meetings in time.

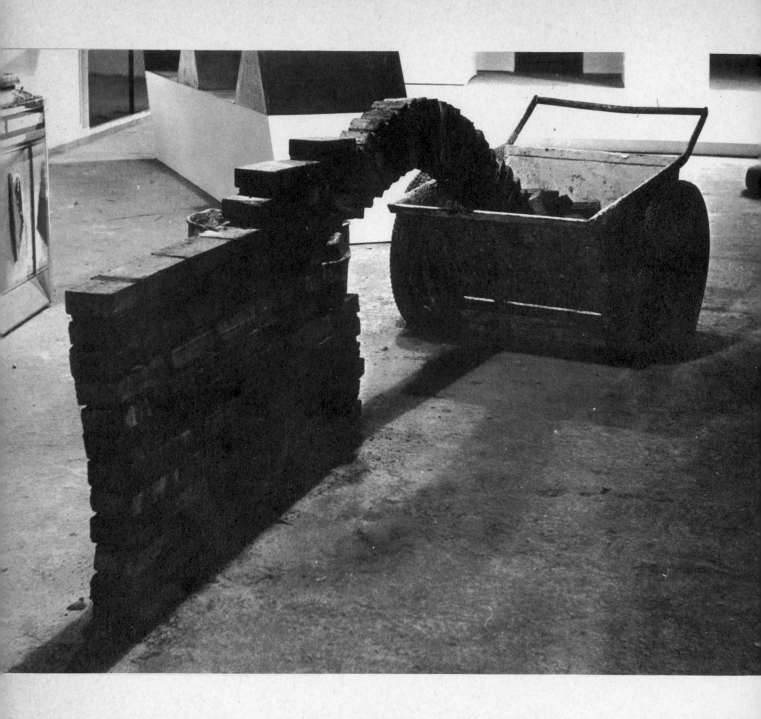

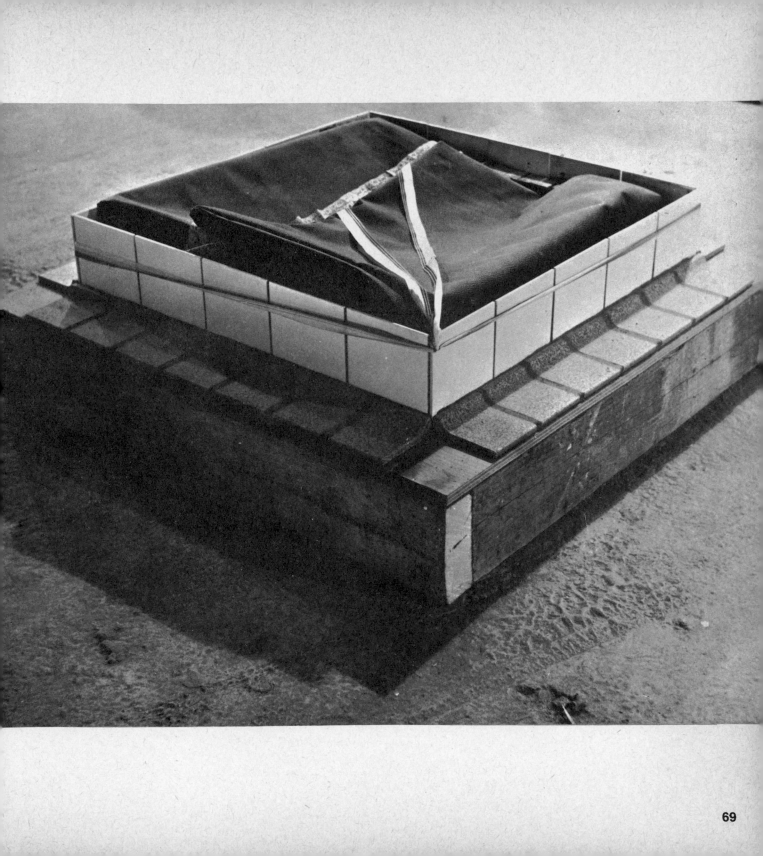

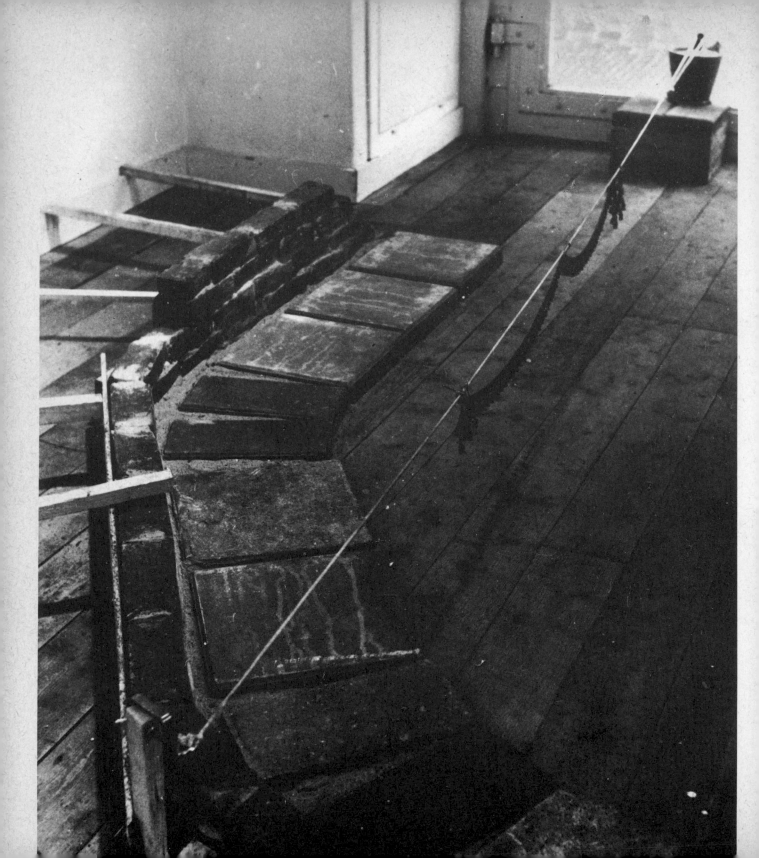

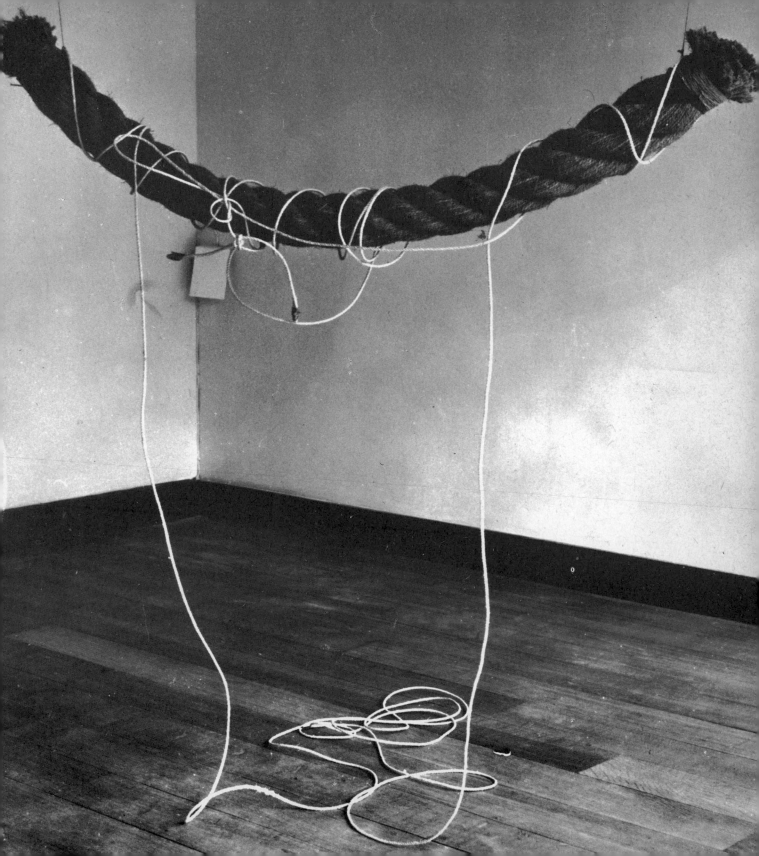

9 May 1969
I shall paint a tree black

15 May 1969
I shall bring a sailing boat from the sea to an alpine lake and paint it black.

20 May 1969
I shall paint dark blue a farm house in the Roman Campagna (and the inside also).

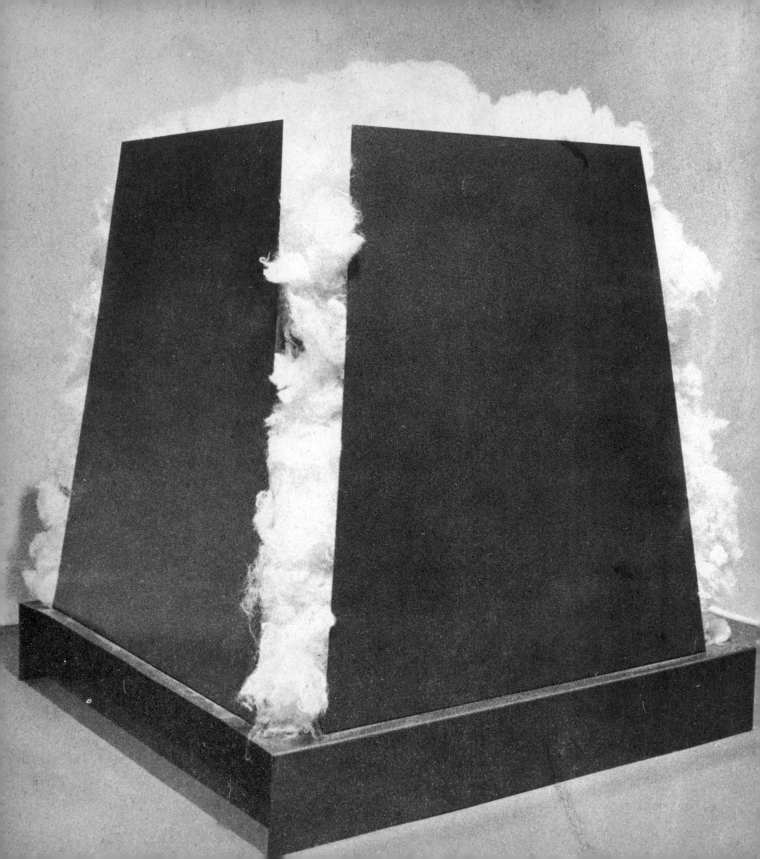

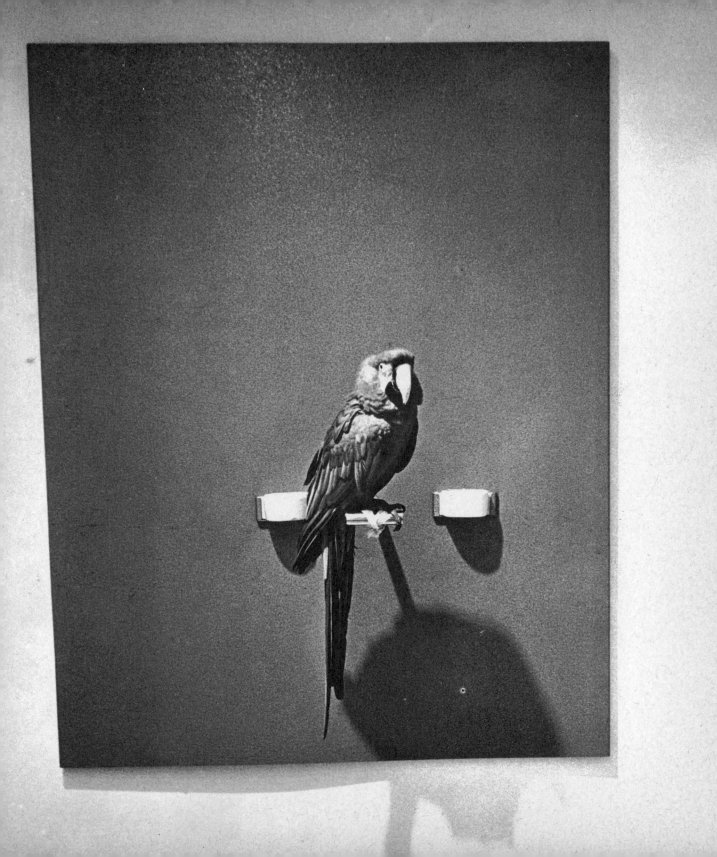

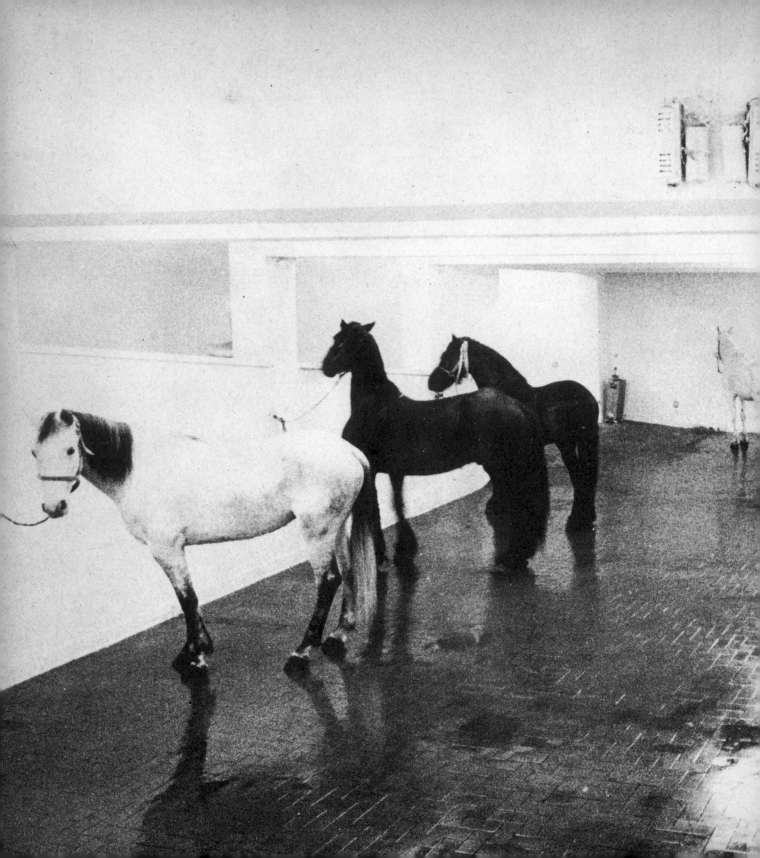

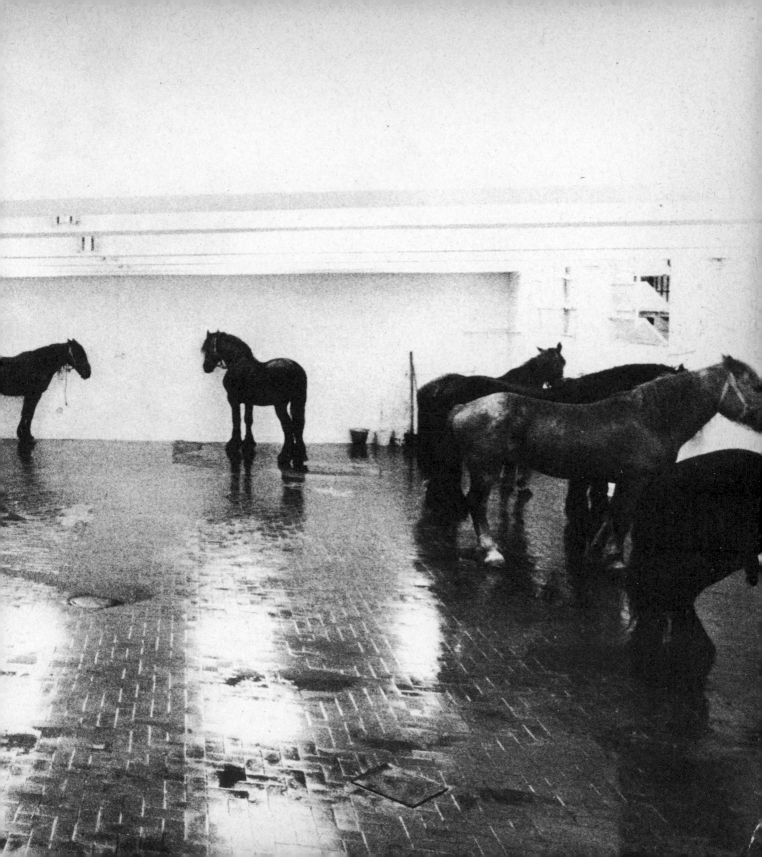

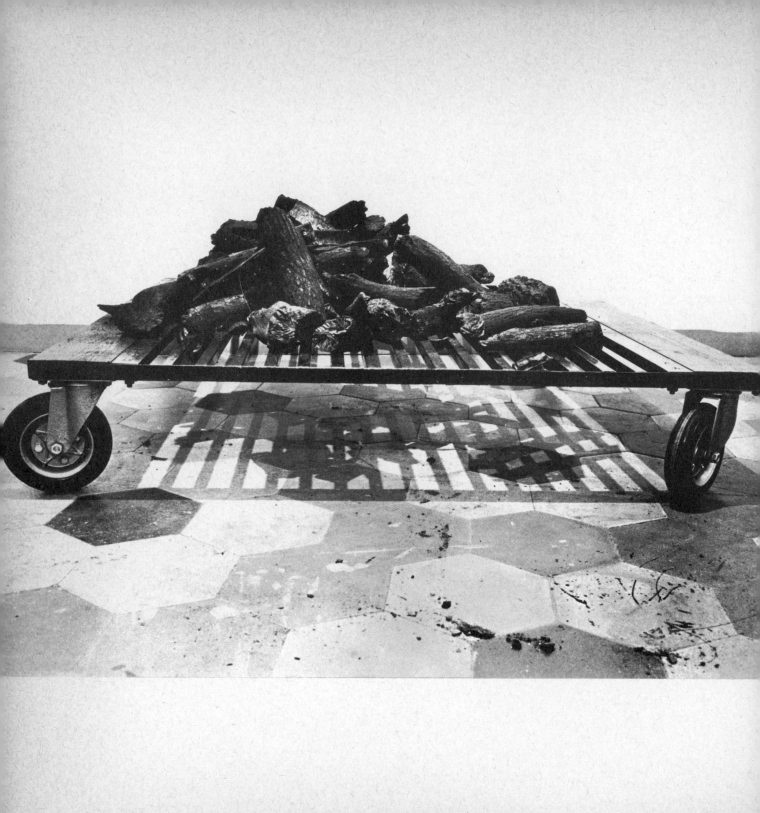

One standard dye marker thrown into the sea.

Common steel nails driven into the floor at points designated at time of installation.

An amount of paint poured directly upon the floor and allowed to dry.

Three minutes of forty pound pressure spray of white highway paint upon a well tended lawn.

The lawn is allowed to grow and not tended until the grass is free of all vestiges of white highway paint.

One square limestone slab of arbitrary thickness.

One sheet of brown wrapping paper bonded evenly with the edges to the top surface of the limestone.

One hole in the ground approximately one foot by one foot by one foot.

One gallon of water-based white paint poured into this hole.

A sheet of brown paper of arbitrary width and length of twice that width with a removal of the same proportions glued to the floor.

LUCIANO FABRO

My certainty: my sense for my action.

A new logic that should be particular and supply the means for the development of the human spirit in the world. To discover the order of things, to determine, instead of the essences, the useful secondary properties, the modes of action, with the aim of an inert contemplation, to induce the cause from the effects that make themselves felt. To sharpen and systematize with this aim the observation and reflexion. To acquire the instruments of the spirit and to extend by their means the power of the hand into new instruments, to extend one's own body into all things of the world; the things as obedient members; imitating nature but aiming to transform her according to human ideas. To analyze her instead of abstracting. To substitute the inventory of chance by the adequate method of profitable reformative invention.

To assume this infinite undertaking.

To « make » this infinity, in which man will neither lose himself nor vainly agitate. To choose this herculean path of virtuous weariness, to let go the easy, seducing, flowery path without the fruits of work, of edifying contemplation, of the outlets that at their most, are just good enough for those that love to hurl themselves into nothing.

(word and thought by Francis Bacon)

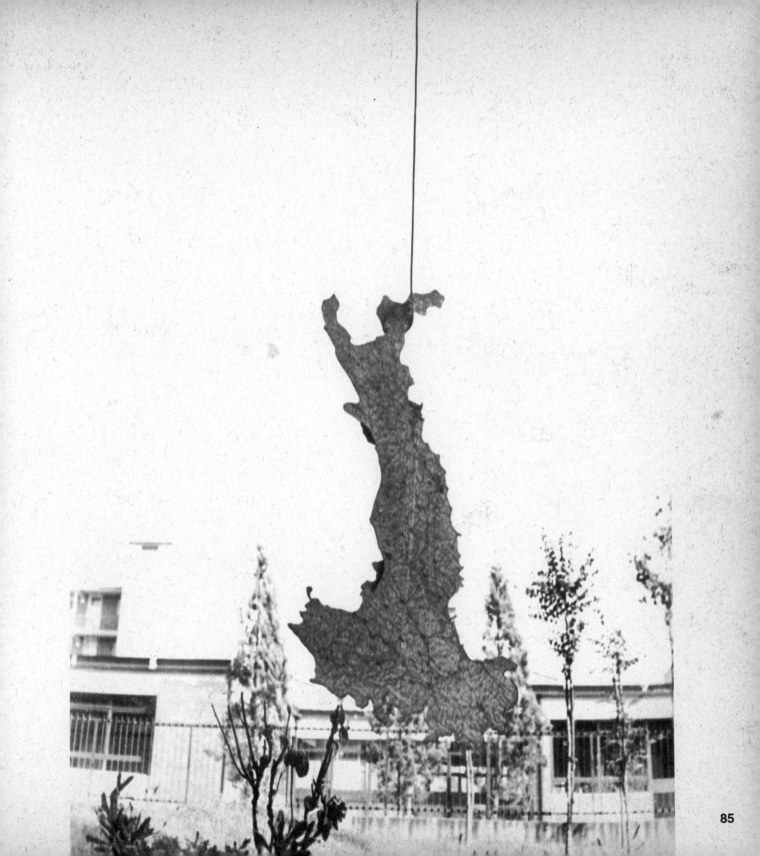

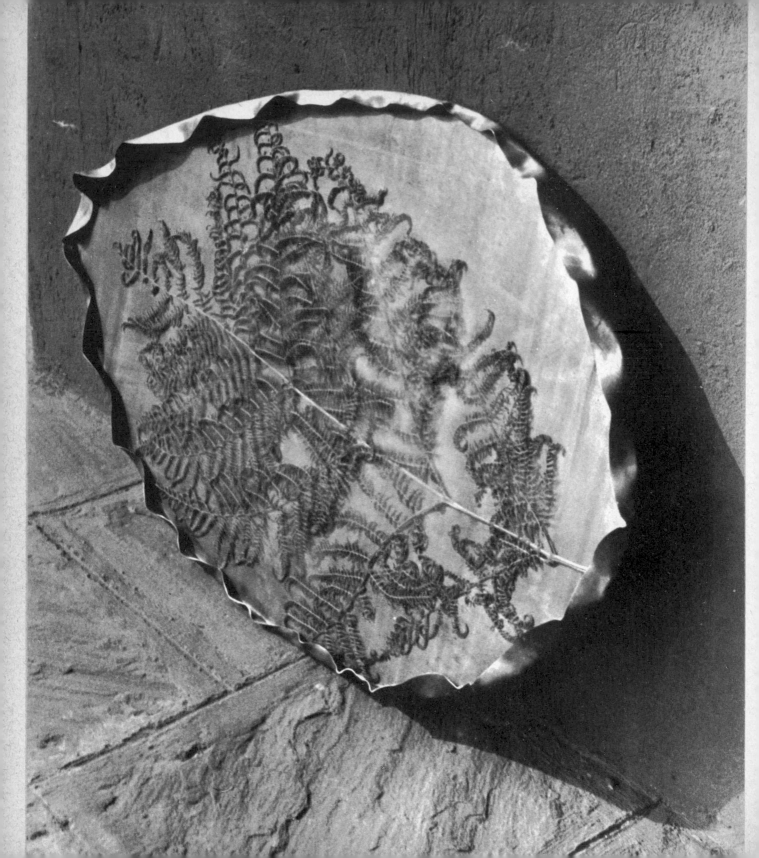

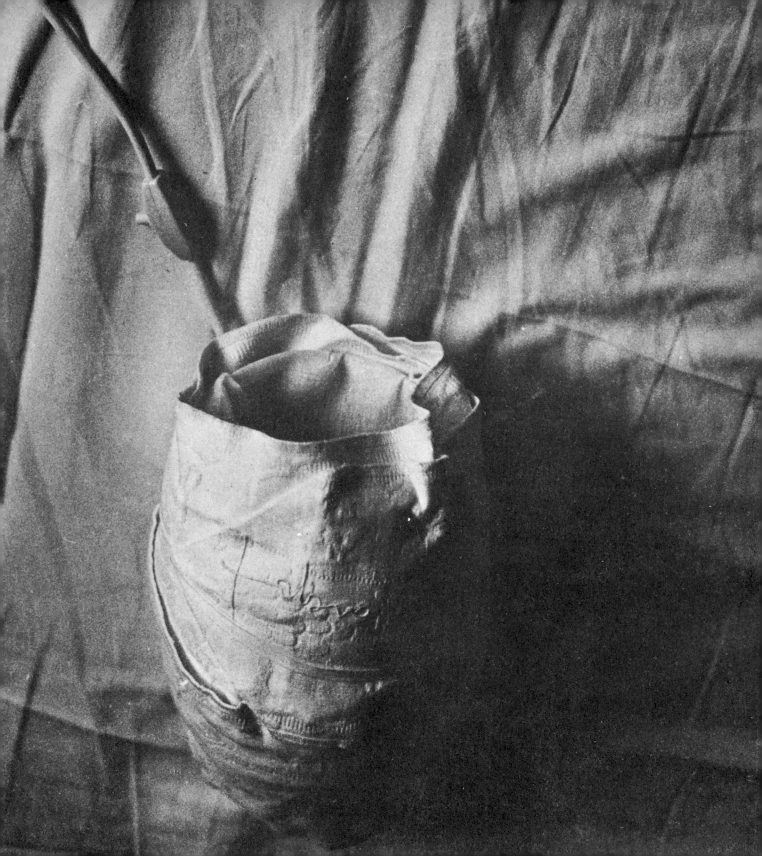

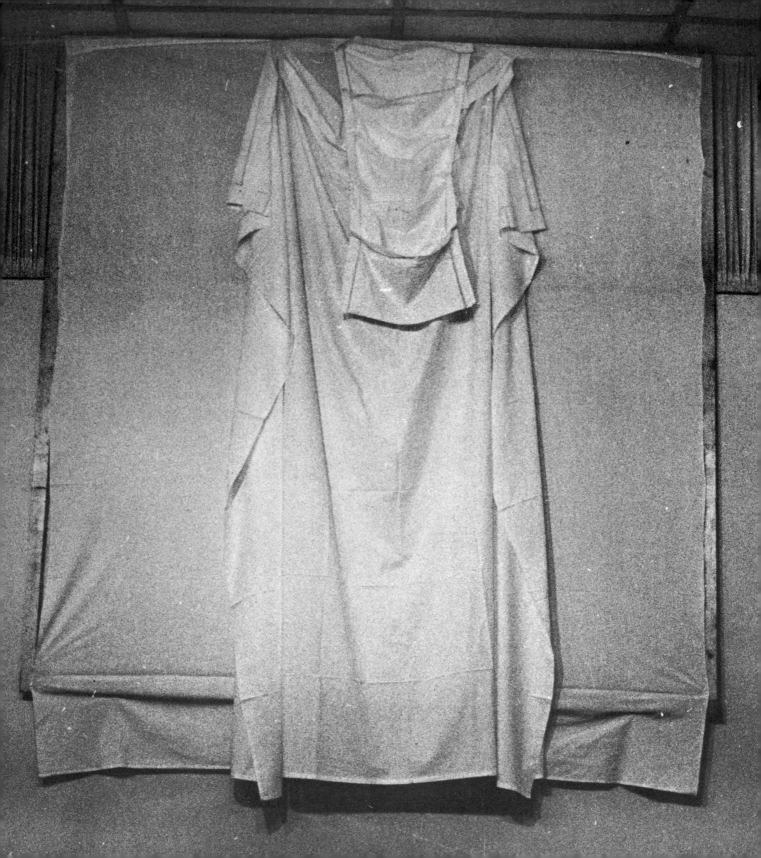

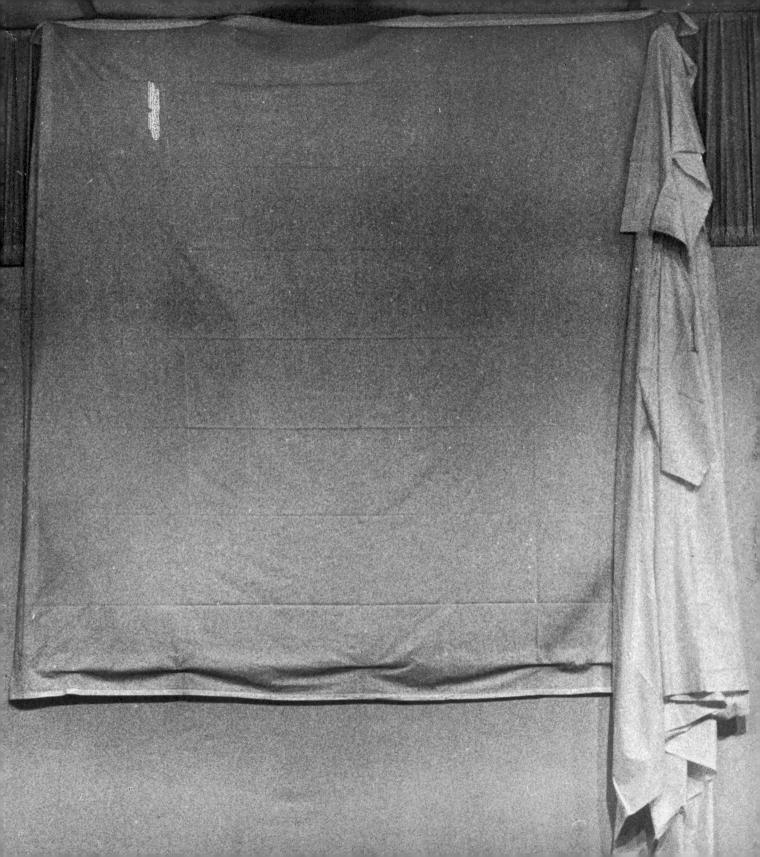

BRUCE NAUMAN

6 day week - 6 sound problems.

Monday; walking in the gallery.

Tuesday; bouncing two balls in the gallery.

Wednesday; violin sounds in the gallery.

Thursday; walking and bouncing balls.

Friday; walking and violin sounds.

Saturday; violin sounds and bouncing balls.

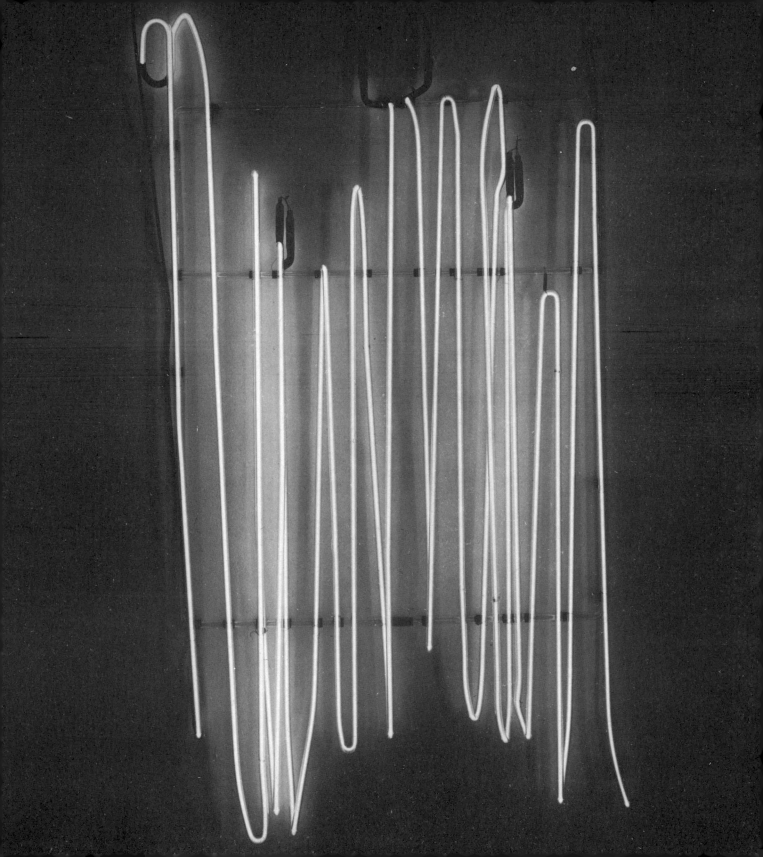

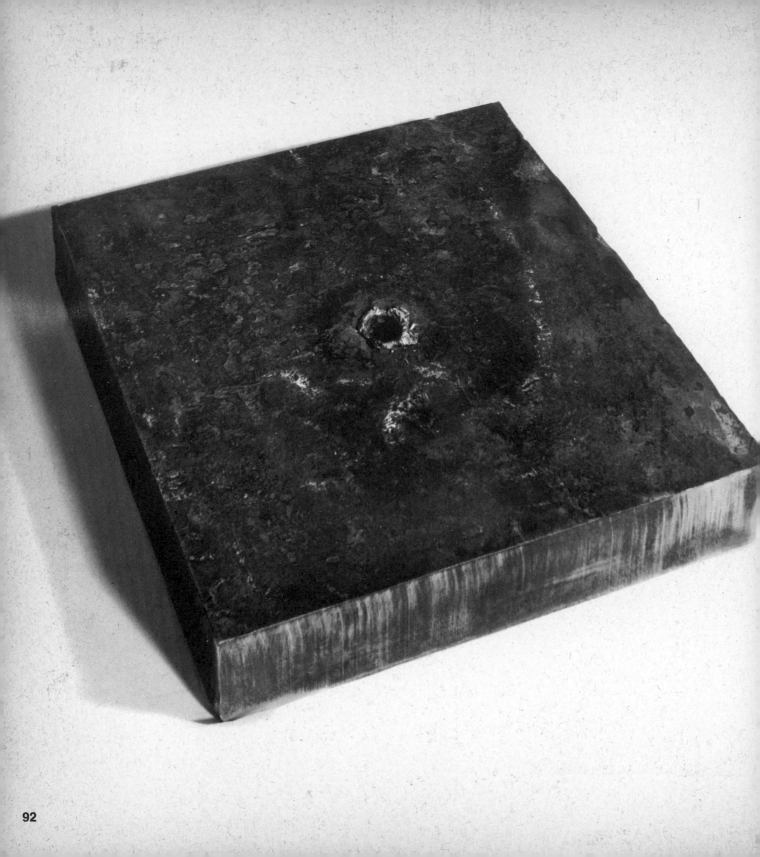

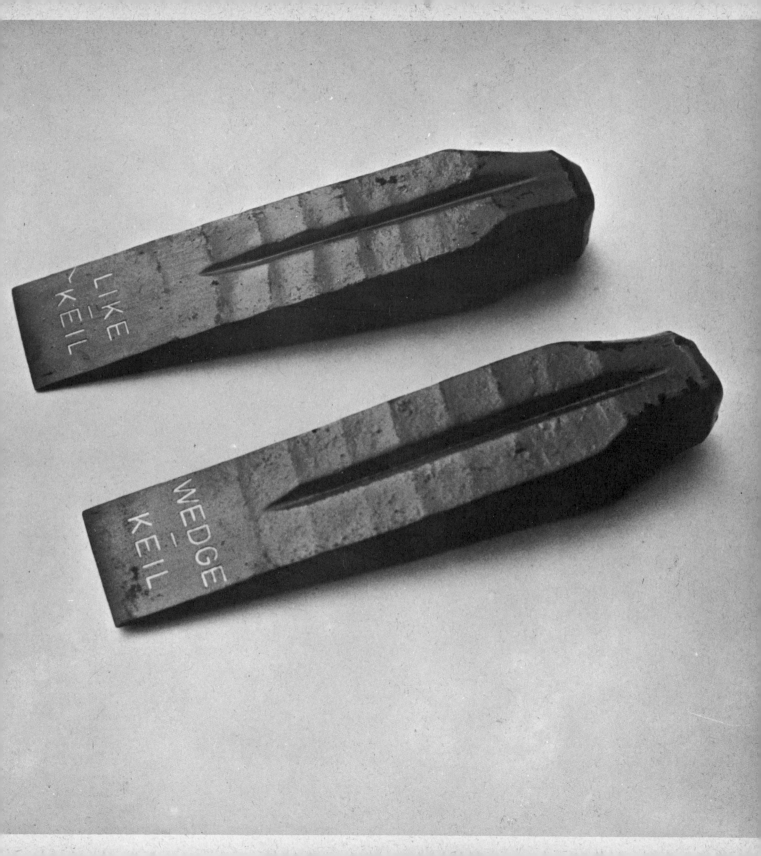

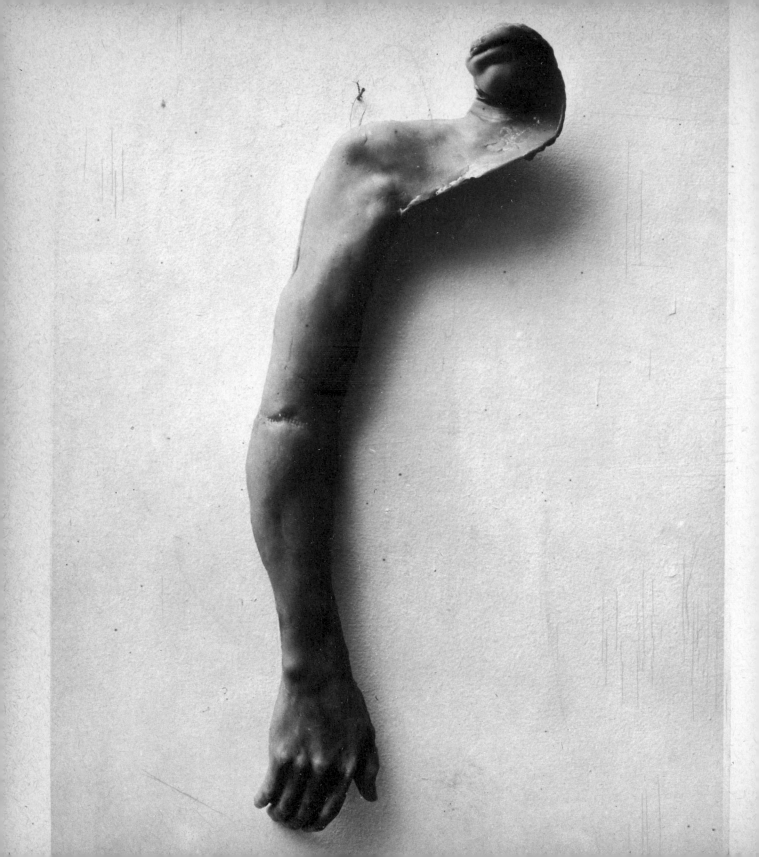

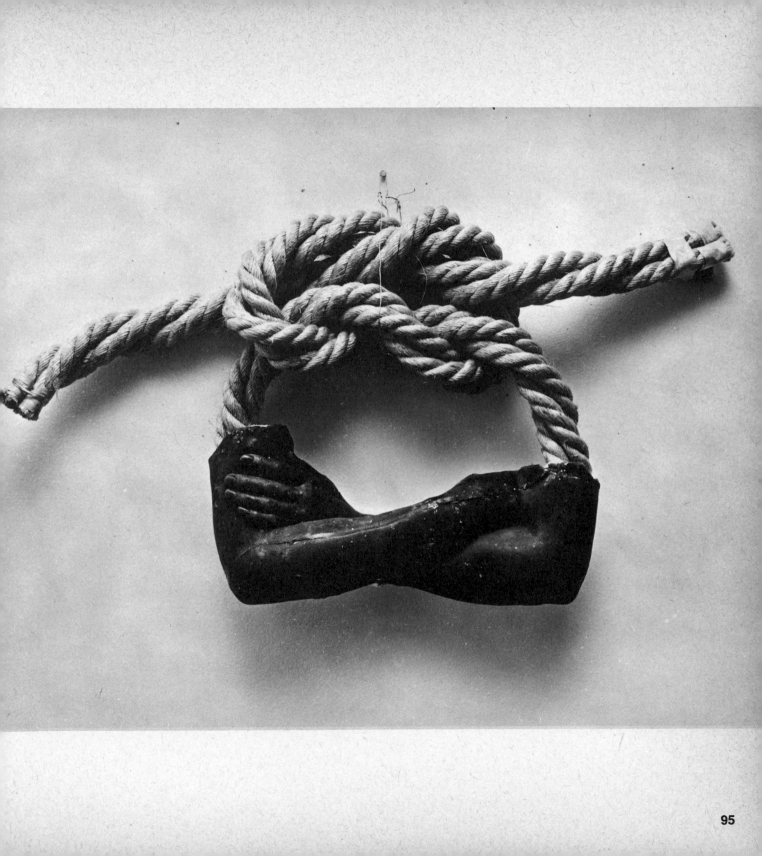

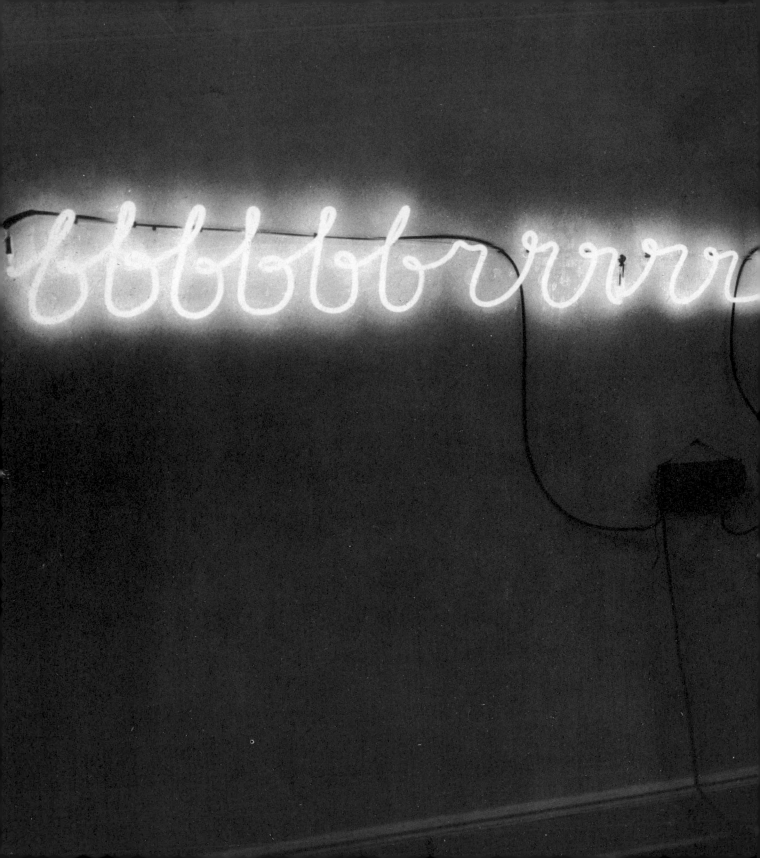

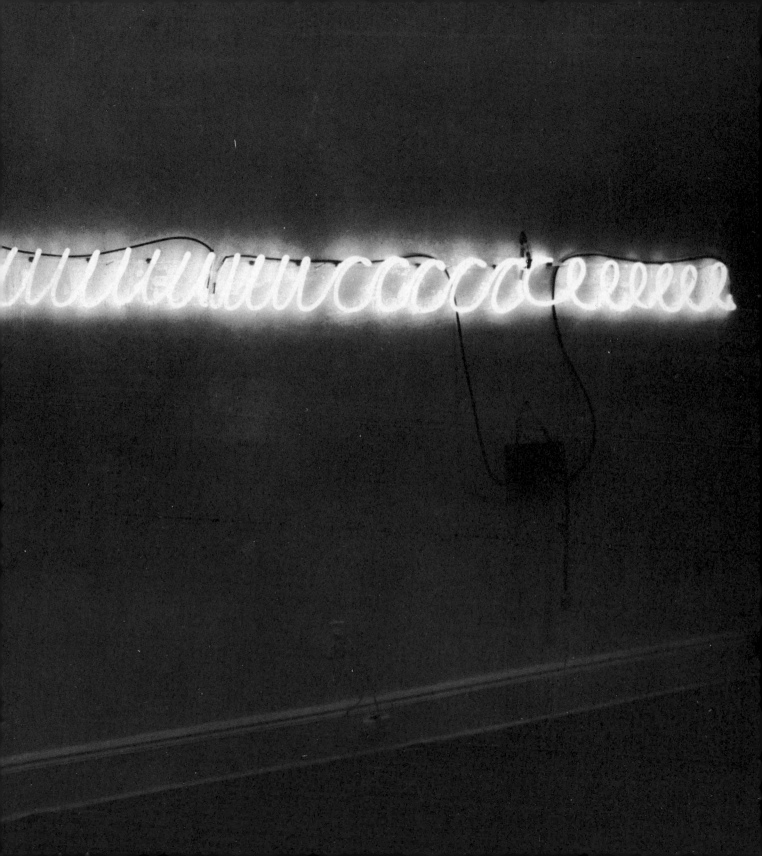

JOSEPH KOSUTH

My current work, which consists of categories from the thesaurus, deals with the multiple aspects of an idea of something. I changed the form of presentation from the mounted photostat, to the purchasing of spaces in newspapers and periodicals (with one « work » sometimes taking up as many as five or six spaces in that many publications - depending on how many divisions exist in the category). This way the immateriality of the work is stressed and any possible connections to painting are severed. The new work is not connected with a precious object — it is accessible to as many people as are interested, it is non-decorative — having nothing to do with architecture; it can be brought into the home or museum, but was not made with either in mind; it can be dealt with by being torn out of its publication and inserted into a notebook or stapled to the wall — or not torn out at all — but any such decision is unrelated to the art. My role as an artist ends with the work's publication.

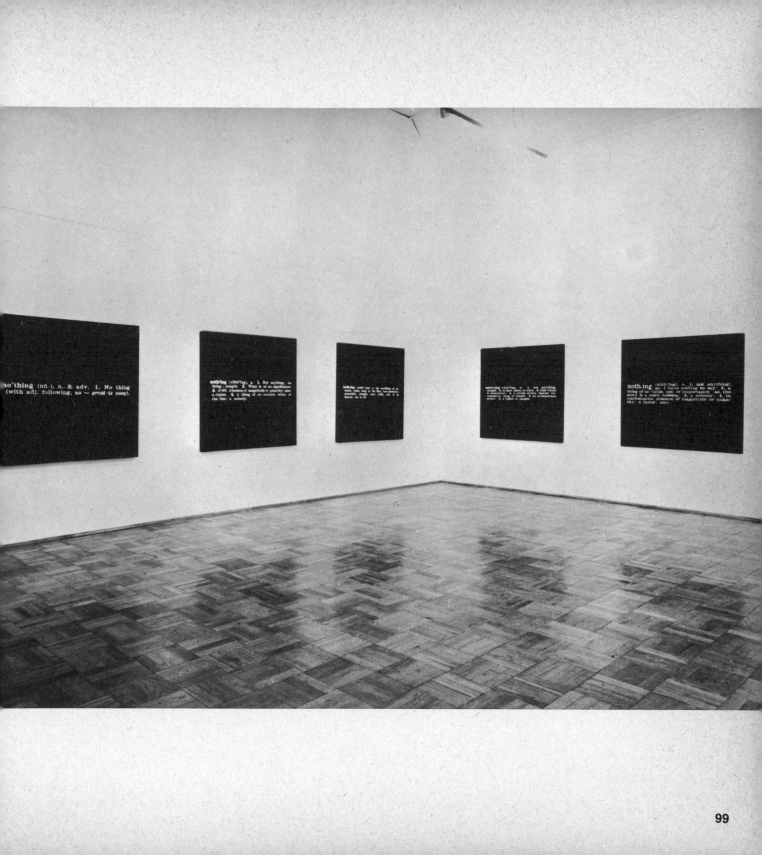

1. *Idea*, adopted from L, itself borrowed from Gr *idea* (ἰδέᾱ), a concept, derives from Gr *idein* (s *id-*), to see, for **widein*. L *idea* has derivative LL adj *ideālis*, archetypal, ideal, whence EF-F *idéal* and E *ideal*, whence resp F *idéalisme* and E *idealism*, also resp *idéaliste* and *idealist*, and, further, *idéaliser* and *idealize*. L *idea* becomes MF-F *idée*, with cpd *idée fixe*, a fixed idea, adopted by E Francophiles; it also has ML derivative **ideāre*, pp **ideātus*, whence the Phil n *ideātum*, a thing that, in the fact, answers to the idea of it, whence 'to *ideate*', to form in, or as an, idea.

pāint′ing, *n.* **1.** the act or occupation of covering surfaces with paint.
 2. the act, art, or occupation of picturing scenes, objects, persons, etc. in paint.
 3. a picture in paint, as an oil, water color, etc.
 4. colors laid on. [Obs.]
 5. delineation that raises a vivid image in the mind; as, word-*painting*. [Obs.]

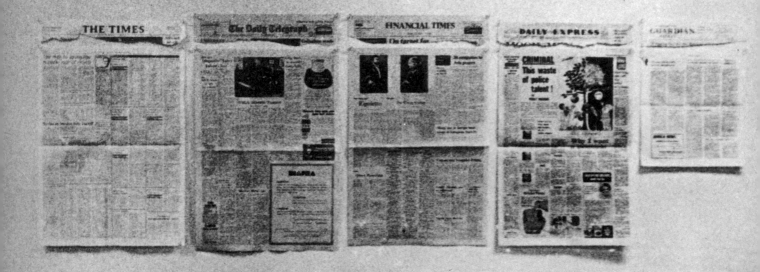

Institutes such as galleries and museums have become in our society to be promoters of new directions in fine arts. The museum and the gallery make known the art. This brings in its train the fact that lots of artists without knowing are searching for their conception from the point of view of the museum or with regard to the gallery.

Moreover the gallery thrusts an extra aspect on the art: the possibility of selling. In spite of that you have to realize that the museum and the gallery in their present form are institutes which don't meet any longer the new demands that art is asking for. Besides it is a hindrance to creativity to fasten yourself to a norm of showing and selling.

Painting and the selling have become clichés of fine arts. I search consciously for a form of art which is not tied by tradition and in which an oeuvre is less important than the research. There are so many different situations in which to look at something, that standing right before the painting or walking around a sculpture could well be the most simple kind.

You can fly over something, you can walk along something, drive (by car or train) sail etc. You can « disorientate » the spectator in space, integrate him, you can make him smaller and bigger, you can force upon him space and again deprive him of it.

I start by thinking I'm going to make use of all possibilities without troubling any longer about problems when something starts to be art. I don't make the ETERNAL work of ART, I only give visual information. I'm more involved with the process than the finished work of art. The part of my object is untranslated. I think objects are the most usual part of my work. I'm not really interested any longer to make an object.

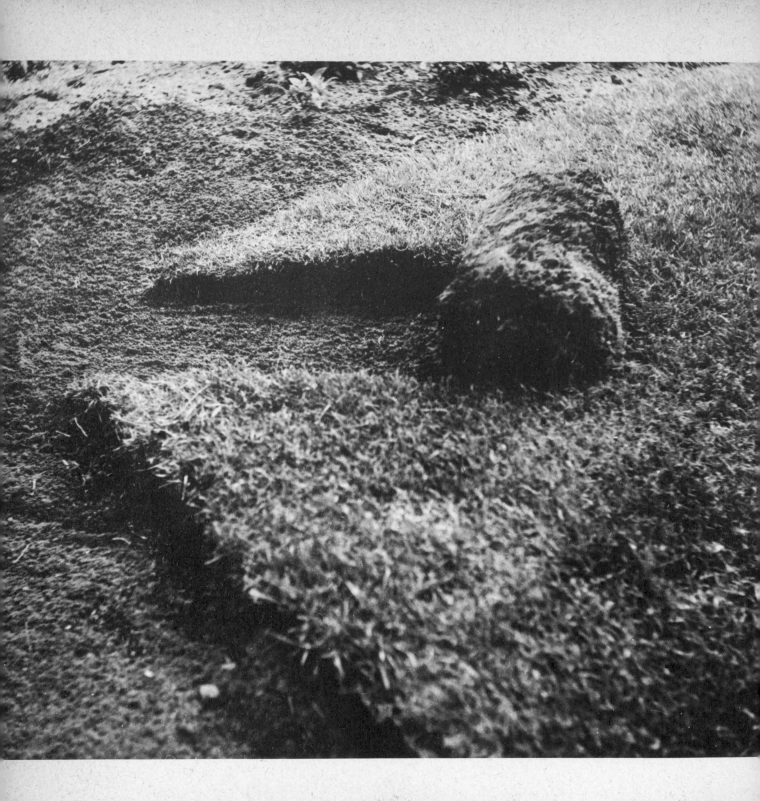

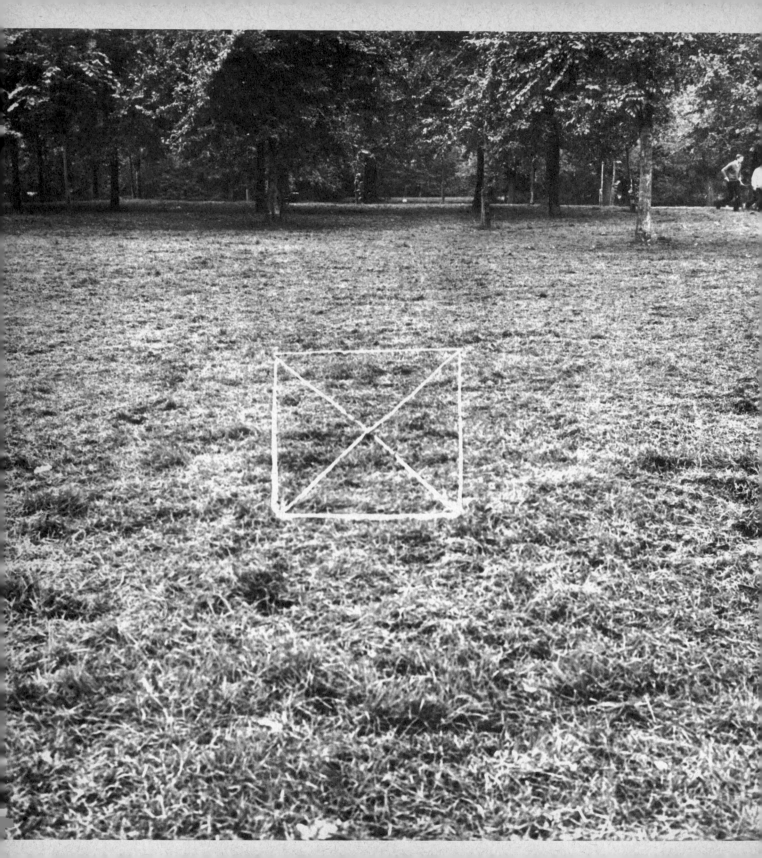

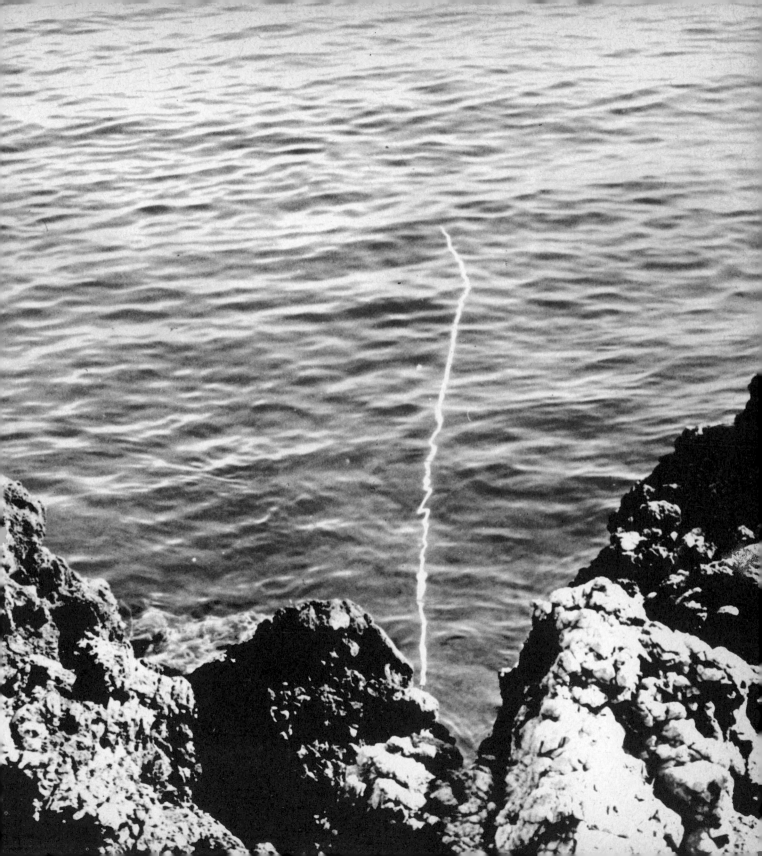

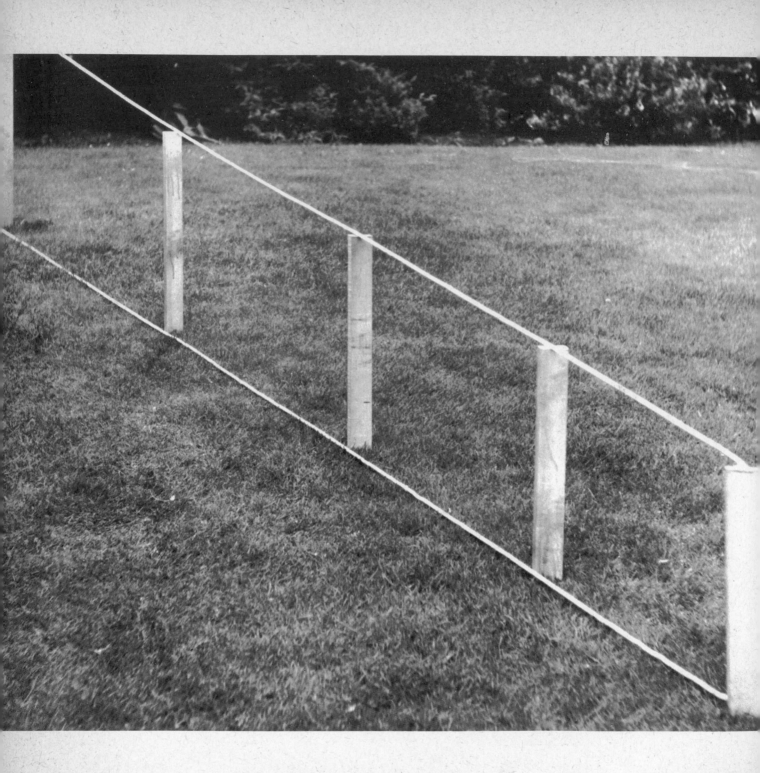

I, the world, things, life, we are situations of energy and the point is not to crystallize such situations, though maintaining them open and alive is a function of our living.

Since every way of thinking or being has to correspond to a way of acting, my work really is the physication of the force of an action, of the energy of a situation or an event, etc., not just the experience of this on the level of annotation or of a sign or of dead nature.

It is necessary, for example, that the energy of a torsion lives with its true force; it certainly wouldn't live just by its form.

I think that to operate in this direction, since the energy exists under the most various appearances and situations, there must be the most absolute liberty of choice or of the use of materials; there would thus be a flavour of nonsense in speaking of styles, of form or anti-form and anyhow it would be a very secondary and superficial discourse.

It is necessary for me to work in this way because I know of no other system for being within the heart of reality, which, precisely in my work, becomes an extension of my living, my thinking, my acting.

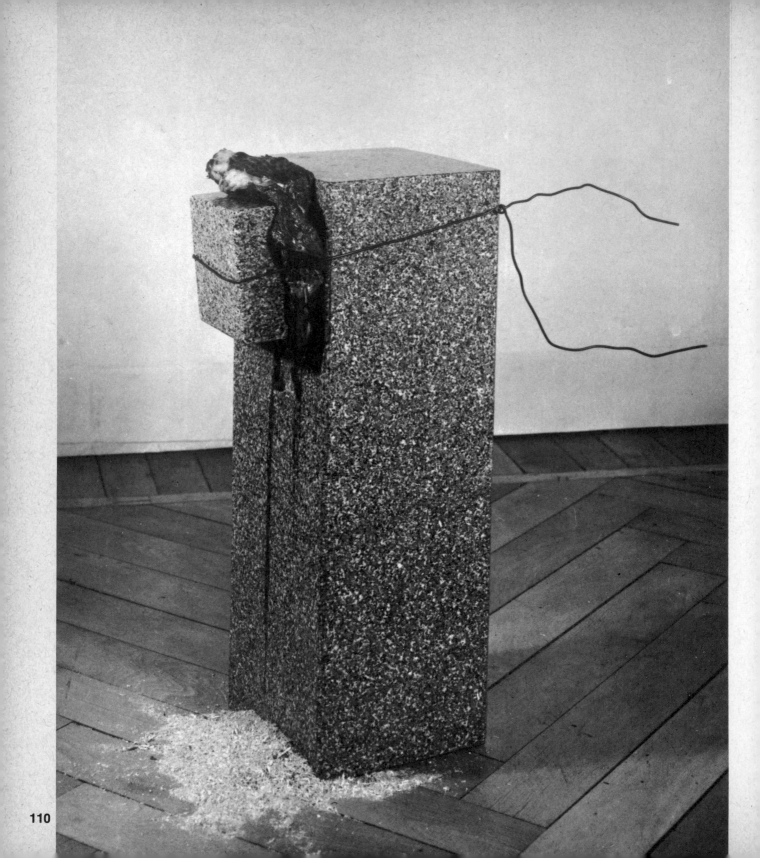

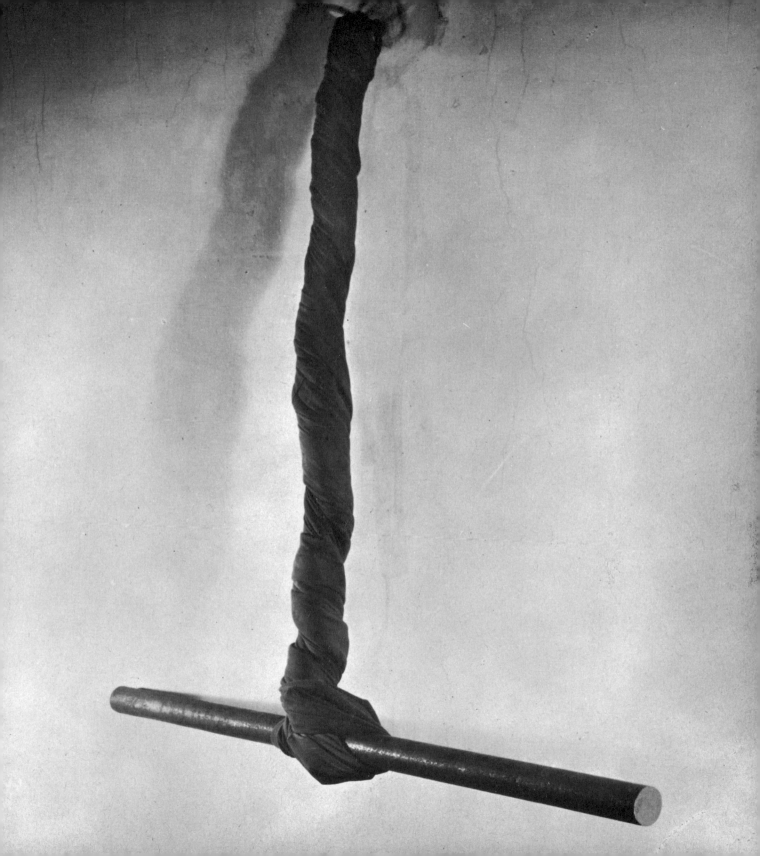

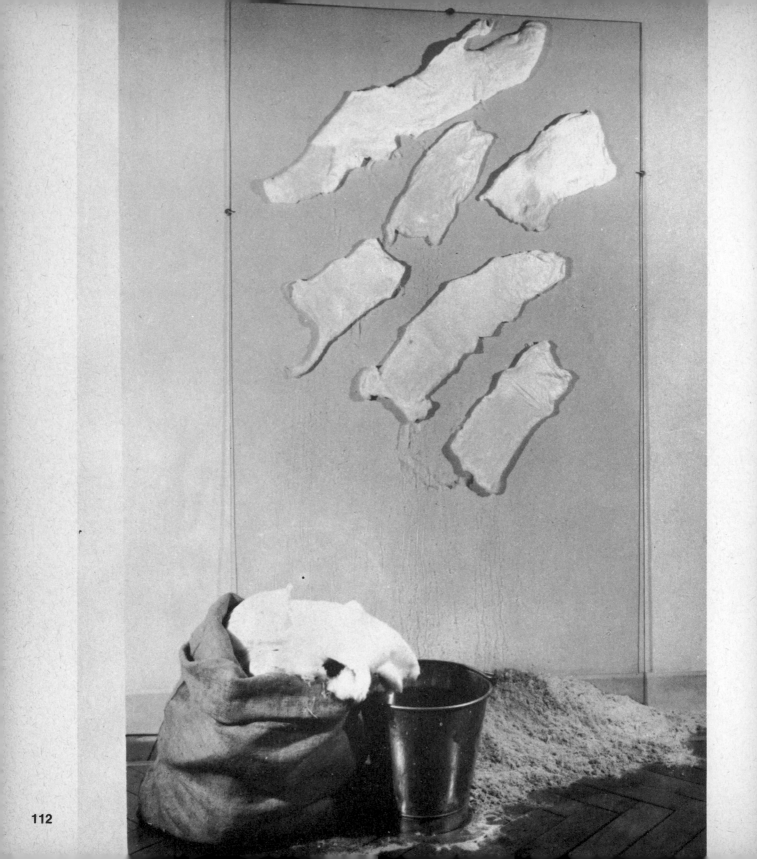

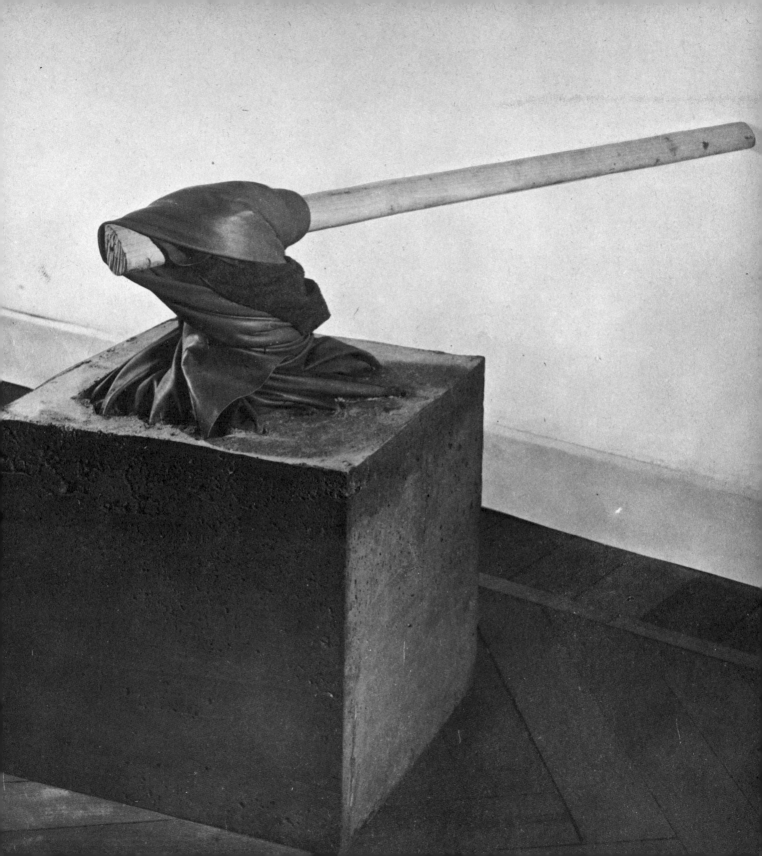

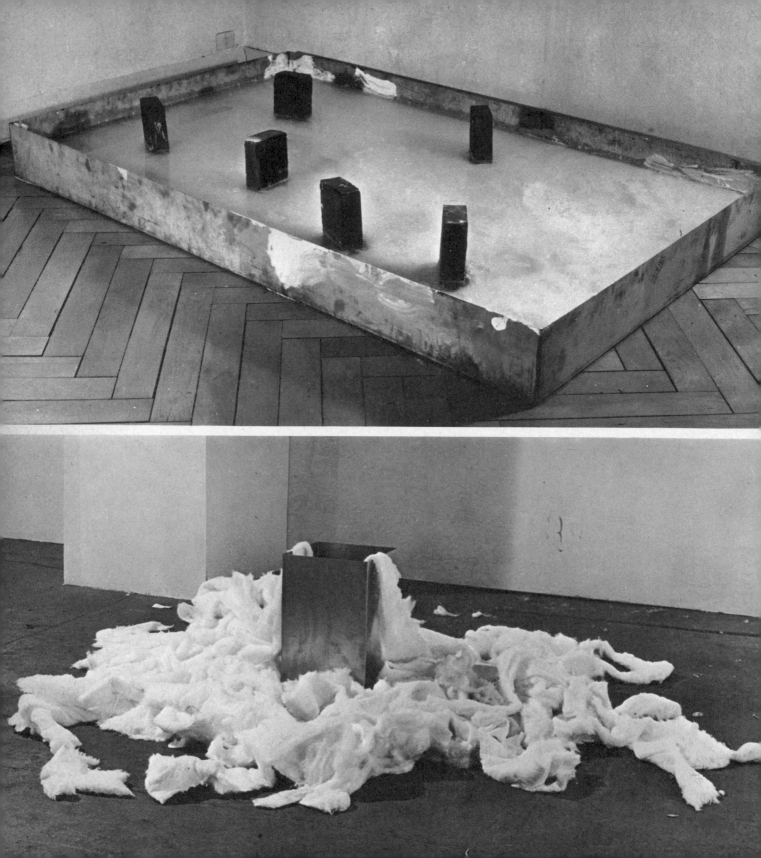

These forms certainly do exist, they are controlled and have their own characteristics. They are made of various kinds of energy which exist outside the narrow arbitrary limits of our own senses. I use various devices to produce the energy, detect it, measure it, and define its form.

By just being in this show, I'm making known the existence of the work. I'm presenting these things in an art situation using the space and the catalogue. I think this will be less of a problem as people become more acclimated to this art.

As with any art, an interested person reacts in a personal way based on his own experience and imagination. Obviously, I can't control that.

One kind of energy is electromagnetic waves. There is a piece in the show which uses the carrier wave of a radio station for a prescribed length of time, not as a means of transmitting information, but rather as an object.

Another piece uses the carrier wave of a citizens' band transmitter to bridge two distant points in New York and Luxembourg several times during the run of the show.
Because of the position of the sun and favourable atmospheric conditions during January, the month of the show, « this » piece could be made. At another time, under different conditions, other locations would have to be used.

There are two smaller carrier wave pieces which have just enough power to fill the exhibition space. They are very different in character, one being AM, the other being FM, but both will occupy the same space at the same time — such is the nature of the material. Also in the show will be a room filled with ultrasonic sound. I've also used microwaves and radiation.

There are many other possibilities which I intend to explore — and I'm sure there are a lot of things we don't yet know about which exist in the space around us, and although we don't see them or feel them, we somehow know they are out there.

117

PIER PAOLO CALZOLARI

I would like to make known that I love a ball of paper, the igloo, shoes, fine thread, fern, the chirping of the cricket; I love reality, the function of a paper ball, of an igloo, of shoes, of fine thread, of a fern, of the chirping of the cricket; I would like to make known that I love these horizontal things as affirmation of a new physiology, but even more I would like to make known that I love the one who has used them for himself, that now I can recognize myself. I would like to make known that irreality exists and the vulgarity of the relations with this irreality kills my inventive faculty and the necessity of democratically expanding my consciousness. There is the dull dimension that wants to measure and to define itself. I would like to make known that no one can limit my need to expand and perceive for a period of time and more. I say that the only definition my intelligence imposes upon me is to distinguish and forbid me the liberty and happiness of stammering at every encounter, and to invent it and then again it orders me to record that I have invented it. I would like to make known that I want expansion, democracy, madness, alchemy, insanity, rhythm, horizontality.

I want to make it known that I don't want moments of consciousness, that I want to be alive as much as possible and expanded as much as one can well be, I would like to say and to make it known that the smile playing around the face and the skull of a cat is more important, and that the discovery of a fountain hiding itself is good, very good and I want to make known an insupportable list, physicality, verticality, behaviour, demonstration, rational intelligence, the humiliation of a procedure, representativity. I would like to say that I want my miming to be the democratic miming of things and I say that I want to be happy.

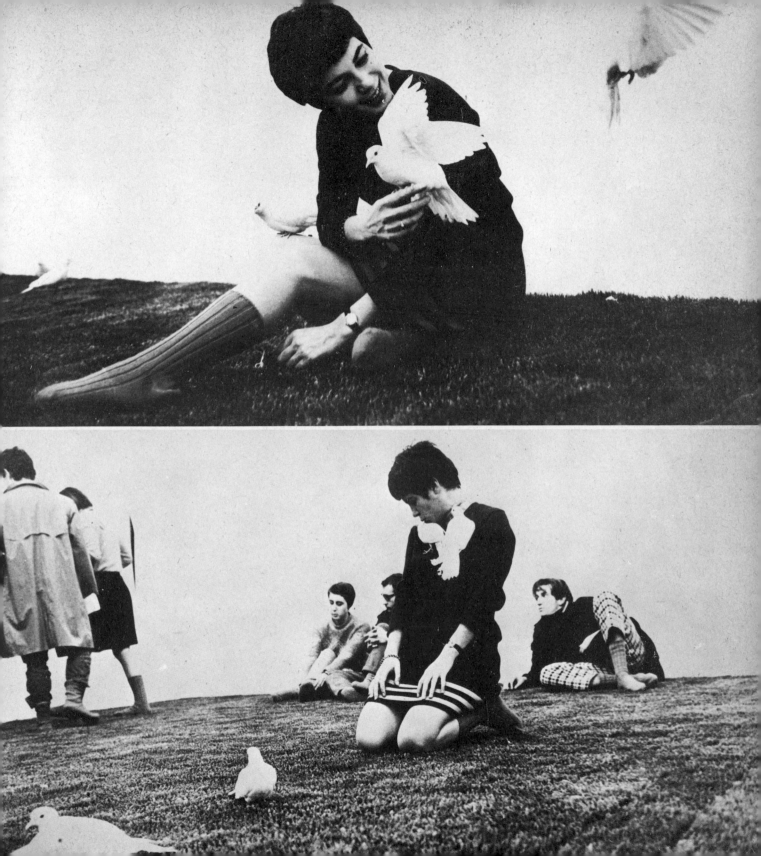

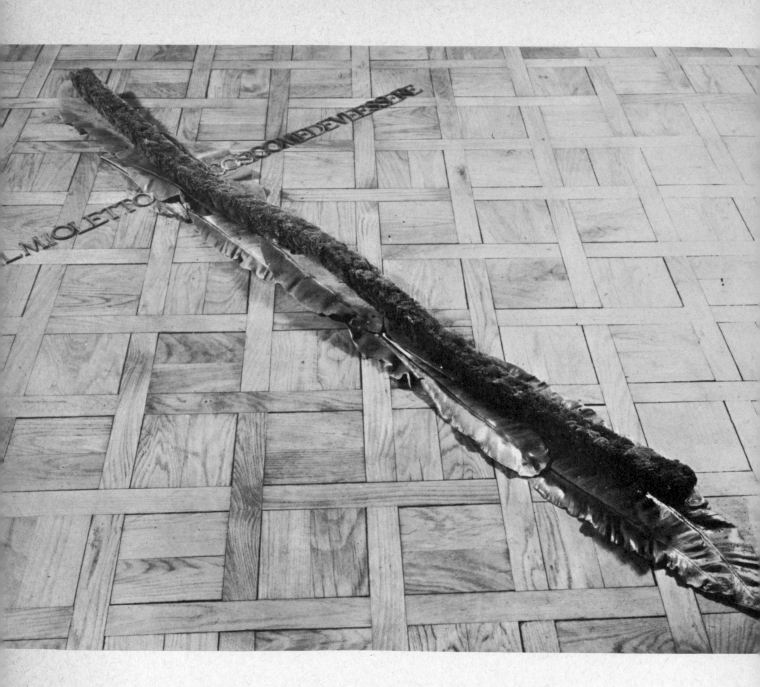

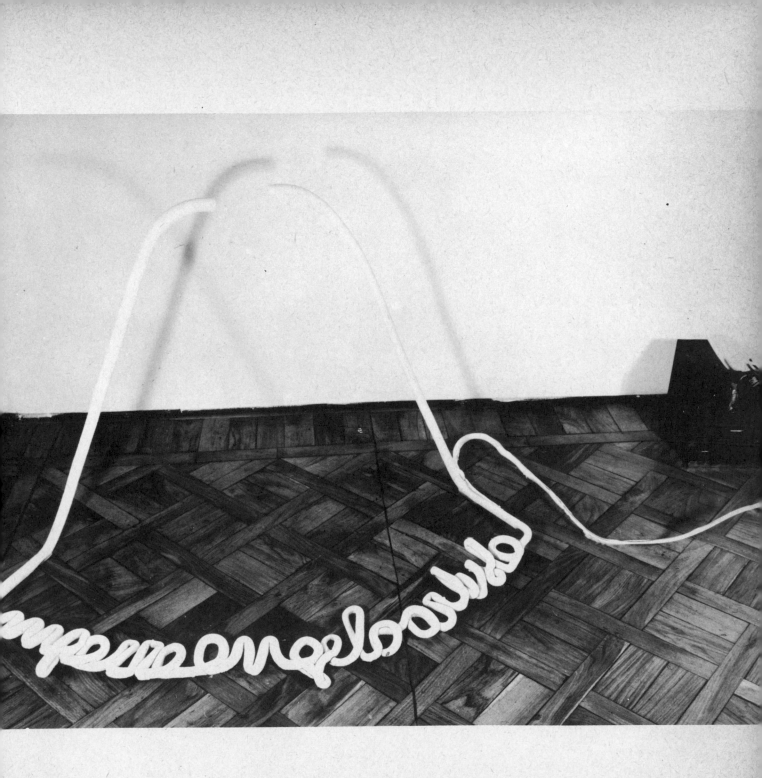

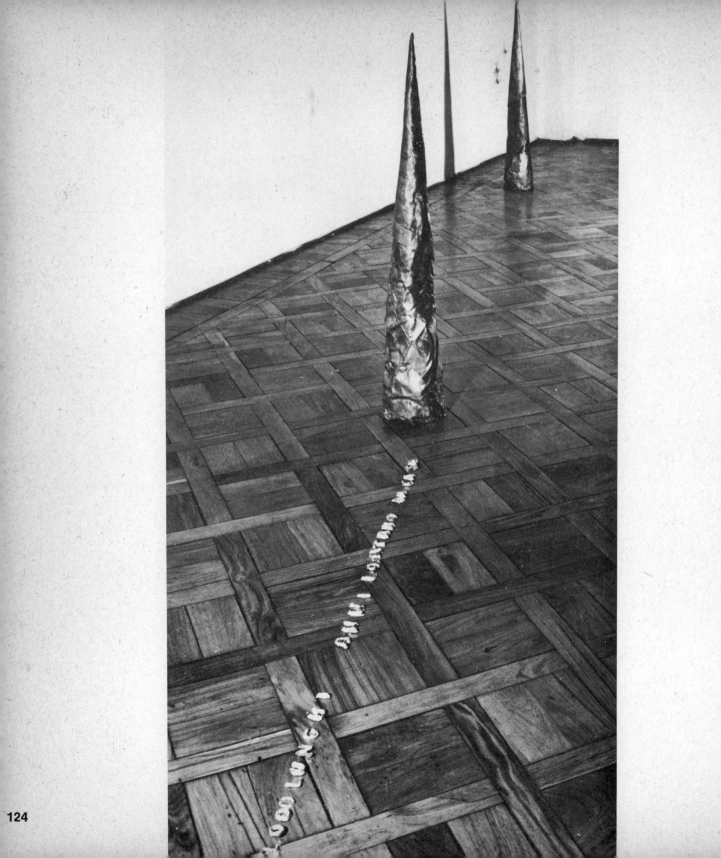

My first field piece involved the use of commercial snow-fencing 4' x 50' to create linear cuts in the surface media. Any imposed linear pattern seemed « forced », so I worked mainly with long single directional cuts. In some cases, however, the fencing was curved and grouped to assimilate truncated or incomplete contour lines. My contours were in opposition to the existing topography.

After watching numerous wheat harvest operations, I approached a farmer in Pennsylvania, asking to direct or plot the harvester's course. A 200' x 500' field bordered by corn was alloted to me. My instruction was simply to make a cut directly down the centre of the field - photo 1 . The same farmer will allow me to organize the planting of his crops (corn, oats, barley, hay, wheat) this coming year.

What became interesting with the field pieces were the isolated stages of progress.

If we see the 200' x 900' field of wheat as kind of non rigid media held in geometry, which through linear cuts or eradications are transformed into separate sub-forms (bales) later to be subjected to a mobile topographical displacement (trucking bales to stock piles), each stage is art.

My most recent piece, located on a New Haven, Connecticut, swamp grid, is divided into rectangles (150' x 175') each bordered by water. Using a sickle mower, I described altitude or contour lines in the thick surface. The cuts were filled with iron filings (residue from steel borings).

Altitude lines on contour maps serve to translate measurement of existing topography to a two dimensional surface. With my piece, I create contours which oppose the reality of the existing land, and impose their measurements onto the actual site, thus creating a kind of conceptual mountainous structure on a swamp grid.

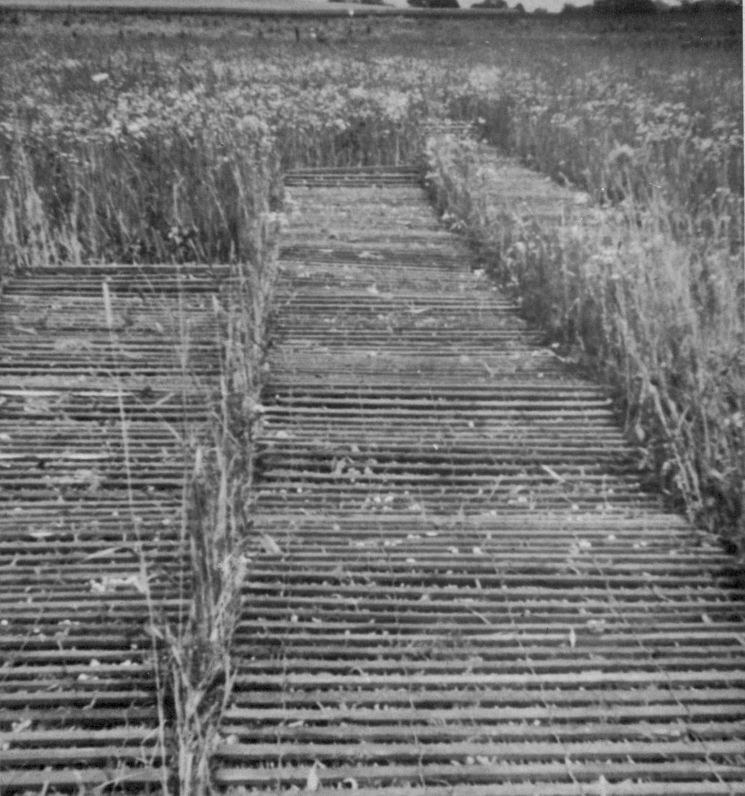

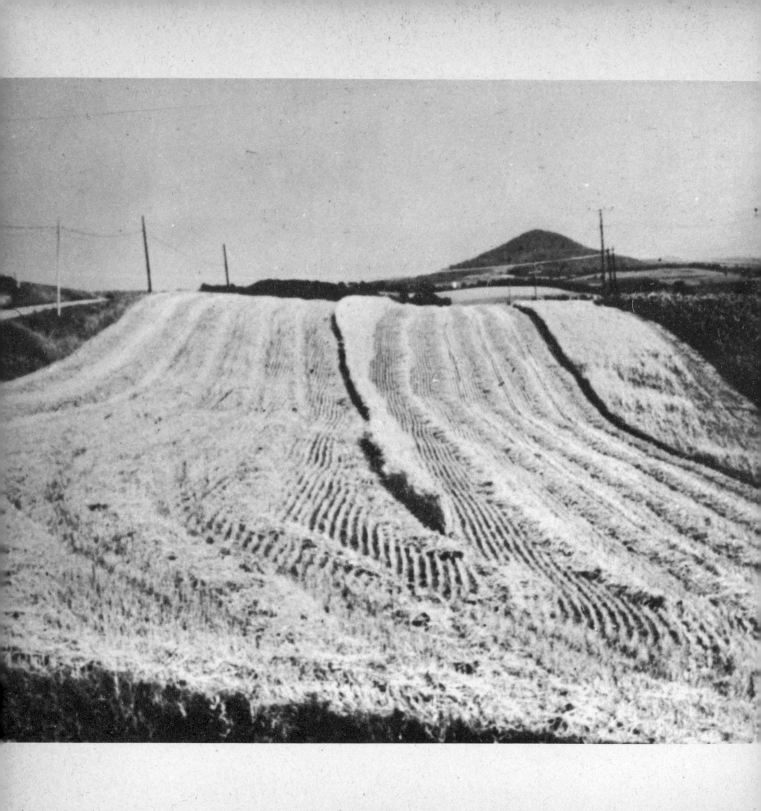

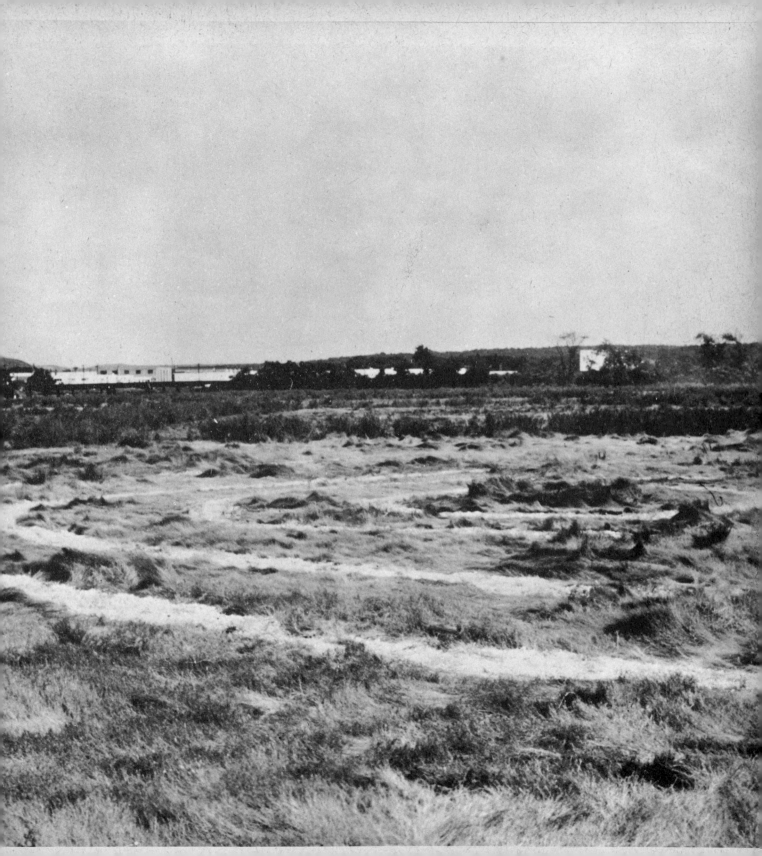

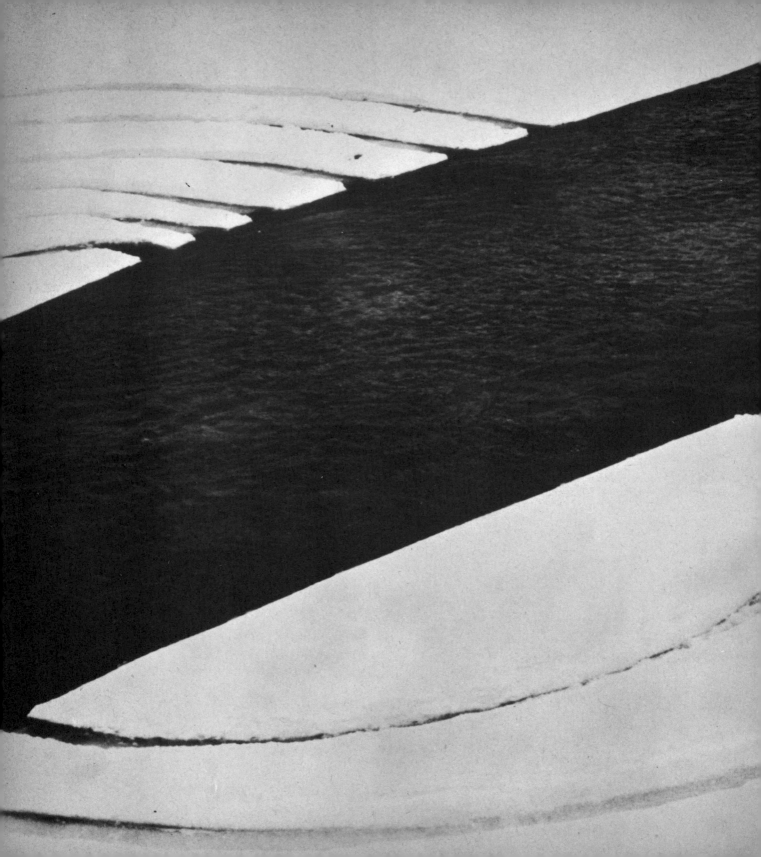

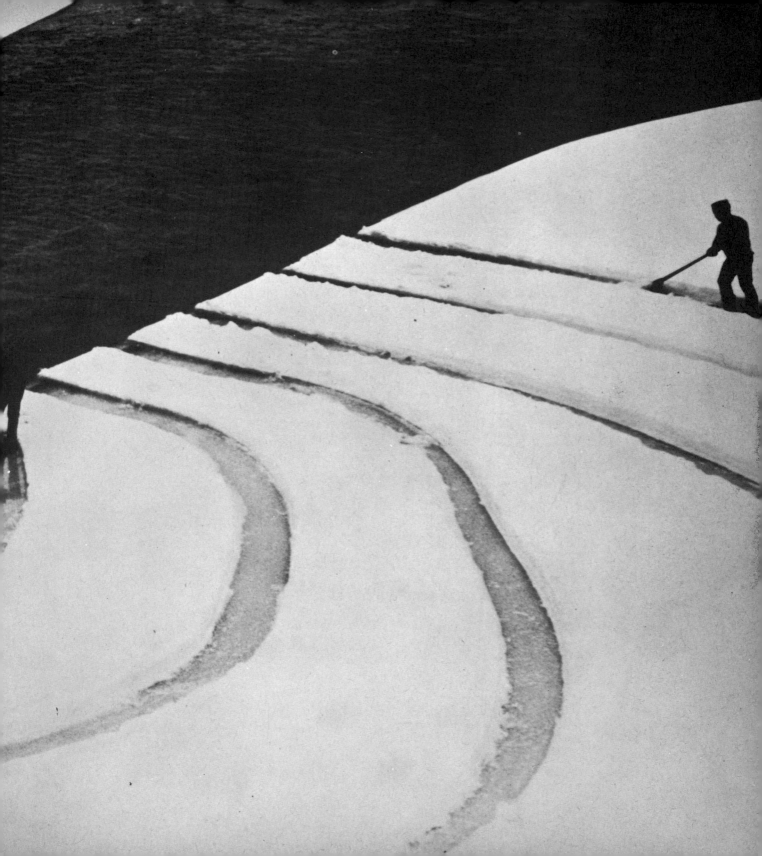

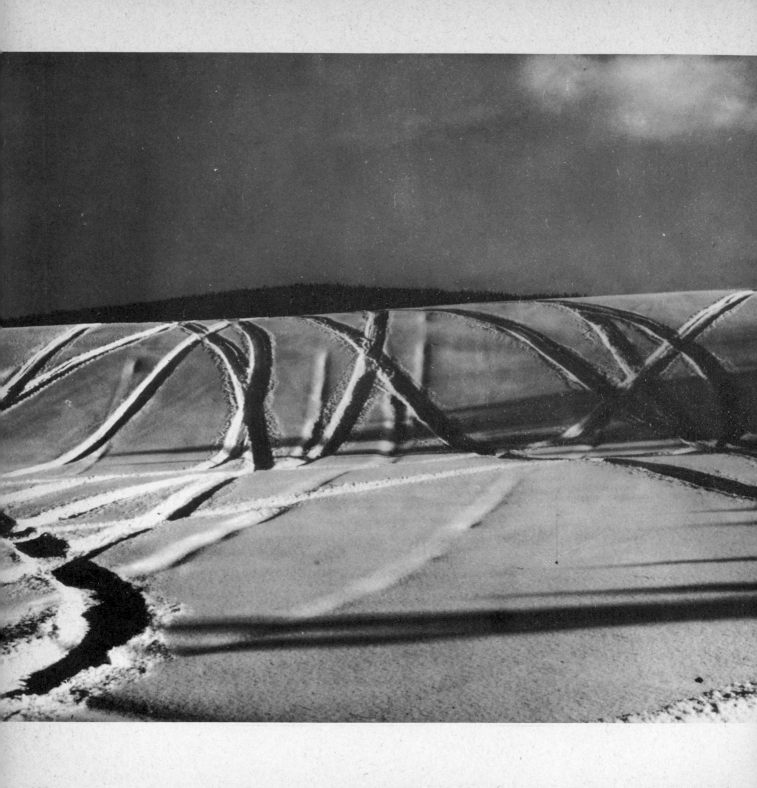

Operations grow from the sculptural premise; its exactness and independence is the clue to the scale of its physical, visual, and actual consequence in society.

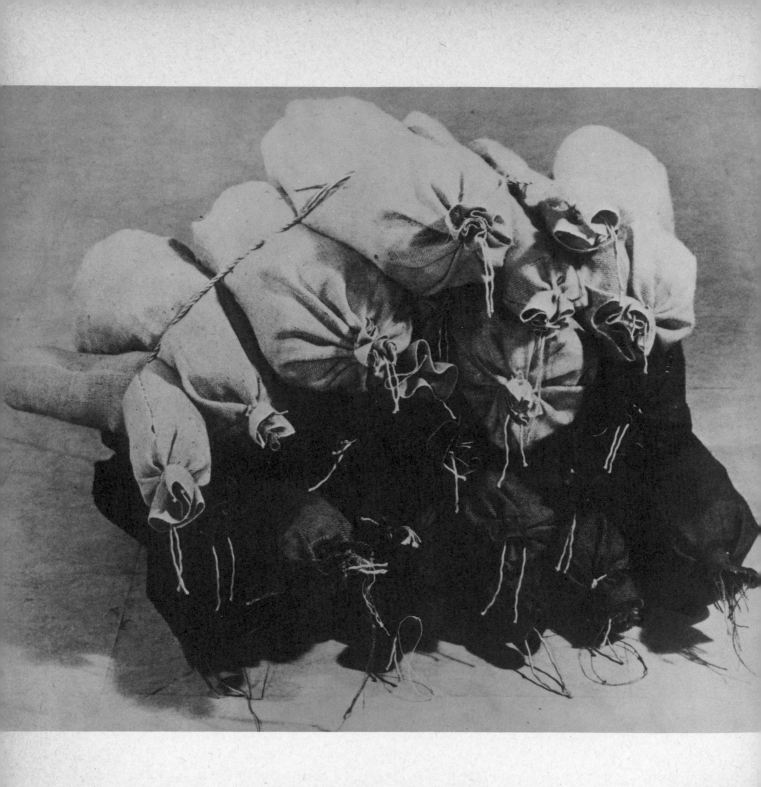

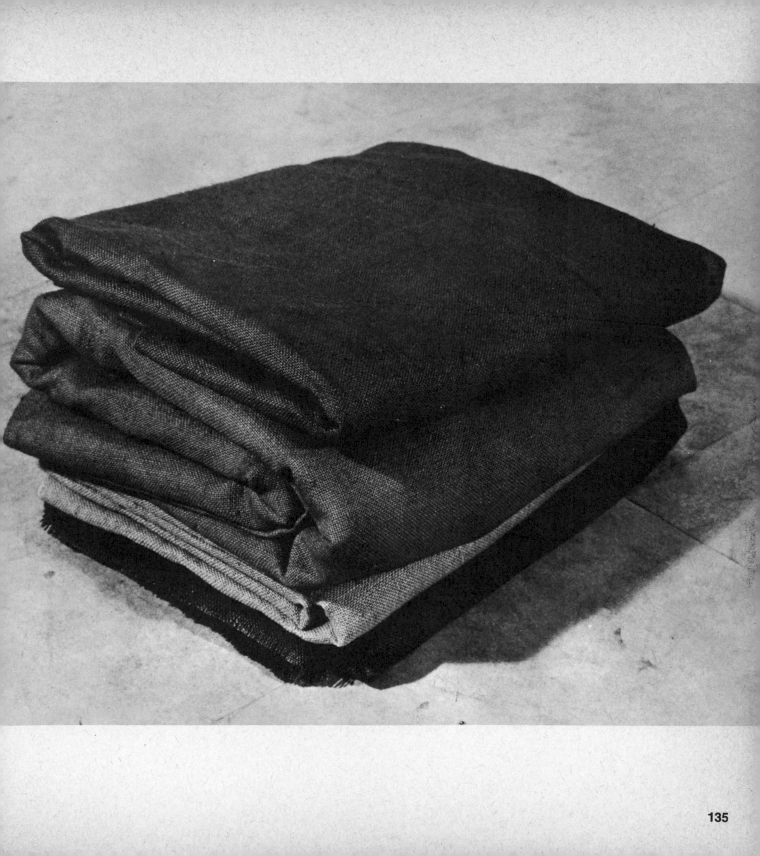

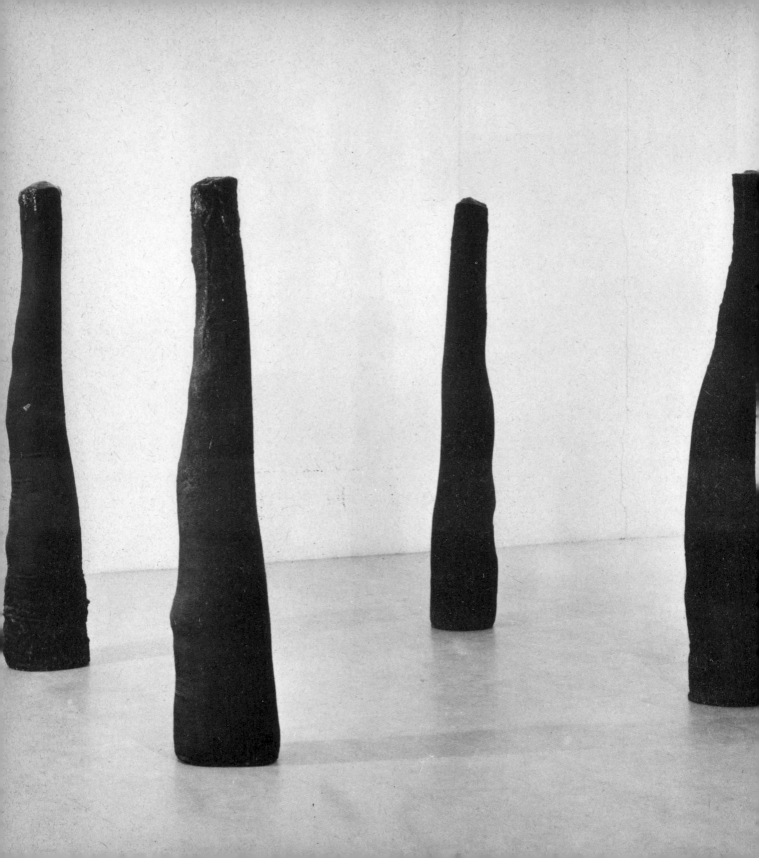

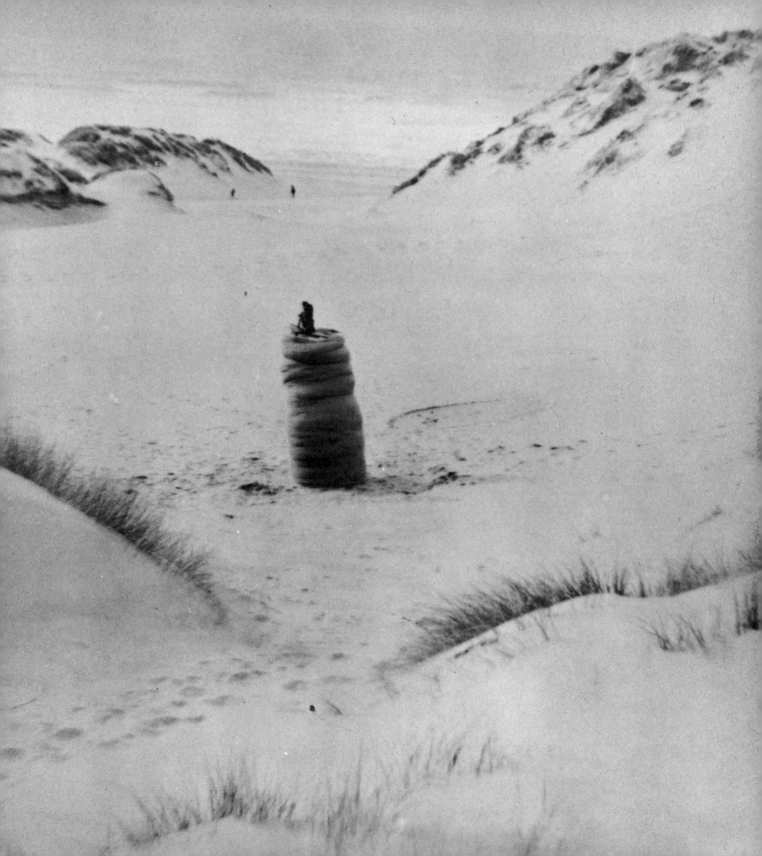

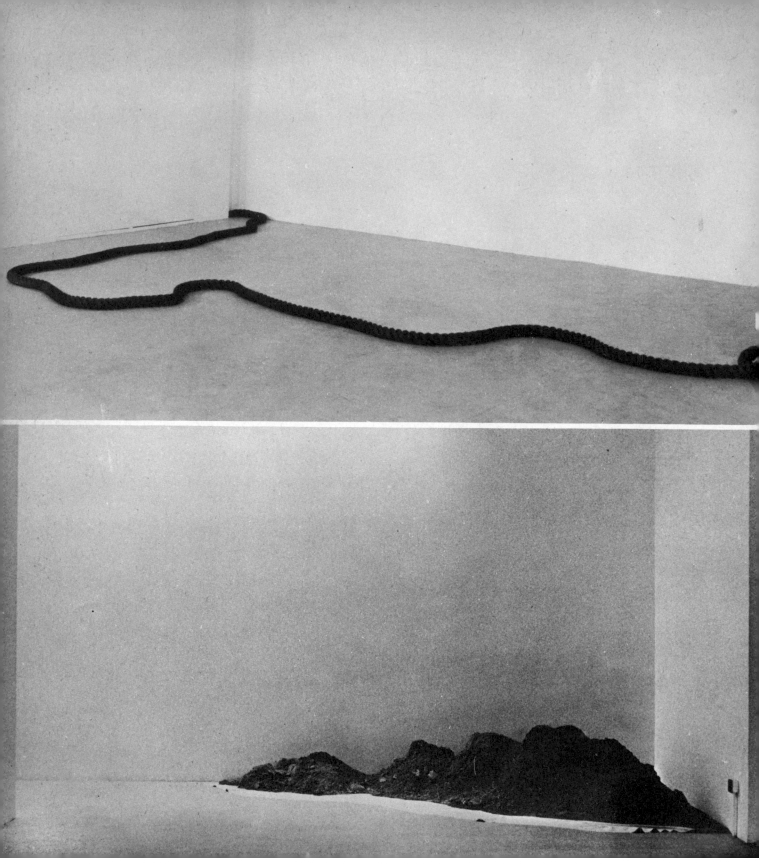

DOG TRACKS

From the « First Step » on Six Steps on a Section.
On the site of my « first step » (Bergen Hill N.J.) from « Six Steps on a Section », I discovered an array of dog tracks around a puddle of water. The distribution of the tracks was indeterminate. Each of these tracks radiated many possible paths leading in all directions, a maze-like network came into view with the help of my camera, which acted as a single point of view from an aerial position. My wife counted 38 paw prints in the 3' x 3' photo-blow-up of my snapshot, but many of the prints were obliterated by the overlapping of other print-points, rendering a clear view impossible. Visualizing a direct route from any of these tracks would be hazardous, and bound to lead the viewer astray. The « section » of my Six Steps is based on a stratigraphic (sub-surface map) that extends along a line from New York to Dingman's Ferry on the Delaware River in Pa. Each « step » is a point where particles of earth were collected and then deposited into containers that follow the cross-section contours of the six mapped sites. The points of collected earth become enormous land masses in the containers. If you consider everything in N. Y. C. collapsed to the size of this book, you will get some notion of the process. A point in the mind, or a paw print in the mud, becomes a world of serial closures and open sequences that overflow the narrow focus of conscious attention.

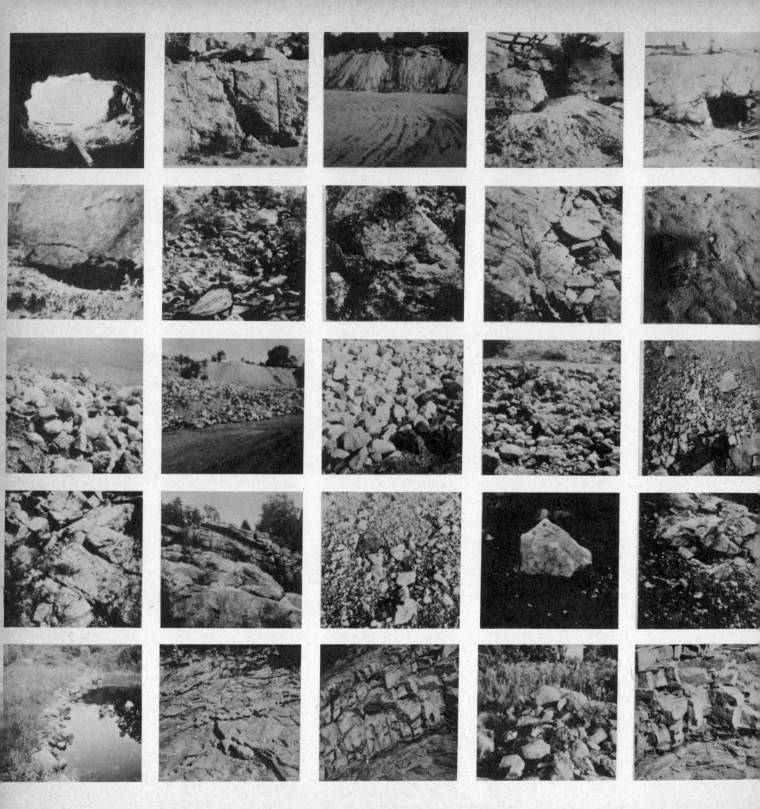

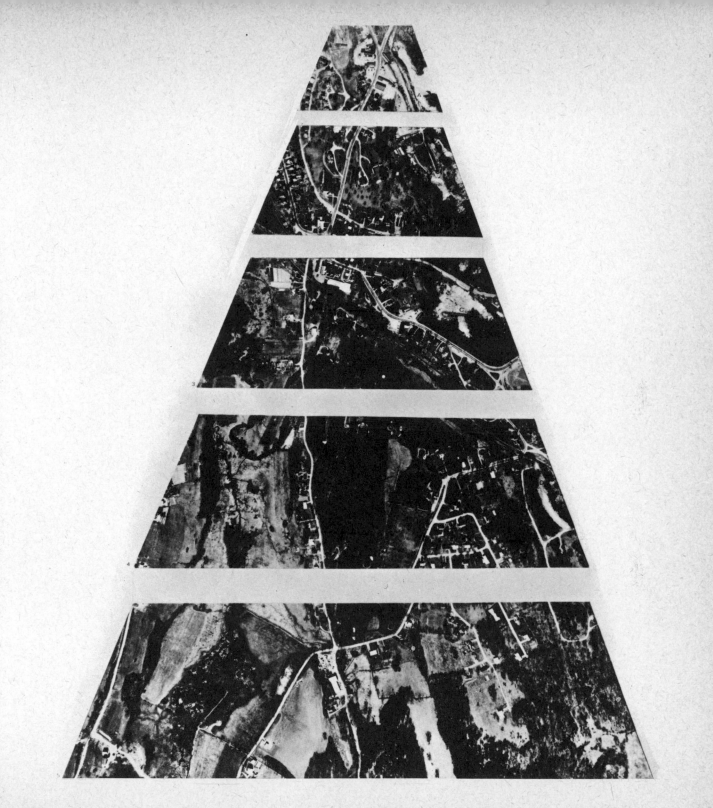

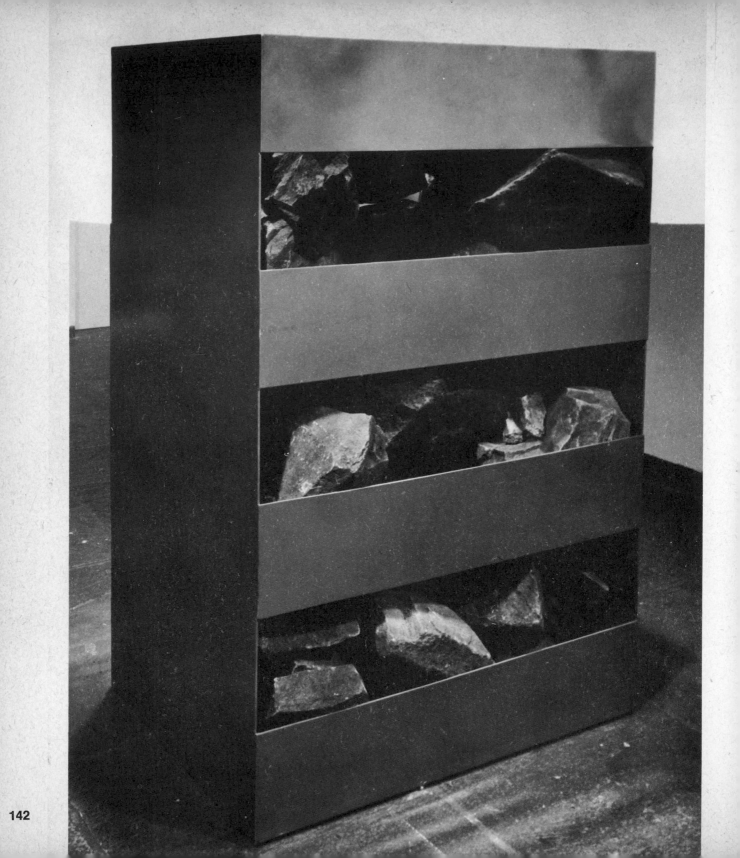

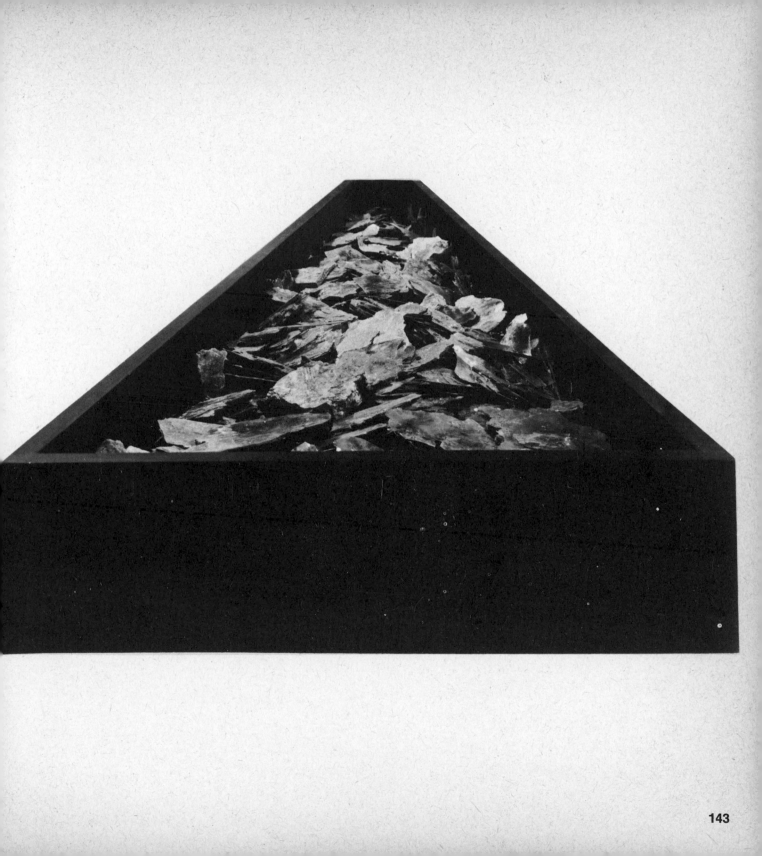

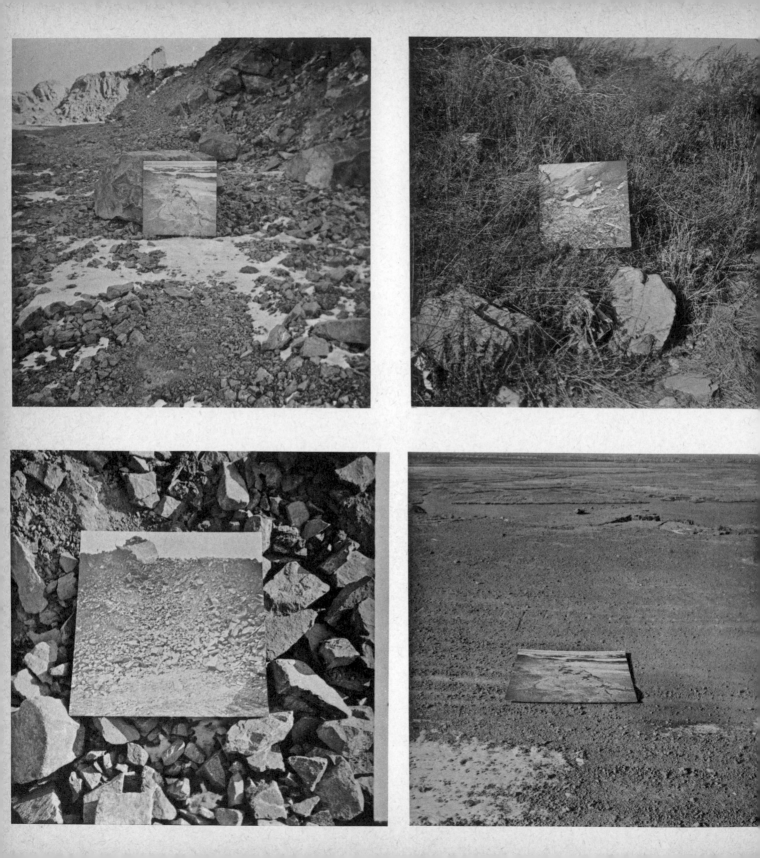

**Amongst other things he lacked the essential qua-
lity that makes an artist, which is the choice of the
forms, to be amongst the most excellent.** G.B. Ca-
valcaselle - J.A. Crowe (Storia della pittura in
Italia, 1898).

**What I can mean by dignity, by « essential quality » of an artist, does not find its solution in
experience, the project cannot be reduced to the object, the imagination eludes the image,
I am not the picture.**

**Instead, it « concedes itself » to the direct, guaranteed legible translation, corresponds to
the compositive elaboration of a technique, of a process, already existing by itself. From
there comes the difficulty of maintaining the level of research in merit « just » to this prob-
lem, given on the one hand the false solutions offered by tautology, and on the other the
satisfaction of the wit, the difficulty, finally, to give an « aesthetic » valuation of the
problem.**

**For this reason, to project doesn't mean anything else today than the will to accomplish a
« finished » experimentation (that is not tending « to » but turned « on »), such that by
oneself one arrives at defining the relation and the qualitative difference (not according to
superannuated hypotheses of purity and liberty of language, but of correctness of expres-
sion) between painting and design, for example: in terms of a close reading of the work,
that is of pure appearance, design « means », it exhibits the project, while the painting for-
gets it, cancels it, in favour of the endless and profound apertures that we can only see in-
distinctly, but that we must pursue so that reality may be more enjoyable, and therefore
more real. (September 1963).**

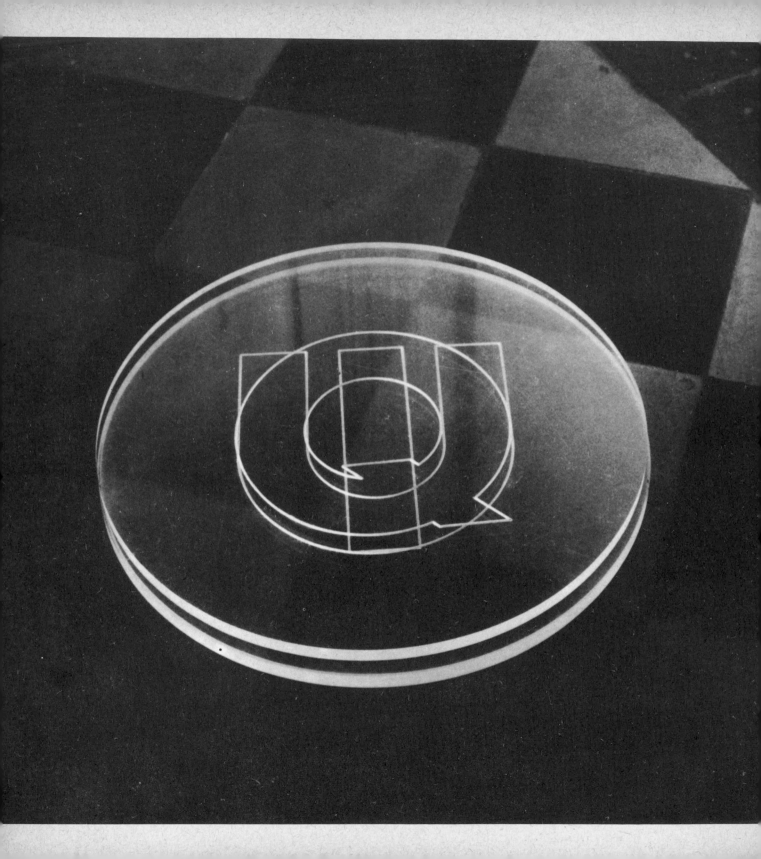

Primo appunto sul tempo

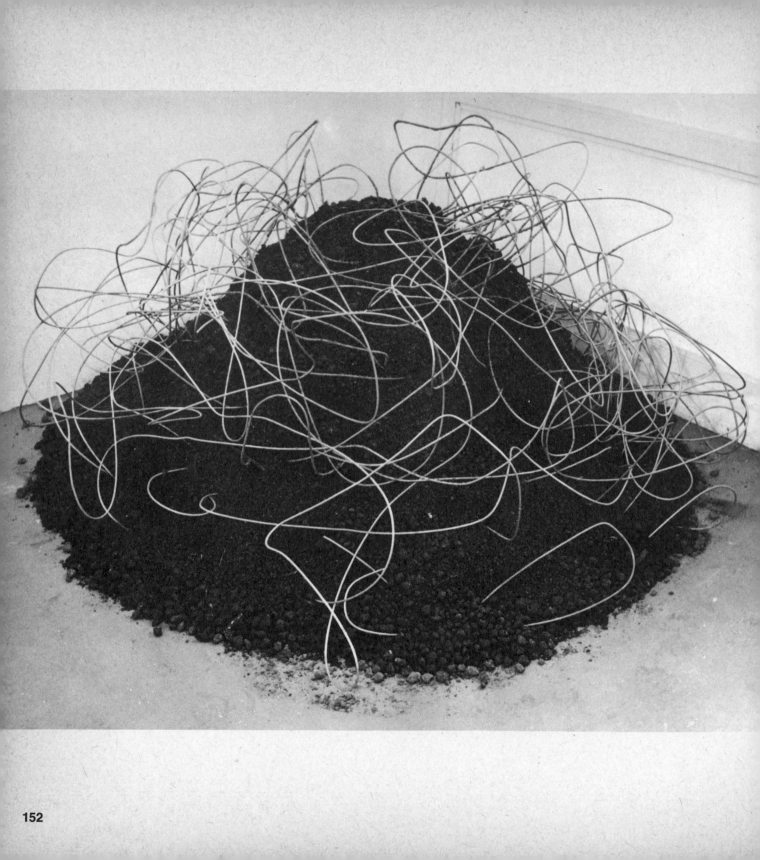

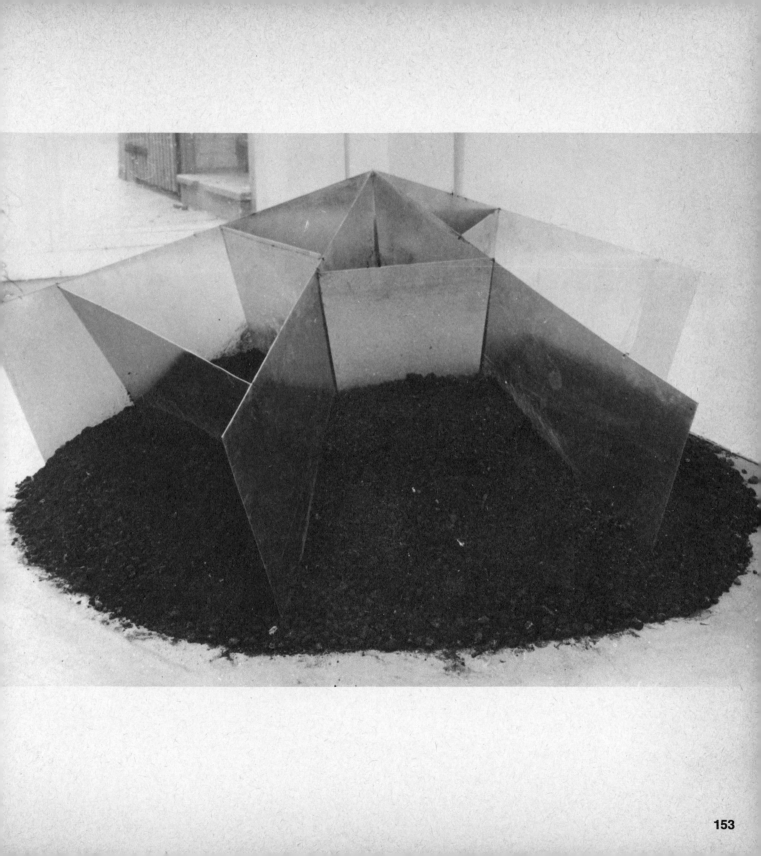

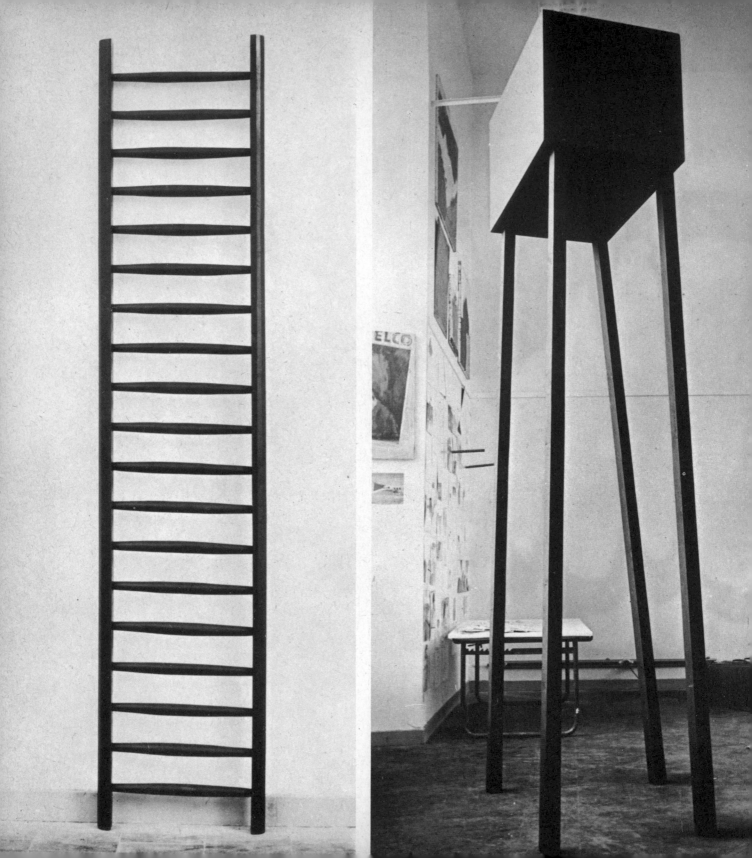

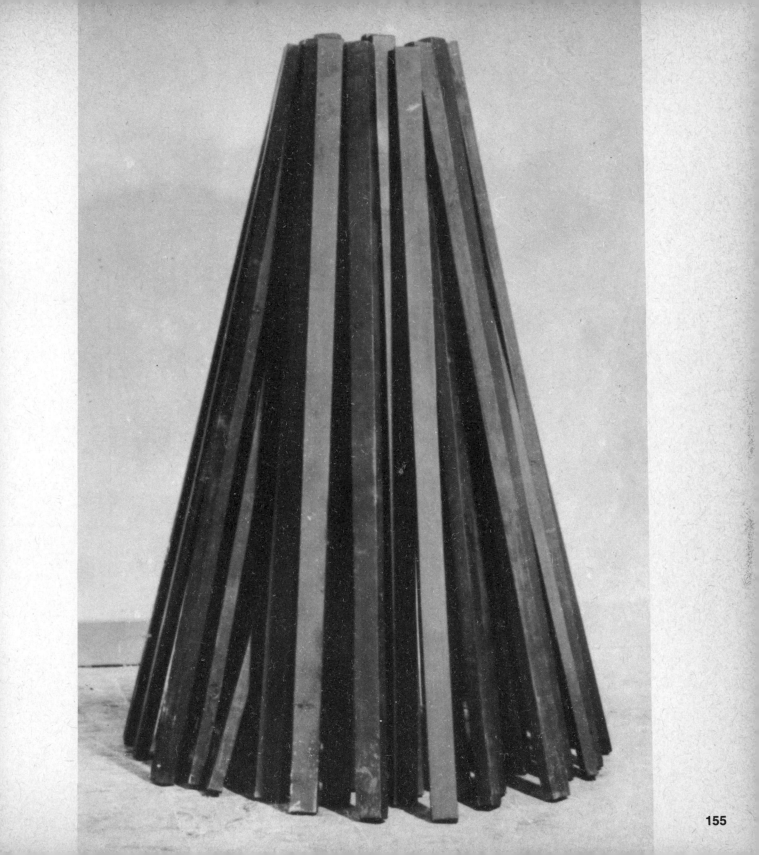

ALIGHIERO BOETTI

The conditions for a passionate life existed, but I had to destroy them to be able to recuperate them.

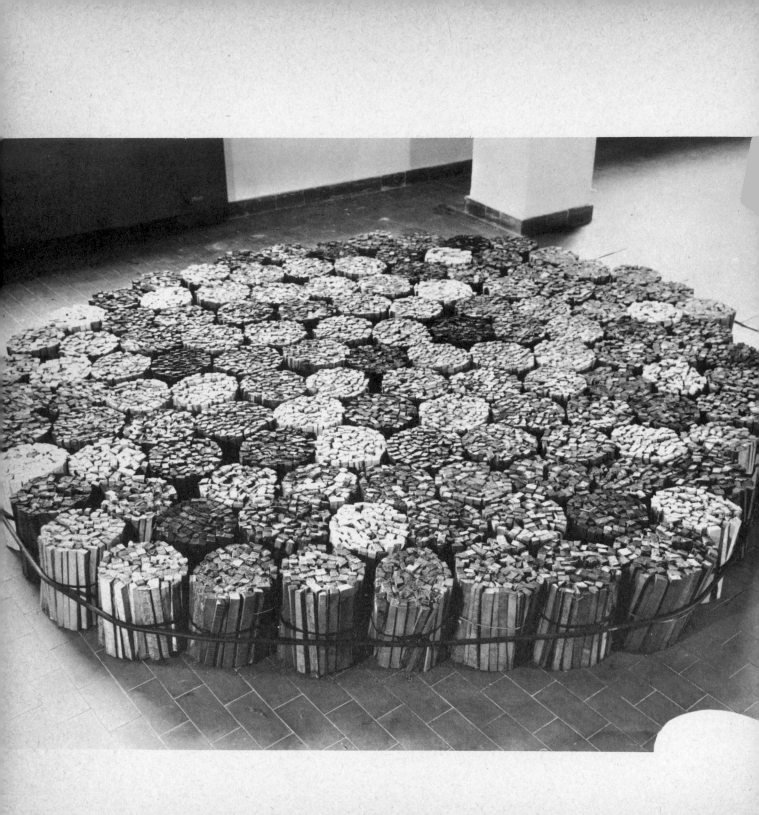

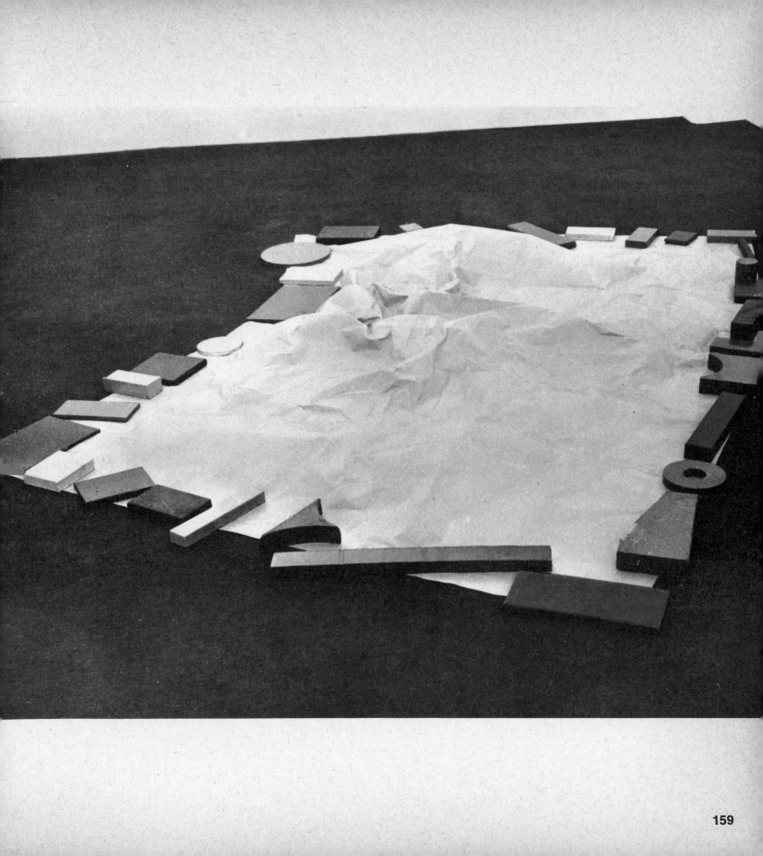

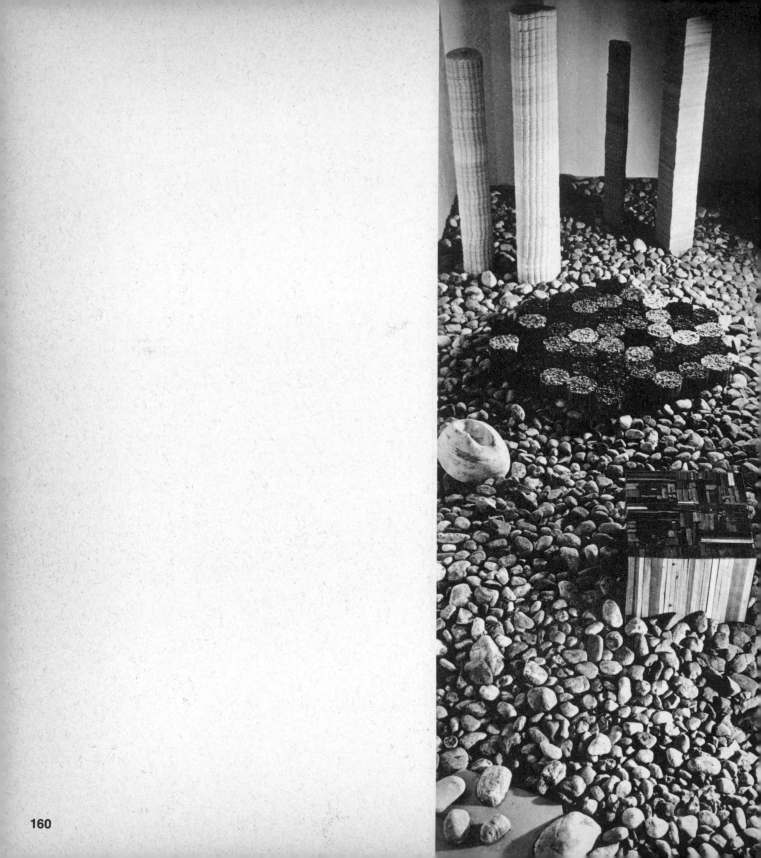

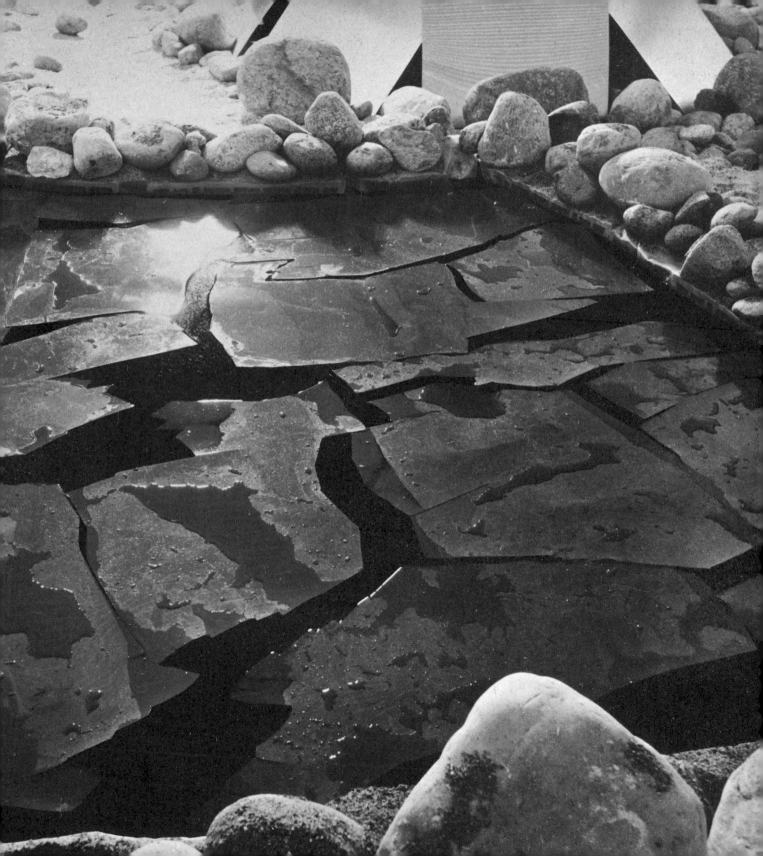

KEITH SONNIER

I would rather look from the center out than look at the sides.

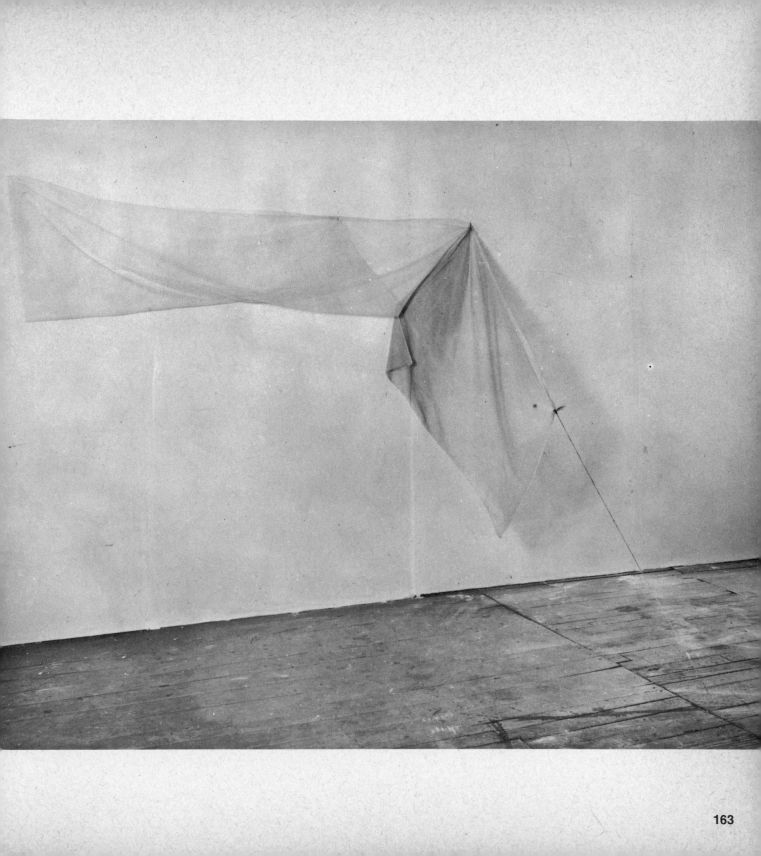

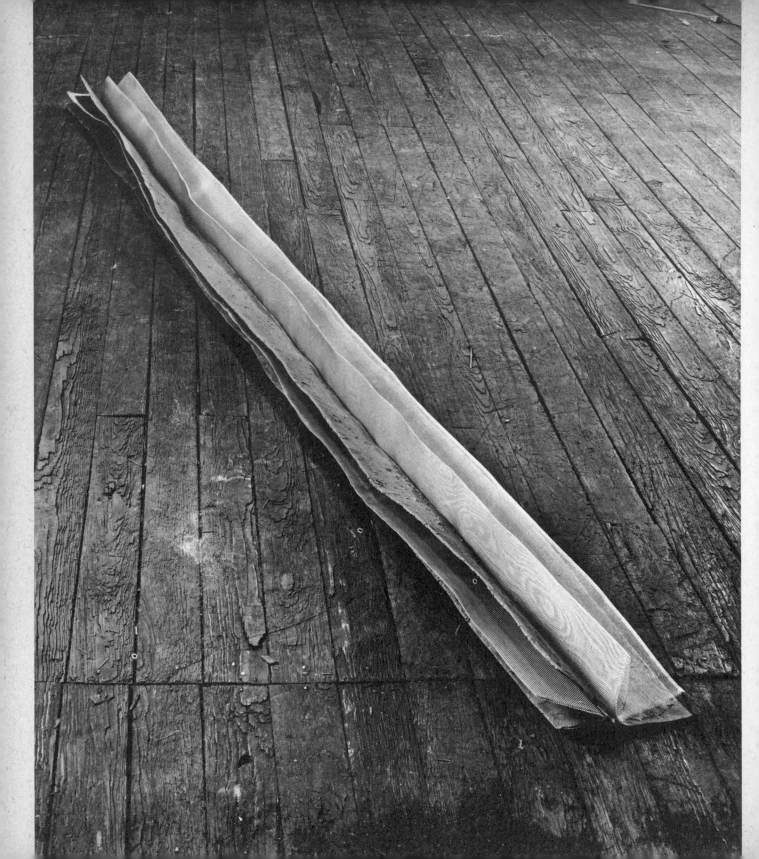

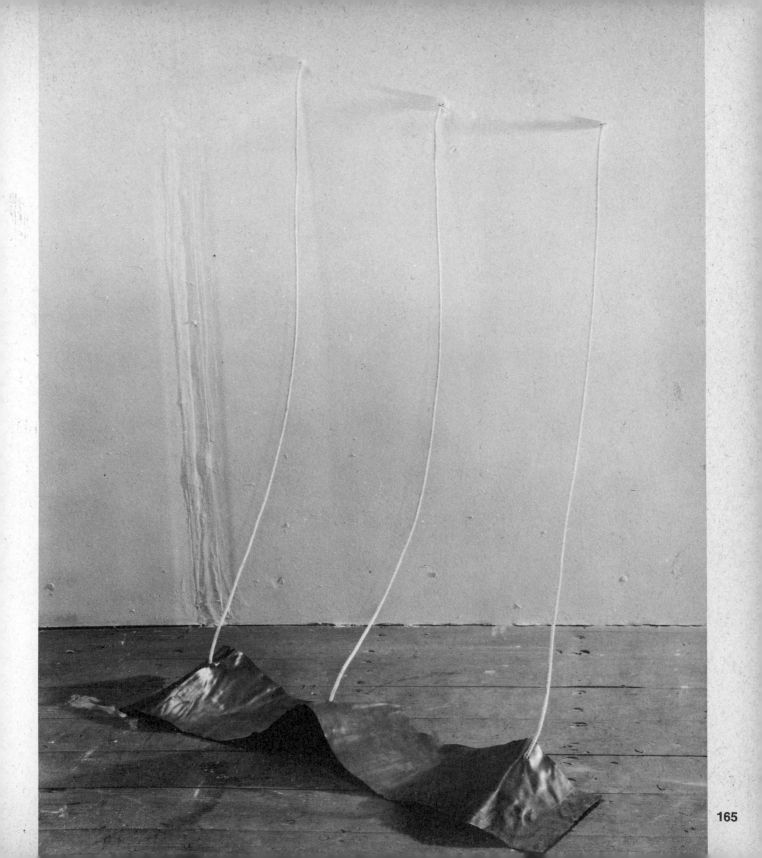

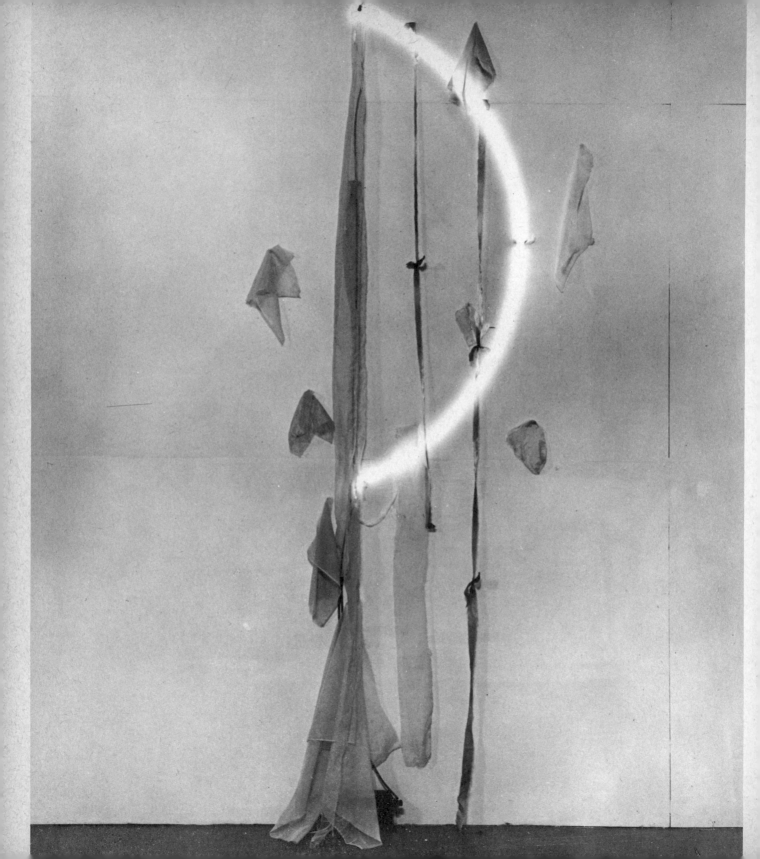

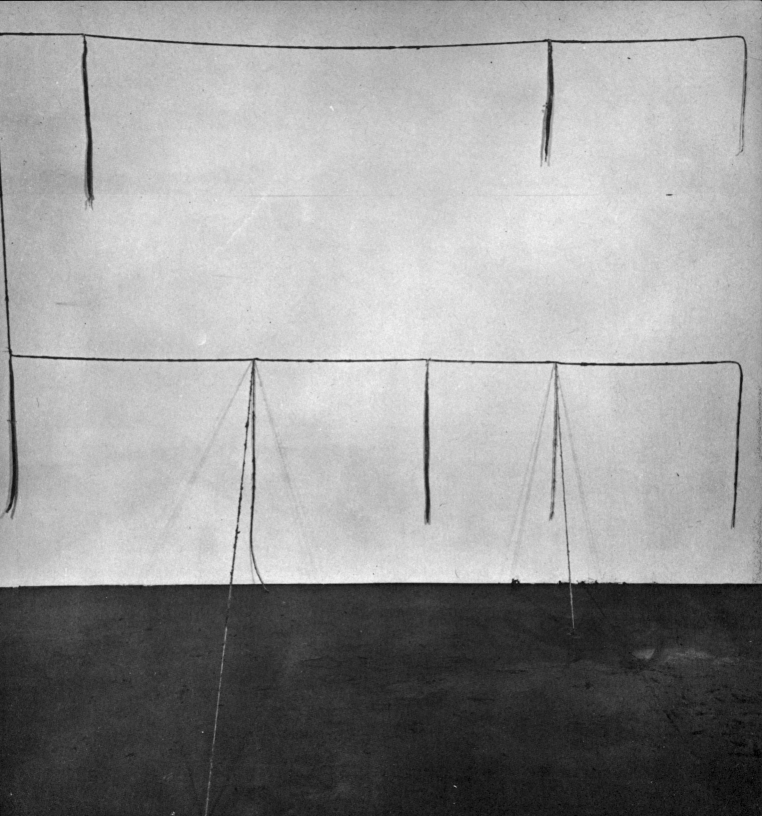

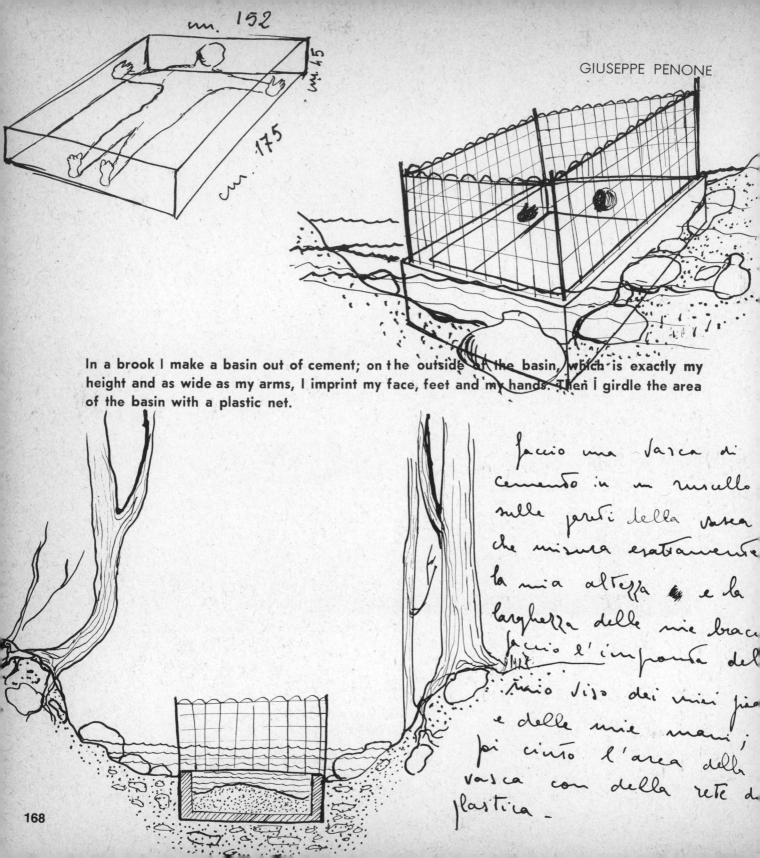

In a brook I make a basin out of cement; on the outside of the basin, which is exactly my height and as wide as my arms, I imprint my face, feet and my hands. Then I girdle the area of the basin with a plastic net.

faccio una vasca di cemento in un ruscello sulle pareti della vasca che misura esattamente la mia altezza e la larghezza delle mie braccia faccio l'impronta del mio viso dei miei piedi e delle mie mani; pi cinto l'area della vasca con della rete di plastica.

cm. 152

cm. 45

cm. 175

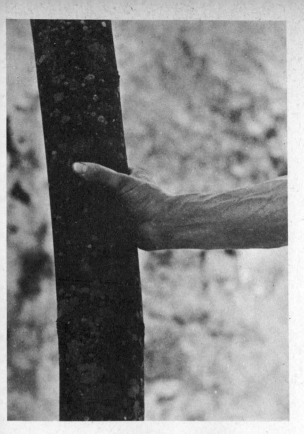

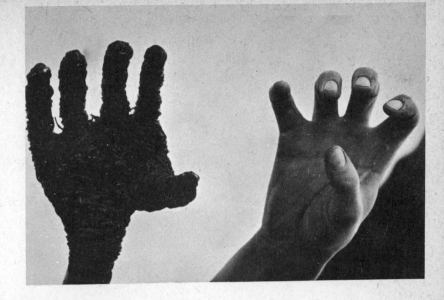

16-20 dicembre 1968

Ho agguantato un albero: continuerò a tenerlo stretto servendomi di una mano di ferro.

L'albero continuerà a crescere tranne che in quel punto.

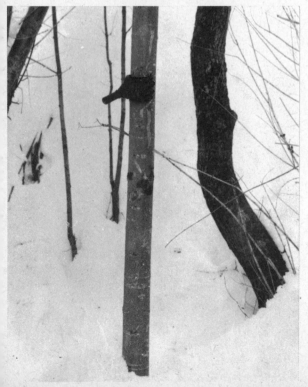

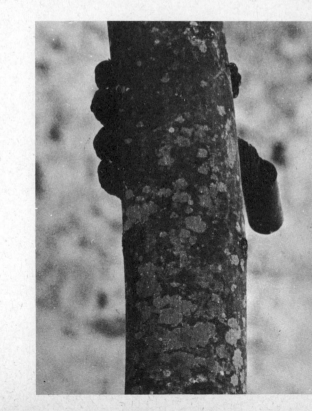

Translations for pages 169 to 173 are provided in the captions list.

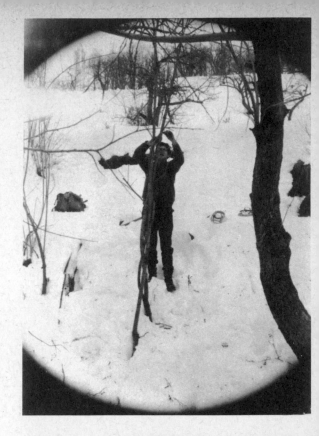

16-20 dicembre 1968

Ho intrecciato fra loro tre alberelli.

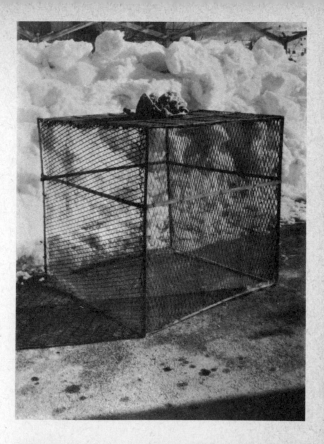

16-20 dicembre 1968
Ho racchiuso la punta di un alberello in un cubo di rete metallica (aperto di sotto) ed ho appoggiato sulla rete un cavolfiore, una fetta di zucca e due peperoni che ho poi ricoperti di gesso e cemento; l'albero crescendo innalzerà la rete.

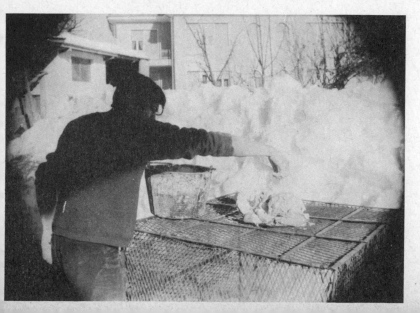

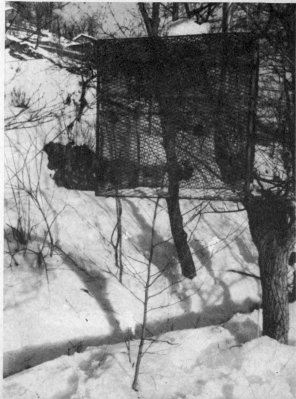

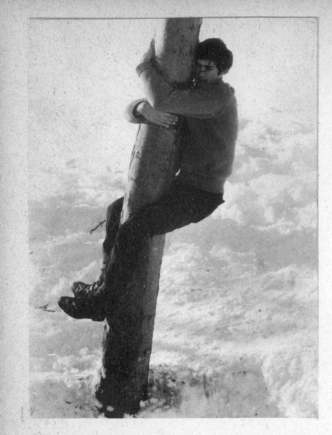

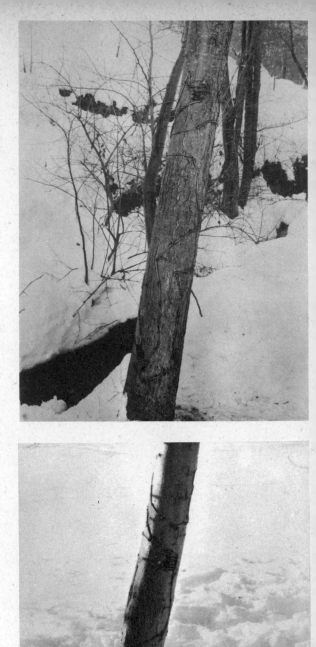

16-20 dicembre 1968

Mi sono aggrappato ad un albero ed ho segnato in seguito con chiodi e filo di ferro la mia sagoma nei punti di contatto. L'albero, crescendo sarà costretto a conservare la mia azione.

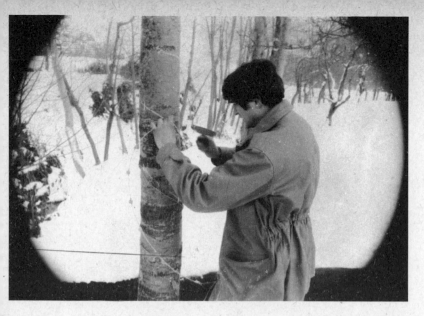

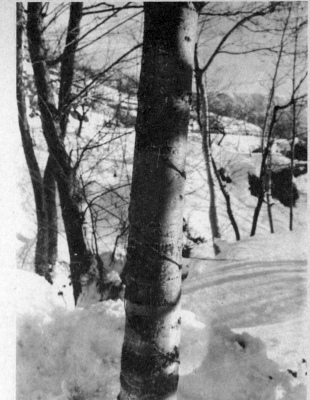

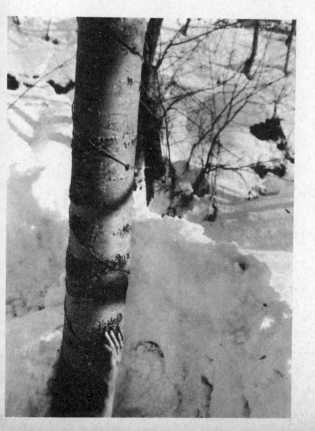

16-20 dicembre 1968

Ho scelto un albero su cui ho applicato la mia mano e ne ho seguito il profilo con dei chiodi. Successivamente ho posto sull'albero 22 piombini (corrispondenti ai miei anni) collegati fra loro da filo zincato e rame.

Ogni anno aggiungerò un piombino, sino alla mia morte. Lascierò per testamento una disposizione perché venga messo un parafulmine. Il fulmine scendendo forse fonderà tutti i piombini.

FRANZ ERHARD WALTHER Translations for pages 175 to 178 are provided in the captions list.

What I wish for the arts: as I saw it, the conventional forms or media of expression did not put to man the requirement of employing his OWN creative possibilities in a really responsible way.

As I soon knew, these demands could not be posed by these conventional media. But that was what I wanted.

The onlooker, listener, the reader, was to be responsible for what was to be. He would have to do something — without his activity hardly anything could be.

The former receptor was to become producer.

The artist, in this case me, was to put to disposal the necessary instruments. It was my aim to develop this.

In the conventional arts everything is given beforehand, determined, almost definite. Now only the task remained of conquering the given facts, and of understanding something about what brings an artist to something and how to roll up the development of history of art, and to realize the ability of the modeller.

Of course I learn something about myself through this activity. Experience of aesthetics in a developed state.

When I speculate on the capabilities and possibilities of man as a whole, I must try to find out something about the condition in which these capabilities find themselves.

Using the object, I had the chance of finding this out.

Very soon I learned that my confidence in the capabilities of people was well founded, but these capabilities: fantasy, power of imagination, of judgement, gift of improvization, modelling power, putting together, letting oneself fall, being able to meditate, feeling for relations, ability of taking in events as a whole, etc., did and do only exist in a very regressed way- and in addition orientate themselves according to utility and effectiveness.

But at a certain point of time, I could not understand any more why the people, the « public », should take in the product of a few, without posing question, if these single persons were at all suited for this special product. The special aptitudes and abilities of this person were never questioned. One had to make do with the beautiful object. The obligation of conforming.

This however I never could affirm. I had profoundly experienced the immobility of conventions and been forced to live with this. Thus I did not work against anything unknown.

The objects (I chose this nomination in 1962 as I knew of no better one) as instruments for something. The objects in themselves are not important, but what one does with them, what is possible by and through them. We, the users, have to achieve this. OUR abilities (and inabilities) count, our movement. These must and may not be receptive abilities, because they no longer are useful for experience.

We have to learn to discover our elementary abilities that for such a long time were not demanded any more, in order to be up to the requirements and exigencies that these objects pretend to.

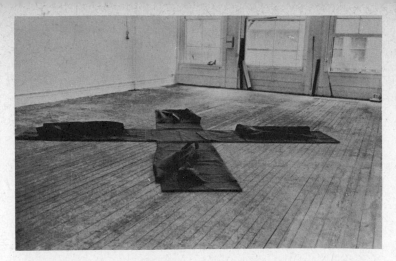

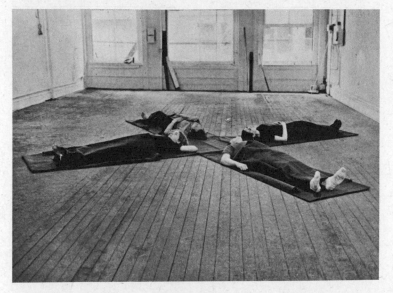

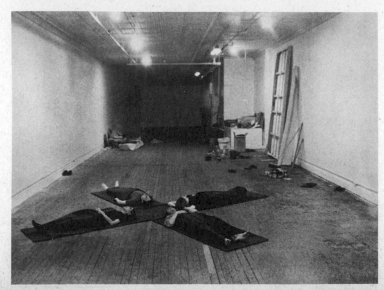

GLEICHZEITIGKEITSSTÜCK

Die Korrespondenz der vier Personen unter den erleichternden Bedingungen. Verbindungen. Die verschiedensten Formen des Gegeneinanders. Entwickelte Möglichkeiten von mittelbaren Einflüssen für bessere Objektnutzung.

Nicht das Objekt, aber zum Beispiel die wünschenswerten Verhältnisse oder enthülltes Unvermögen.

Die jeweils wechselnden Bedingungen und Bezüge einer Person. Die jeweils wechselnden Bedingungen der anderen Personen. Der Wechsel des Gesamtklimas. Der Wechsel von Teilen der Umgebung.

MULTIPLIKATION

Punkte, um Ansätze für Anwesenheiten zu finden. Anwesenheit der verschiedensten Entstehungsbedingungen aufgeben für tragende Auskommen:

gegenseitige Vermutungen über Vorhaben. (ganz einseitig und gewiss entbehrlich).

Beobachtung der angenommenen Bewegungen. Kein Denken in Richtungen.

Dauernde Behinderung des Wunschdenkens - um Entscheidungen und Ausnahmen weitgehender zu machen.

TEILBARKEIT

Verhältnisse. Distanzen. Proportionen durch Distanzen. Ähnlichkeiten nicht ergänzen. Vordringlichkeiten verwerfen. Angebliche Wichtigkeit ist wahrscheinlich nur Vorwand und Zweifel. Abgebendes Eingehen auf Beiträge.

Vom Vorher behalten. Annäherung ohne besondere Gründe. Die Wirkung deutlicher Besonderheiten verlangsamt.

Ausnahmen:

Schweigen äussern

sachliche Erklärung

entfaltete Einförmigkeit

bedeutungslose Gegenüberstellung

zufällige Vorkommnisse

Grundsätzlich nur den wirklich zugänglichen Momenten nachgehen, das Nur-Fühlen nicht bestimmend werden zu lassen.

 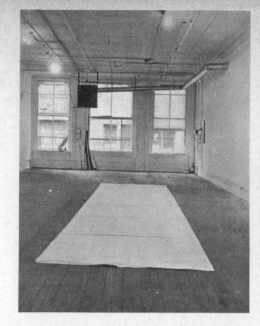 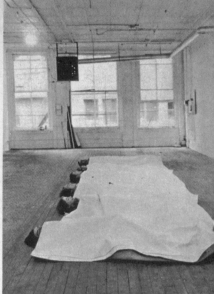

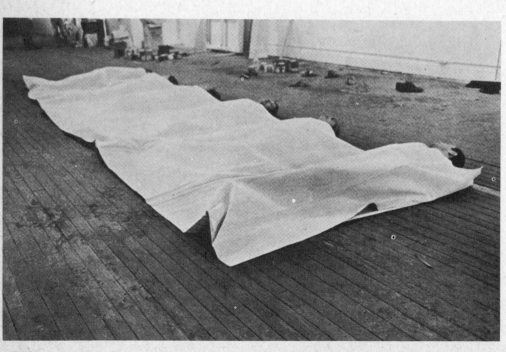

OBJEKT F. MEHRERE

Anteilnahme an der Frage nach
notwendigen Zeit, um Prozess
Gang zu setzen. Voraussetzur
und Verhältnisse der Benutzer.
bau der Ziele und Antworten,
vorher da waren. Entscheidunger
oder gegen die mögliche Situa
Summen daraus nicht verlieren!
wicklung der Entstehungen als F
Beschäftigung mit gewissen (of
bar notwendigen) Erscheinur
beim Benutzen zeigt die Vermu
gen als Projektion.

Zeitweilige Gedanken an - Er
nisse vom Vortag. Was morgen o
gend erledigt werden muss /
chologische Situation durch Eri
rungen / Körperliches Befind
Störungen durch Vorkommnisse
Welche Einflüsse dadurch bei
Objektbenutzung.

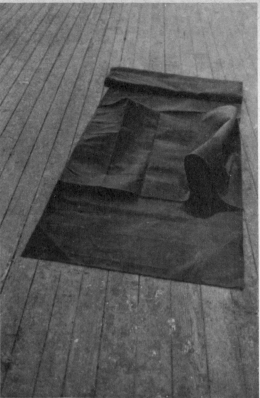

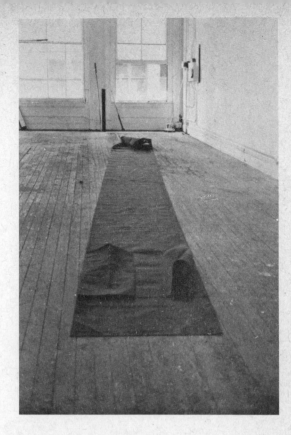

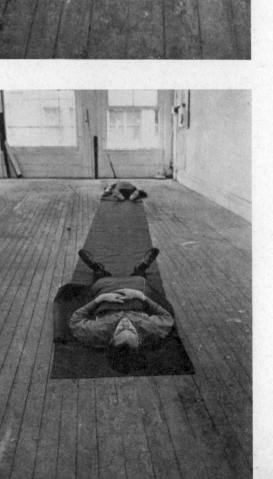

STREIKOBJEKT
BELIEBIGE BEZEICHNUNG

Offensichtlich ist es für zwei Personen gemacht. Was ereignet sich bei der Benutzung zwischen den beiden Personen? Gewiss kann man auf das Wollen verzichten. (Und gewiss bleibt ein bestimmter Grad an Widerstand unabdingbare Voraussetzung für Erfahrungen).

(DIE ENTWICKELTHEIT)

Natürlich bedeutet die Bezeichnung bei dem Benutzen nichts. Eher die jeweiligen Empfindsamkeiten.
Die ständig vorhandenen Bedingungen können zum Dagegenarbeiten veranlassen (was heisst: begegne den Bedingungen des Objektes, was du vorher willst, verlasse).
Verstärken dieses merkwürdigen Gegeneinanders. Bestreiken der Forderungen.
Gebrauch der Wünsche entsprechend.

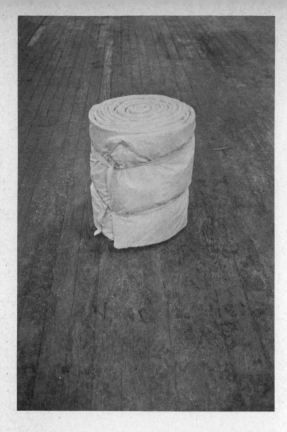

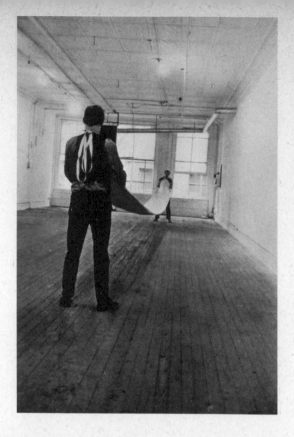

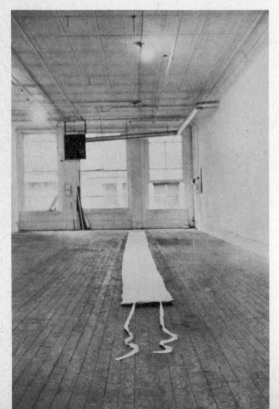

DAS OBJEKT

Was man ohnehin aus ähnlichen Situationen weiss - für erste Hilfe. Das Gegeneinander der beiden darin Liegenden. Was bewirkt die Entfernung. Das offensichtliche Verbundensein. Kräfte aus dem Wissen des Verwickeltseins etc.

A « sculpture » that physically reacts to its environment and/or affects its surroundings is no longer to be regarded as an object. The range of outside factors influencing it, as well as its own radius of action, reach beyond the space it materially occupies. It thus merges with the environment in a relationship that is better understood as a « system » of interdependent processes. These processes — transfers of energy, matter or information — evolve without the viewer's empathy. In works conceived for audience participation the viewer might be the source of energy, or his mere presence might be required. There are also « sculpture » systems which function when there is no viewer at all. In neither case, however, has the viewer's emotional, perceptual or intellectual response any influence on the system's behaviour. Such independence does not permit him to assume his traditional role of being the master of the sculpture's programme (meaning), rather the viewer now becomes a witness. A system is not imagined; it is real.

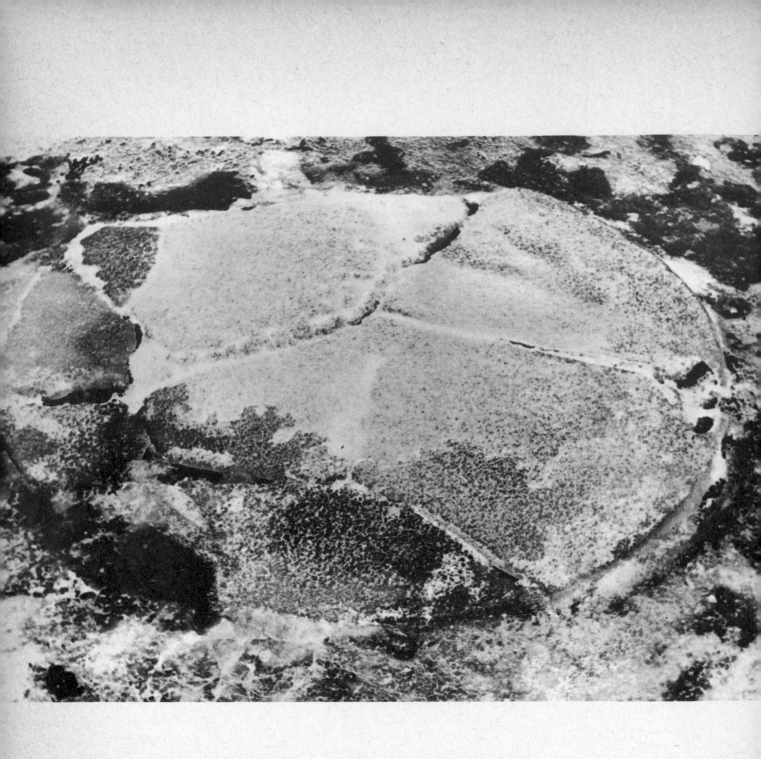

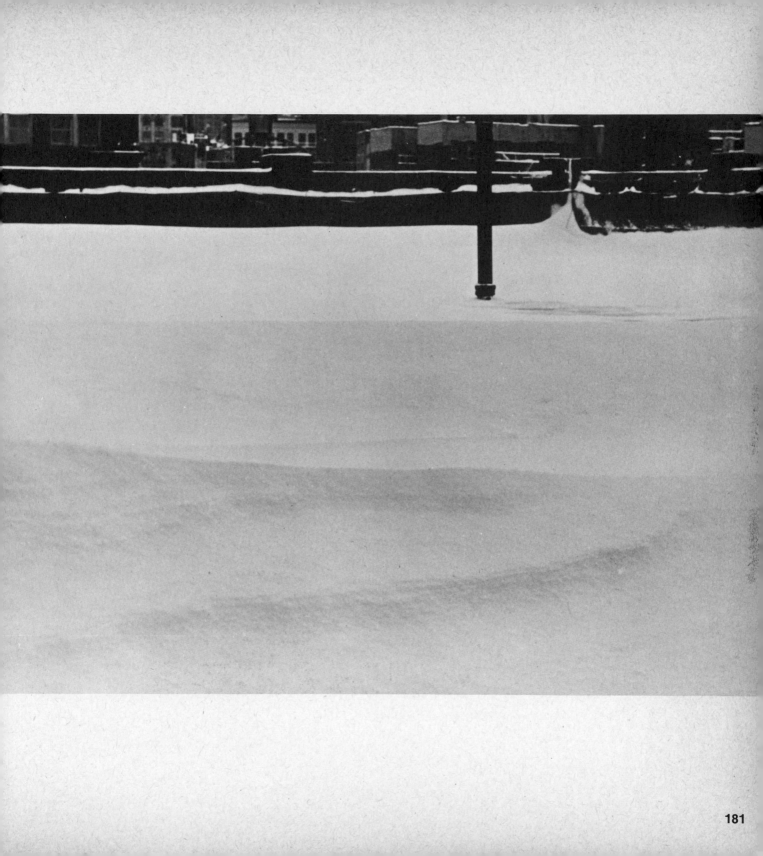

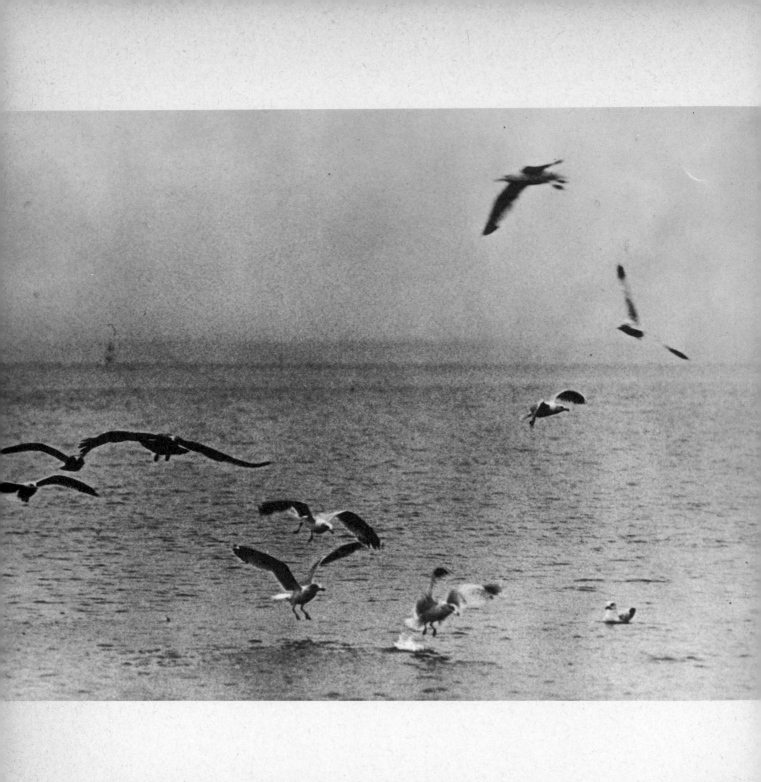

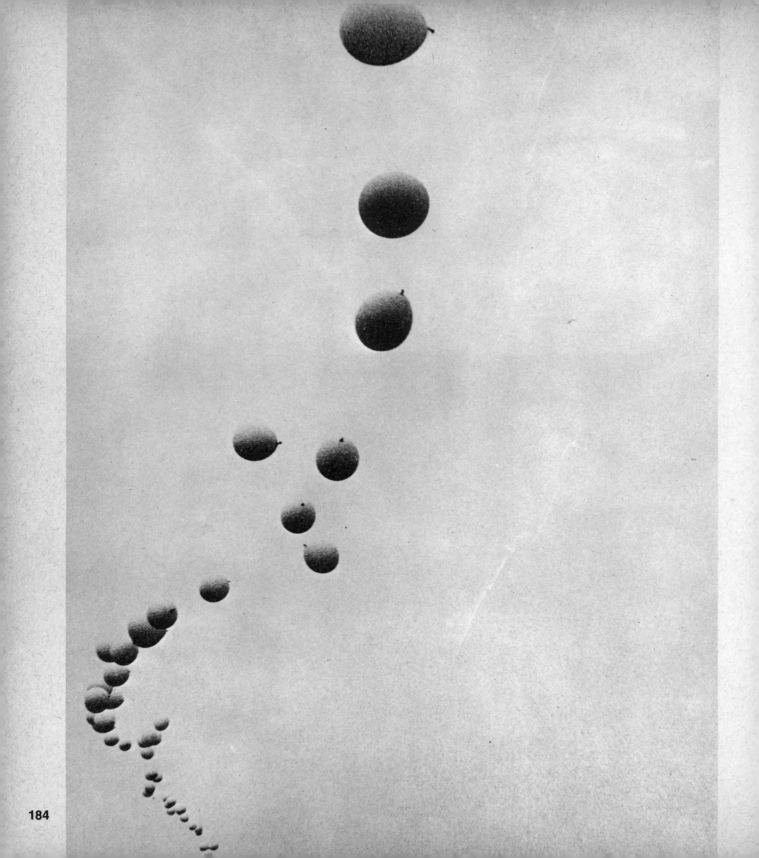

I like to talk of fluid and elastic things, things without lateral and formal perimeters. A plane, in order to take off and to land, needs an airport, that is, it needs two surfaces that act as a mediator between earth and sky; if a plane lands in a forest, its landing will be said to be lucky; a bird instead, leaves where it wants to leave from, the flight of a bird thus is an invention.

A word that is absorbed by a microphone and repeated several times by a loudspeaker, loses its literal meaning and becomes an incomprehensible sound that is nevertheless mentally and physically perceptible. I place a sheet of paper, on which I have written with invisible ink, on a hot metal plate, for a few moments I see the phrases that could also be a death sentence. Sometimes I dream of being a thief who flame-cuts a safe, not to steal the jewels, but a bit of the inside. Sometimes I dream (or perhaps it isn't true) of traveling to the centre of the earth where I see birds, covered with asbestos, flying in the middle of the lava.

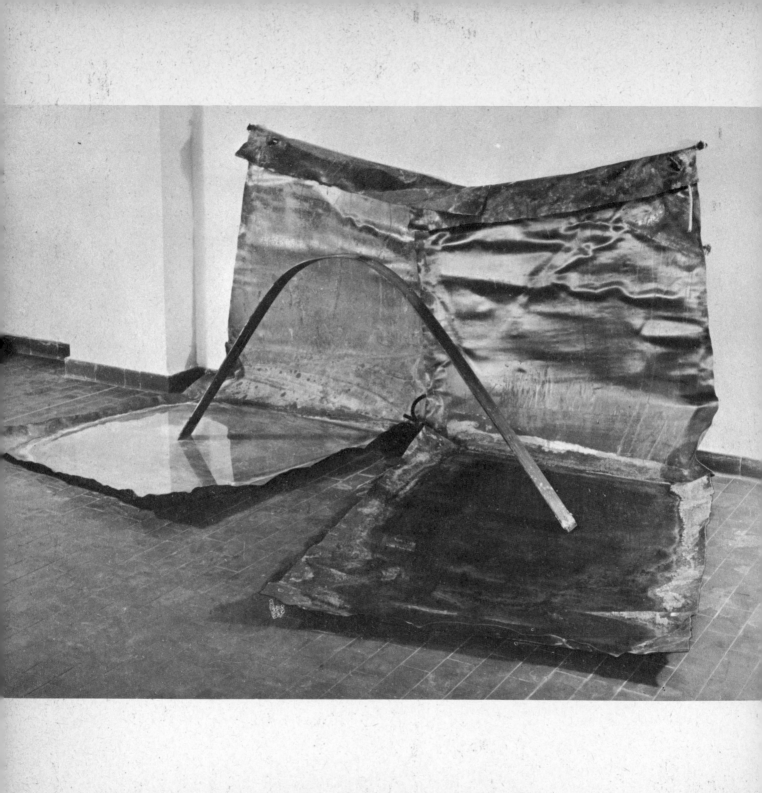

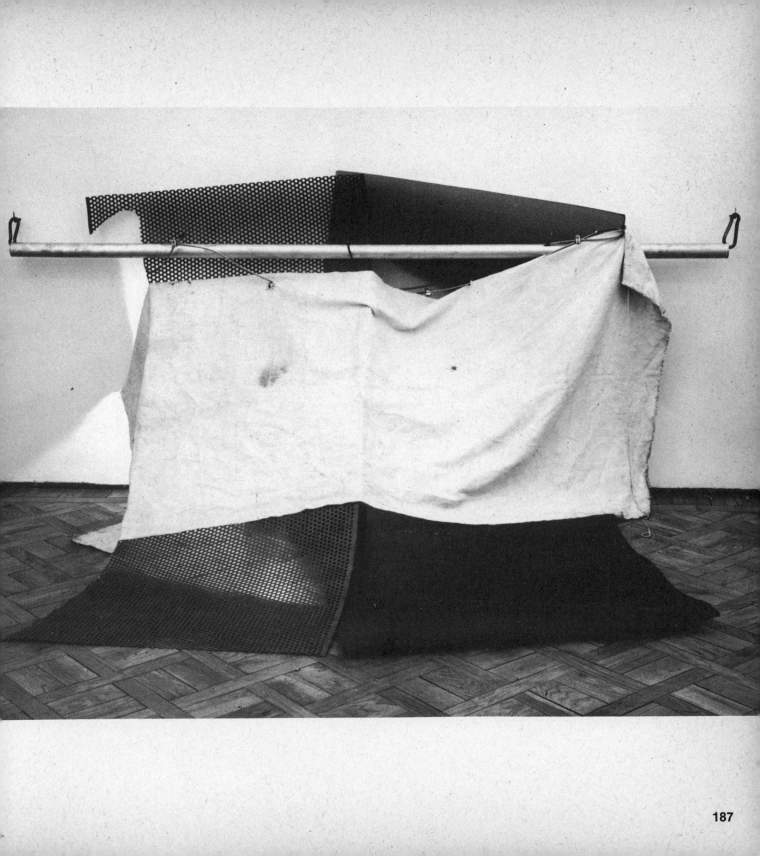

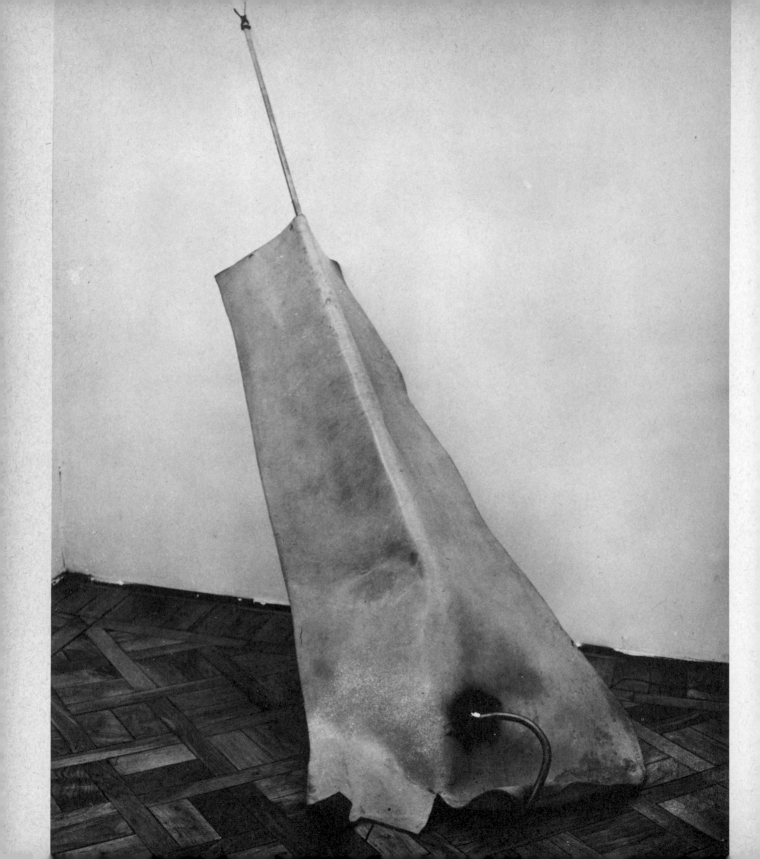

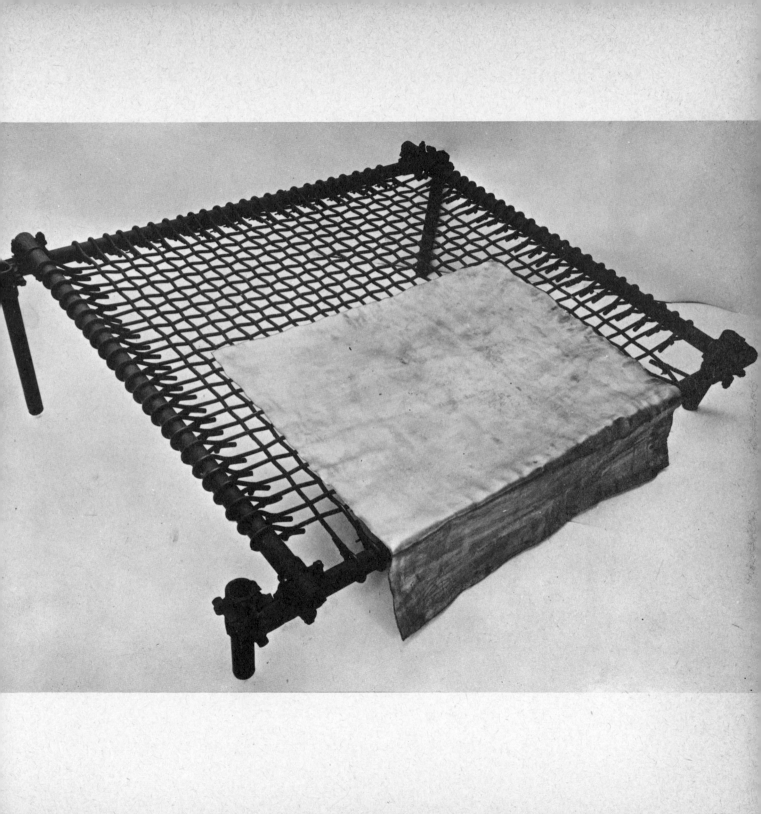

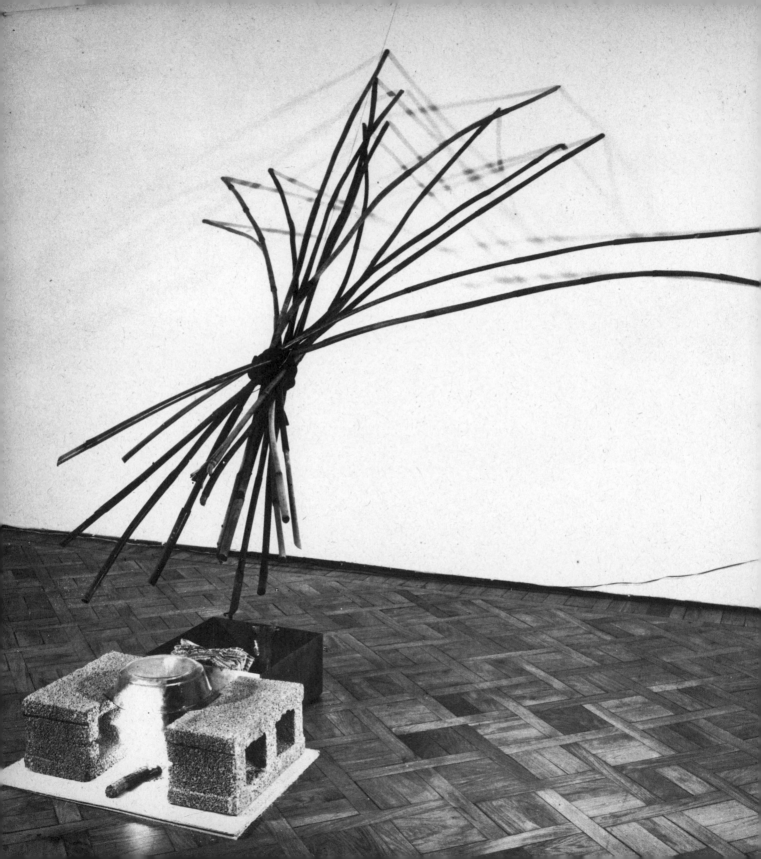

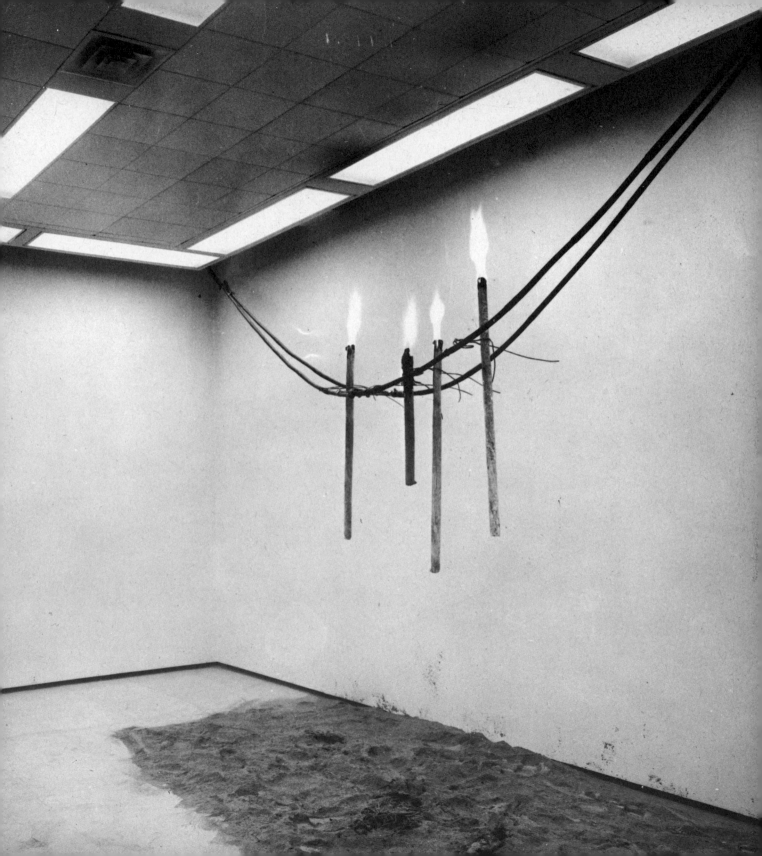

<u>Statement of Esthetic Withdrawal</u>

The undersigned, ROBERT MORRIS, being the maker of the metal construction entitled *LITANIES*, described in the annexed Exhibit A, hereby withdraws from said construction all esthetic quality and content and declares that from the date hereof said construction has no such quality and content.

Dated: November *15*, 1963

Robert Morris

STATE OF NEW YORK
COUNTY OF NEW YORK
} ss.:

On the *15th* day of November 1963, before me personally came ROBERT MORRIS, to me known, and known to me to be the individual described in, and who executed the foregoing instrument, and duly acknowledged to me that he executed the same.

Notary Public

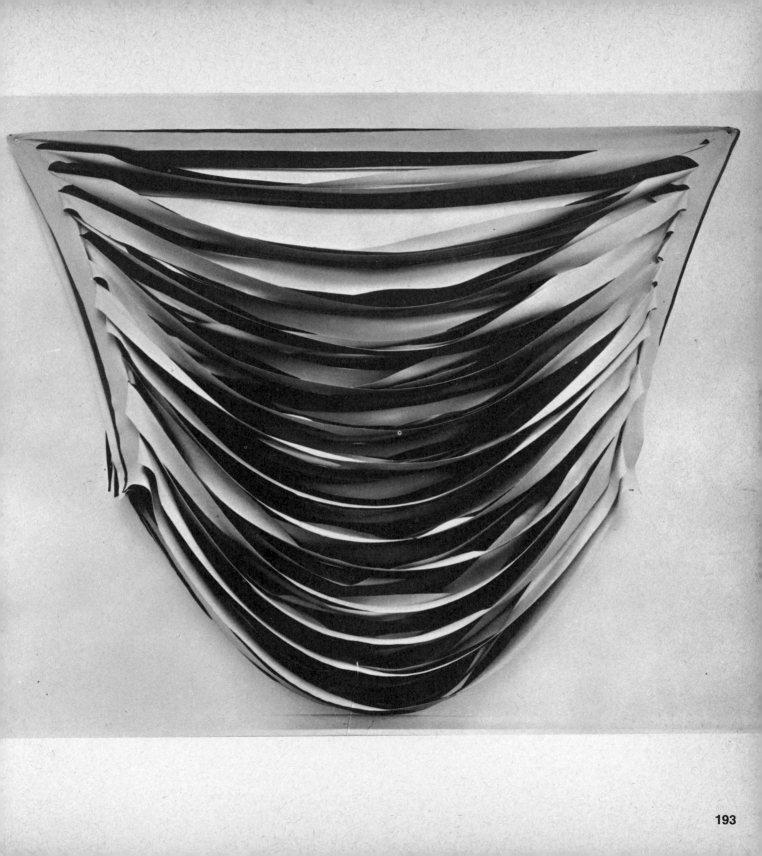

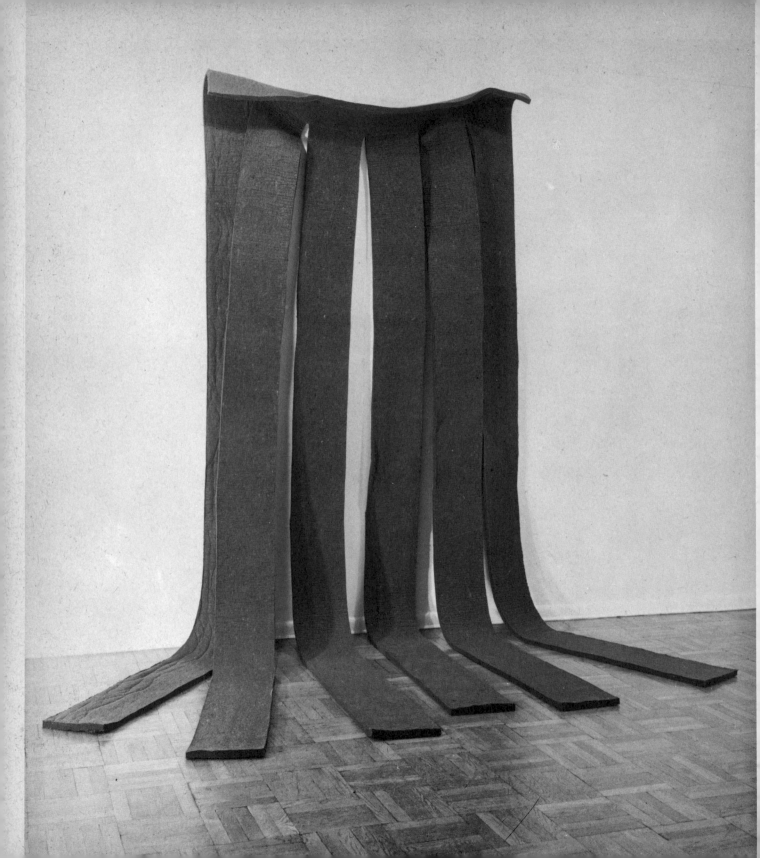

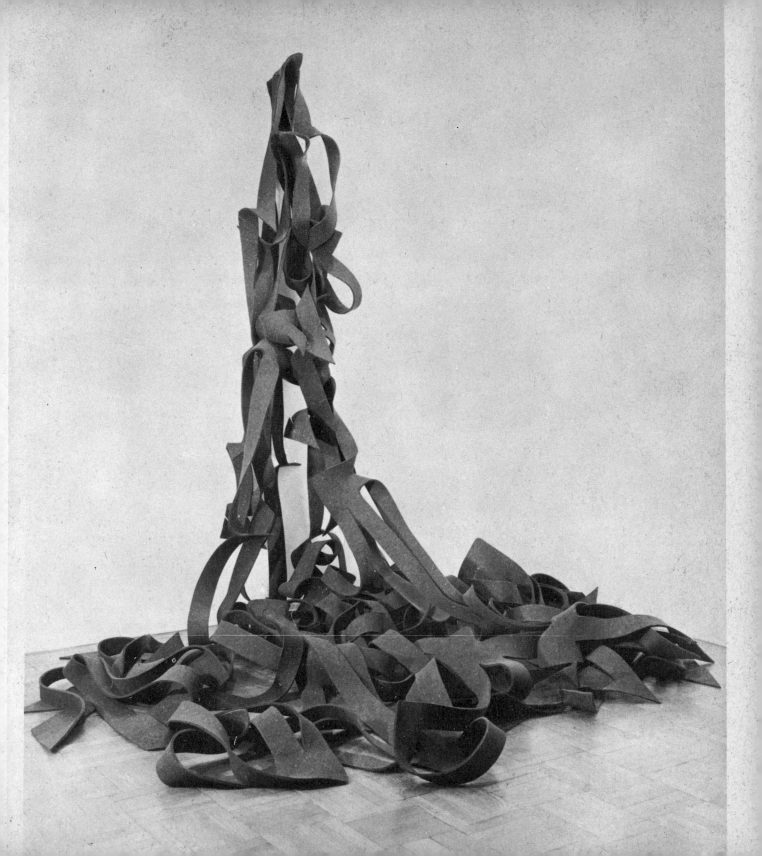

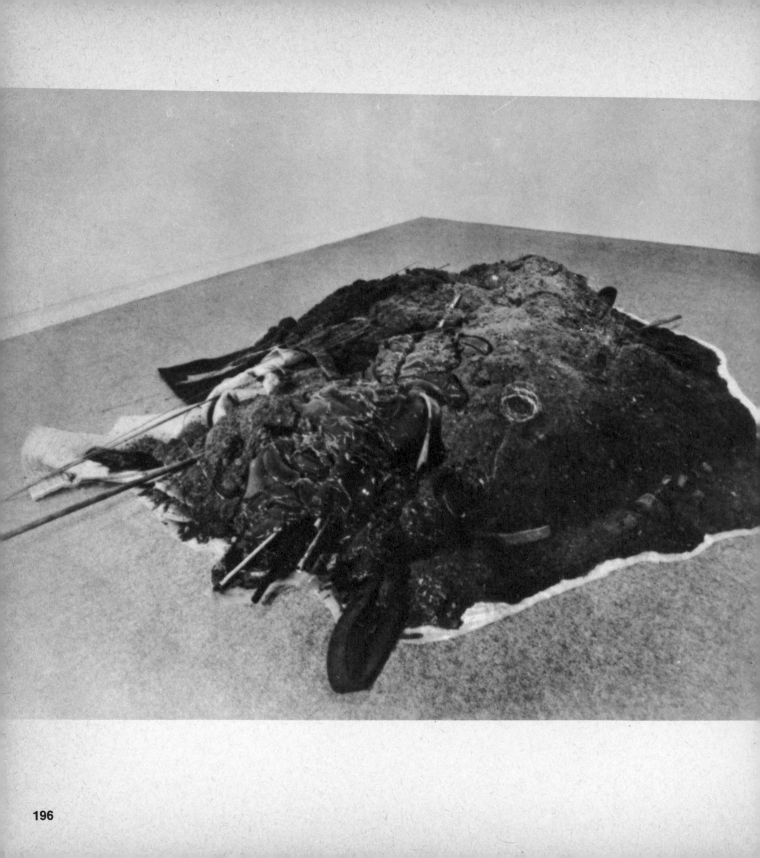

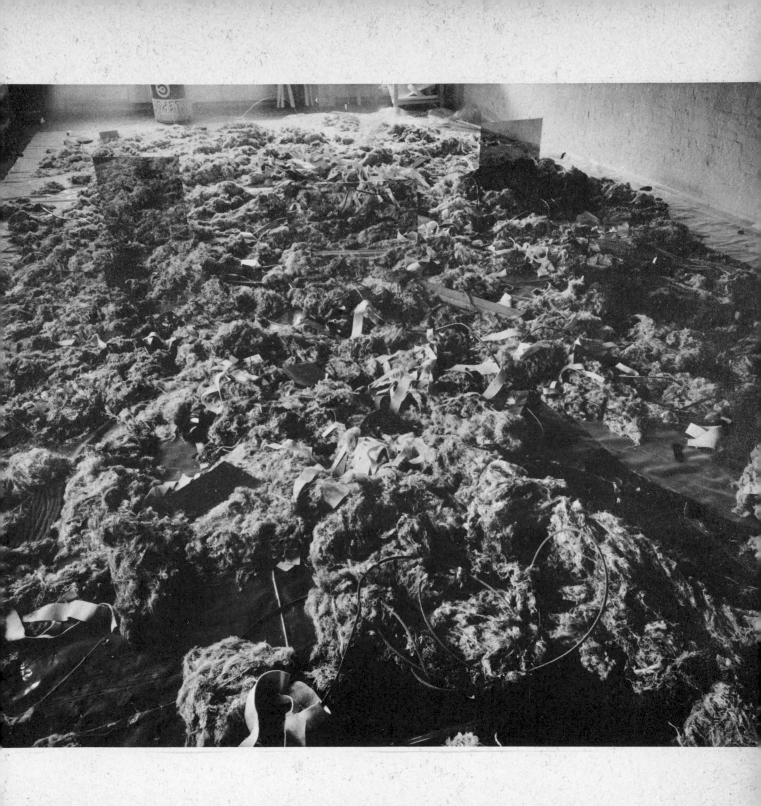

MARINUS BOEZEM

Creativity is not only expressed by an art-object but not least in a mental attitude on the strength of which communication and research are made possible.

In my opinion this must be the most essential feature in this new trend of art, which on account of its anti-stylistic characteristics will not fail to have an influence upon our culture and which will easily contact the latent revolutionary ideas in our society.

February 1969

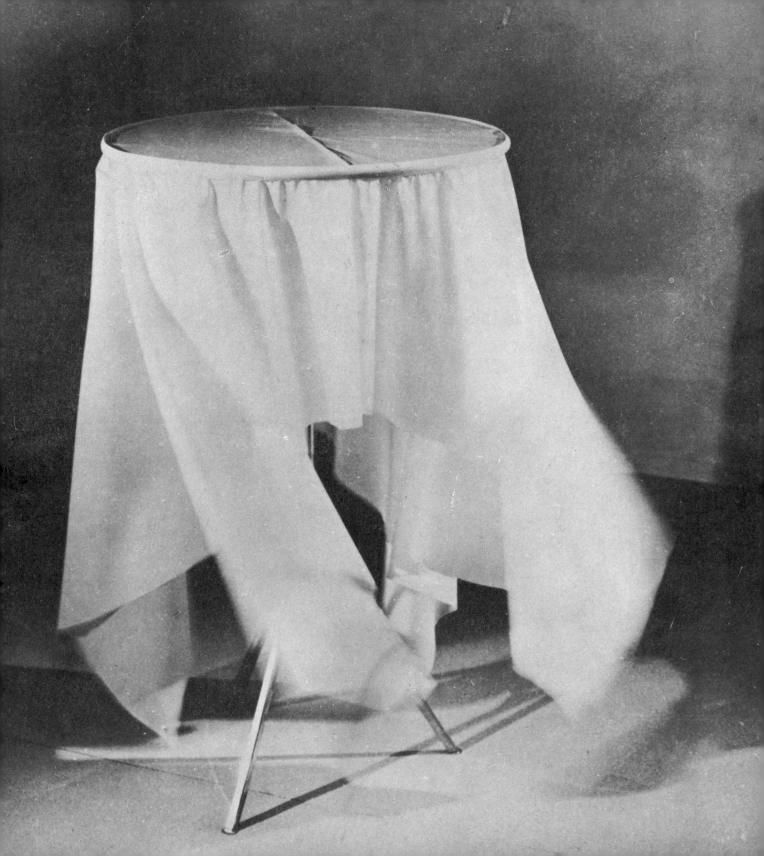

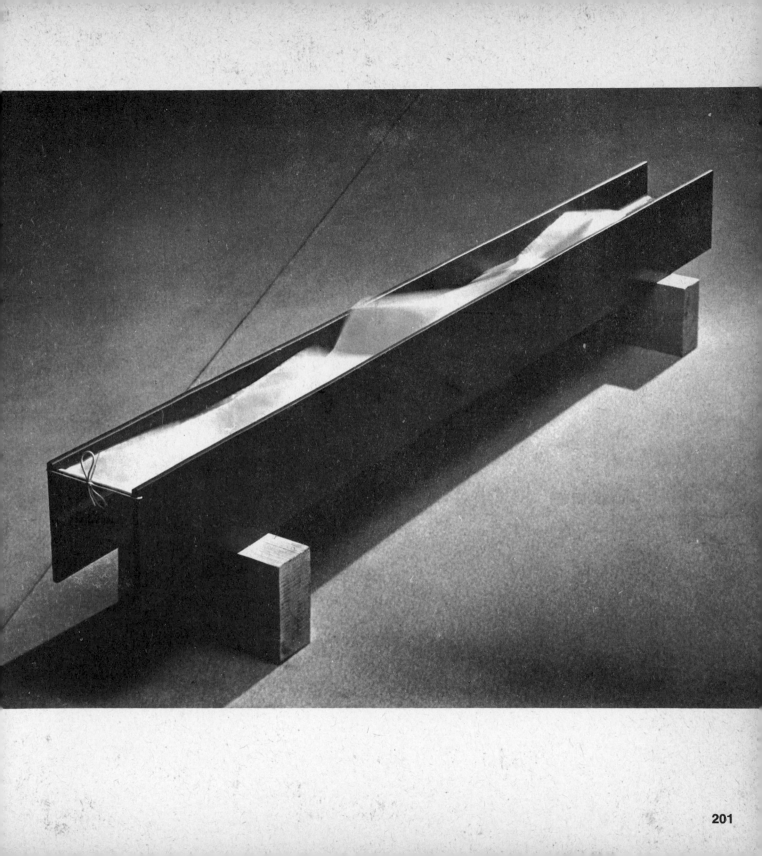

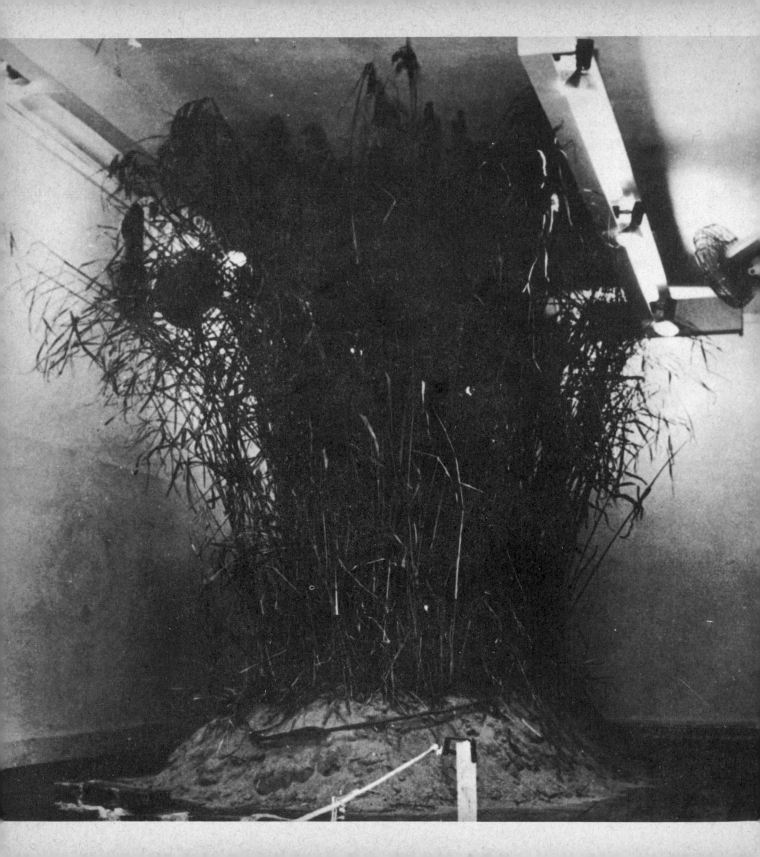

CARL ANDRE

A man climbs a mountain because it is there.

A man makes a work of art because it is not there.

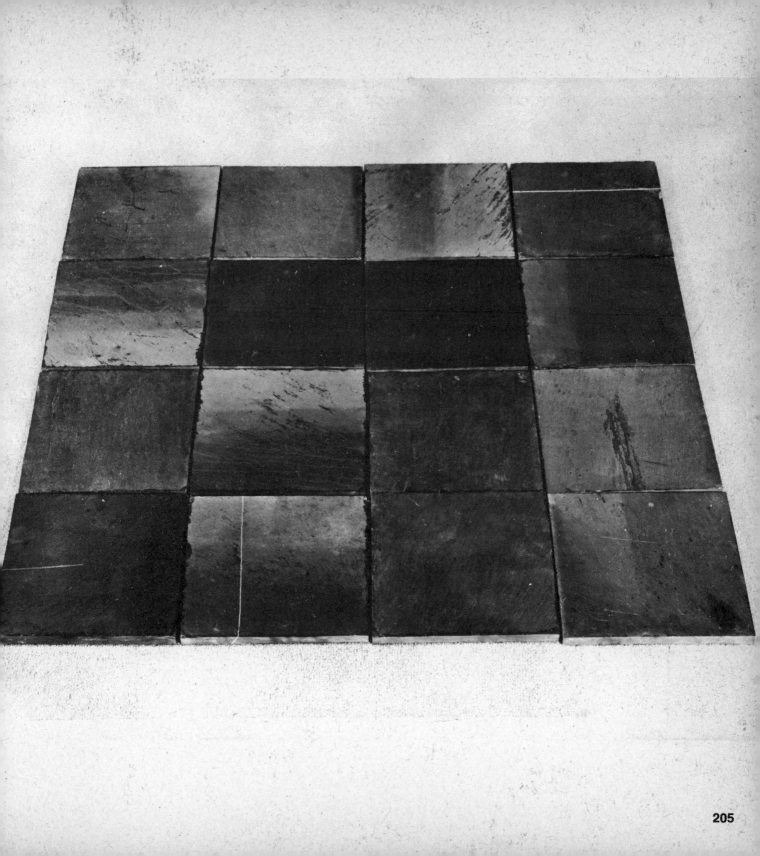

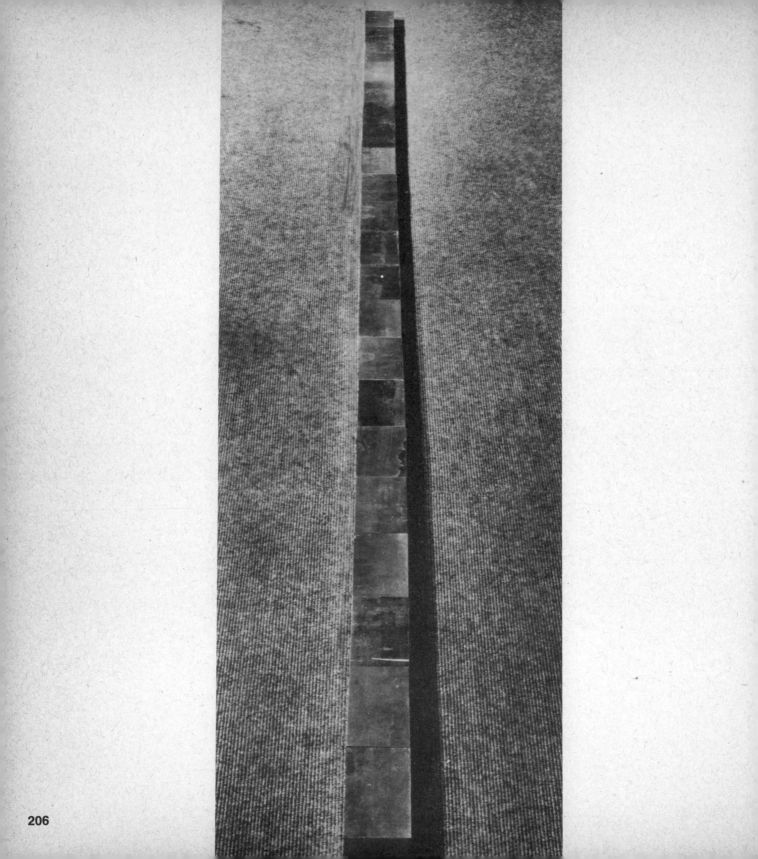

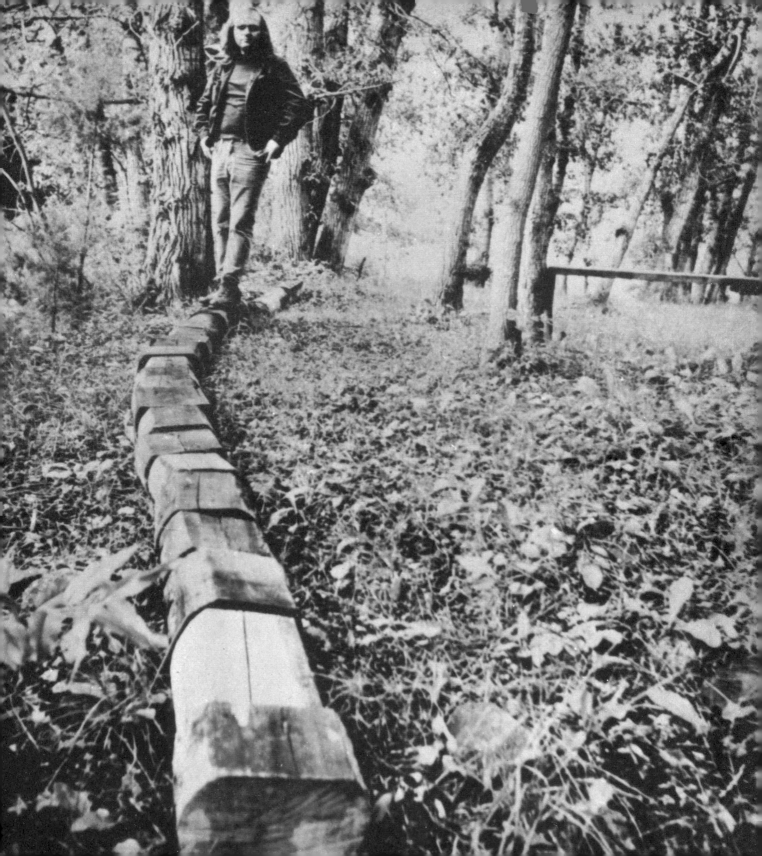

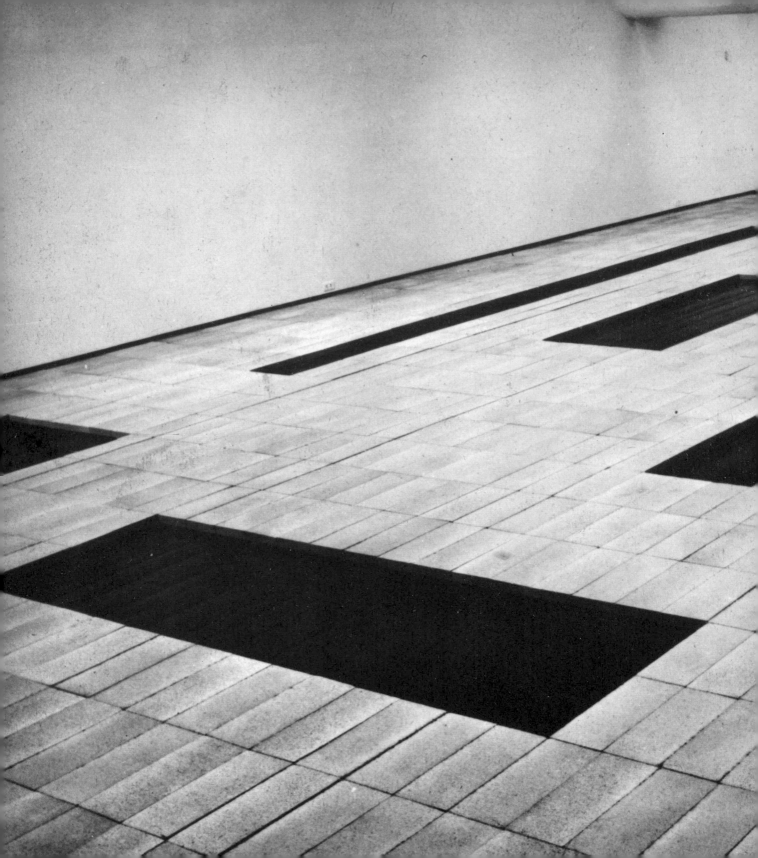

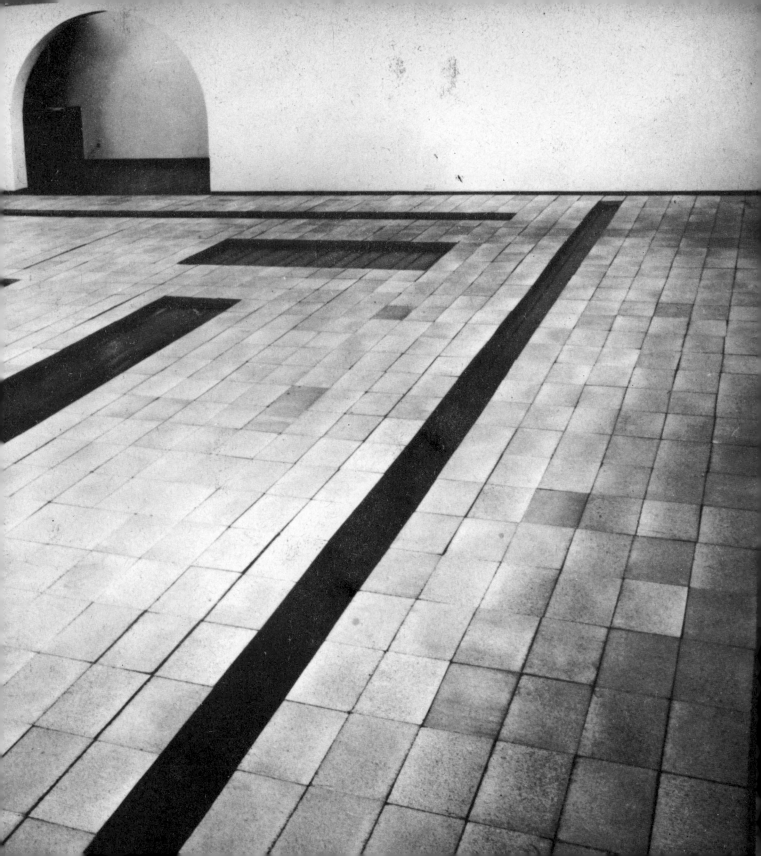

sto rantolo m'ammazza
a un povero grillino
'erba di un prato
cantava un concertino
mante e stentato
ginella della guazza che
zi fra i fiori
sta vo__ __ strapazza
a fatina
sto rantolo m'ammazza
irò di raffreddor
i »
a bianca pratolina
no odoroso
a fuori la regina
ando al doglioso
mio povero giullare
oglio medicare
ino grillino
tura hai da fare
ssido e di fer
i »
l grillino è lì
lima
rro per cura
lima lima lima
far limatura
nella della guazza
ra o basterà?
empire quella tazza
ino grillino
fatina tu sei pazza
atica morirò, e

EMILIO PRINI

The section on Emilio Prini remains untranslated in accordance with the wishes of the artist.

Ho preparato un progetto di oggetto viaggiante (5 punti di luce sull'Europa).

Ho costruito una valigia contenente suonocombustibileregistratorecartageograficaspecchio ho segnato sulla carta i 4 punti Dusseldorf Amsterdam Parigi Londra; ho trovato il quinto punto unendo i quattro vertici. Il tempo di sosta nelle città è stato limitato alle coincidenze di orario fra i diversi treni. Il funzionamento del registratore è stato limitato alla discesa nelle città. Il funzionamento dello specchio è risultato illimitato. Il funzionamento del fuoco falòsuono si è ripetuto costantemente nel centro di ogni città visitata. La carta geografica è risultata tracciata e segnata. Sono state spedite a persone diverse moltissime fotografie dell'oggetto in comportamento ottico e sonoro nelle città. E' stato fissato un appuntamento alla stazione di arrivo. Le fotografie sono state scambiate. La valigia è stata vista e ascoltata sono ripartito.

Ottobre 1967 - Novembre 1967.

lato di vita chiave biolo

Ho preparato una serie di ipotesi d'azione a punzone su piombo nel peso del mio braccio che scrive. 67/68.

Ho preparato una serie di appunti frasi slogan a punzone su piombo nel peso del mio braccio che scrive. 67/68.

lato di vita chiave biologica

1 Ho fatto un viaggio con Renato
Ho fatto un viaggio con Nancy Paolo Grazia
Ho fatto un viaggio con Paolo
Ho fatto un viaggio con Nancy Grazia Renato Paolo
Ho fatto un viaggio con Bea Mario Marisa
Ho fatto un viaggio con Pier Paolo
Ho fatto un viaggio con Paolo Nancy
Ho fatto un viaggio con Germano
Ho fatto un viaggio con Germano Mario Paolo
Ho fatto un viaggio con Pico Grazia Nancy Paolo

2 Ho letto Alice nel paese delle meraviglie

3 Ho preparato una trappola per Alice

4 Ho mangiato un gelato

5 Ho fatto un salto da un'altezza

6 Ho bruciato i miei blocchi d'appunti

7 Mi sono affacciato da una finestra a 20 metri d'altezza. C'era il sole

8 Ho costruito un oggetto di solo peso deciso in 60 kilogrammi. E' in piombo l'ho gettato dalla fin

9 Ho tracciato con gesso bianco una linea perimetrale continua intorno a un quartiere del centro

10 Ho costruito negli stessi materiali del supporto una porzione di strada in salita.
L'oggetto in asfalto è lungo 9 metri, largo 1,38, la pendenza del 6 per cento (5 rilevamenti urbani per ambiente: strada in salita muro di granito in curva, marciapiede ad ellisse in granito, gradino in marmo, muro dritto in mattoni, grande piastra d'asfalto 66/67

11 Ho percorso un lungo tratto di strada a piedi. Il mio corpo è stato fotografato in cinque punti fissi.

12 Ho percorso una strada in salita.

13 Ho preparato una corsa in salita. Ho invitato persone ad assistere alla corsa. Il mio corpo in movimento è stato fotografato a teleobiettivo fisso in 3 punti del percorso. Al termine ho tenuto un discorso di 8 ore.

14 Ho dipinto irregolarmente una porzione di pavimento in anilina marrone. E' stata consumata.

15 Ho ottenuto un movimento.

16 Ho incontrato una tempesta, l'ho salutata.

17 « Il teatro insegna l'inutilità dell'azione che una volta compiuta non è più da compiere e l'utilità superiore di una condizione inutilizzata dell'azione che rovesciata produce la sublimazione ».

18 Un'altra ipotesi sul vuoto.

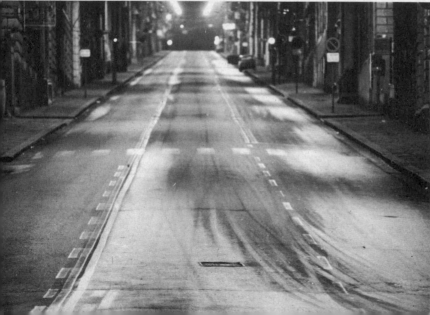

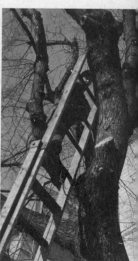

lato di vita chiave biolo

19 Ho preparato un calco fotografico, foto delle paretipavimentosoffitto di una stanza accolla sulle pareti della stanza. Porzioni di pavimentoparetisoffit-to di una stanza accolla sulle pareti della stanza. Porzioni di pavimentoparetisoffitto della mia casa sono collocati nella stanza. L'ambiente non è transitario.

20 Sulla stanza cubo d'aria ecc.

21 Ho giocato a ping-pong.

22 Ho sviluppato un vuoto di 4 m x 50 cm staccando un ramo da un albero. Ho formato una linea di equilibrio continua trasportando la distanza. L'ho bruciato.

23 Ho costruito una casa.

24 Tutta la mia vita.

25 La bottiglia del latte è il simbolo del latte?

26 Ho ricoperto una grande porzione di prato con una foto del prato in adesione totale al terreno. Per azione della luce la foto si è progressivamen-te consumata; è stata arrotolata. Per azione del buio la porzione d'erba scoperta è risultata bianca. La foto consumata è stata tagliata è accatasta-ta in una stanza.

28 Se una pietra fosse una pietra non la si sarebbe mai chiamata pietra.

29 Ho fuso sul pavimento grandi quantità di piombo stagno.

30 Tutto svia e rivela in pari tempo.

31 Ho fatto una gita sui monti intorno a Genova ho rivestito i punti elevati del percorso con materiali specchianti orizzontati sul movimento del sole. I raggi specchianti a grande distanza, hanno ripetuto costantemente l'itinerario seguito da me viaggio corpo movimento.

32 Fai una maschera come un energia

33 Filma 4 ore la nuca in primo piano e il mondo intorno seguendo la direzione del vento che cambia. Metti un sonoro sull'energia

34 Ho costruito una scatola a dimensione di me corpo, specchiante su tutti i lati. L'ho abbandonata sul mare. L'ho seguita filmando il mare per un'ora.

"LA COSTRUZIONE (PROGETTO) DEI CARTELLI CONTINUA DURANTE LA MIA VITA.
IL CONTRASTO PERMETTE L'USO PERFETTO DEL CAR-
SA CONTENITORE E VINCOLA ALL'ACQUISTO DEI CARTEL-
LI. LA CASSA È COSTRUITA IN STAGNO. I CARTELLI
COSTRUITI NELL'ANNO VENGONO COMPLETAMENTE
STAGNATI E DEPOSITATI CON LA DATA DELL'ANNO IL PESO
È COSTANTE, CON IL SOLO VARIARE ANNUALE DELLA DIMEN-
SIONE. LA CASSA È AL MONTE FASCE (m. 834) ESISTE UN
PROGETTO DI INSERIMENTO NEGLI ITINERARI TURISTICI DELLA
CITTÀ È LA DIFFUSIONE IN CARTOLINA, DELLA
IMMAGINE PANORAMICA. 4 (EMILIO PRINI 1967-968)
DEL QUADRO DI FOSCE NUDOSTRE

di vita chiave biologica

lato di vita chiave biologica

Introduzione alle statue.

1. Con un peso (il mio corpo sul/ in piombo).

2. Fermacarte a) 3 particolari da 6 azioni tipo (in corsa con un salto una capriola con un passo salire in piedi) foto più piombo; b) Ermafrodito (foto mercurio verso stagno pochi colori su carta); c) lambicco (foto libro piombo pochi colori su carta).

(Io tu Dioniso anche)

Materiale: foto piombo mosaici pizzo piume pelle stoffa rame zinco stagno luce ghisa colore carta legno lana feltro scrittura canzoni peso.

4 ritrattistatua in piombo io Grazia Pico in posizioni naturali. Il piombo usato in unità di misura. Il piombo come forma arbitraria di riduzione del corpo. Il piombo come massima concentrazione della forma peso. Il mio corpo in piombo è alto 68 cm. Il corpo di Grazia è alto 54 cm. Il corpo di Pico è alto 22 cm. Il corpo di Ubu è lungo 11 cm. Parti del corpo delle statue risultano colorate. Sulle pareti le nostre foto e altre a grandezza naturale colorate a mano. Un noce di terracotta nella dimensione della statua può diventare un astuccio per i personaggi.
Ritratti di parole come supporti alle statue. Quel volume occupato dal supporto corrisponde al volume del corpo reale, lo spessore è quello del corpo di profilo rilevato sul fianco.

Io: 3 cerchi di fusione concentrici a settori. Materiali stagno piombo ghisa ossidati. Cerchio esterno in lettera e a rilievo panna crema biscotto. 2° cerchio a rilievo: identico allieno scambiato. 3° cerchio a rilievo: a sè al mondo all'amico.

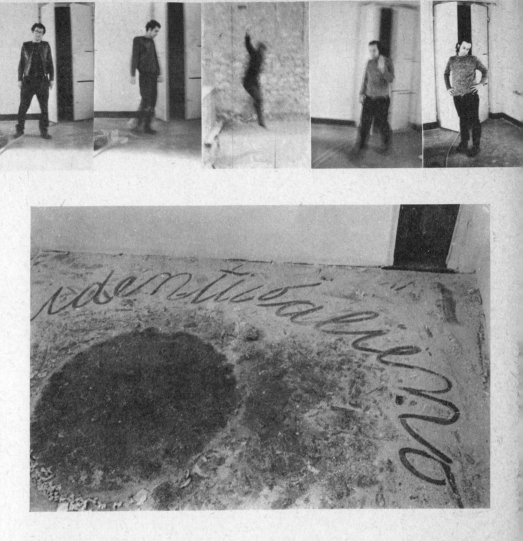

itto a bastone piccolo in fondo a
stra « questo è il mio vestito de-
 in simpatia all'immagine. Le
mensioni del vestito sono quelle
me peso piombo statue. Una
le banderuole della mia mano »
 tu Dioniso anche).

ri Costumi per le statue.

azia. Un manto di piume di pap-
gallo grigio bianco con una coda
sa. Nelle dimensioni di Grazia
so piombo stato. Lei è questo e
esto la completa.

stito di Pico. Busto di pizzo
mato a mano a parete stagna-
sul foglio di rame. E' unita alla
se di parole da una striscia di al-
 pizzo imbevuta di rame fuso.
 busta è tessuta di luce bianca
lla sua larghezza la striscia di
ffa è irregolarmente traversata
lla luce vestito di Ubu. Il costu-
 di Ubu non è stato ancora de-
o. E' molto difficile fare un ve-
to a un gatto.

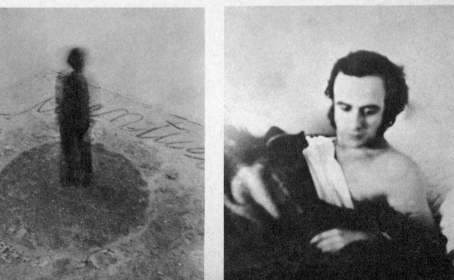

IL MONDO E UNA STANZA / STATI DI SIMPATIA
CON LA TUA STANZA. APPOGGIO MONDO VERTI...

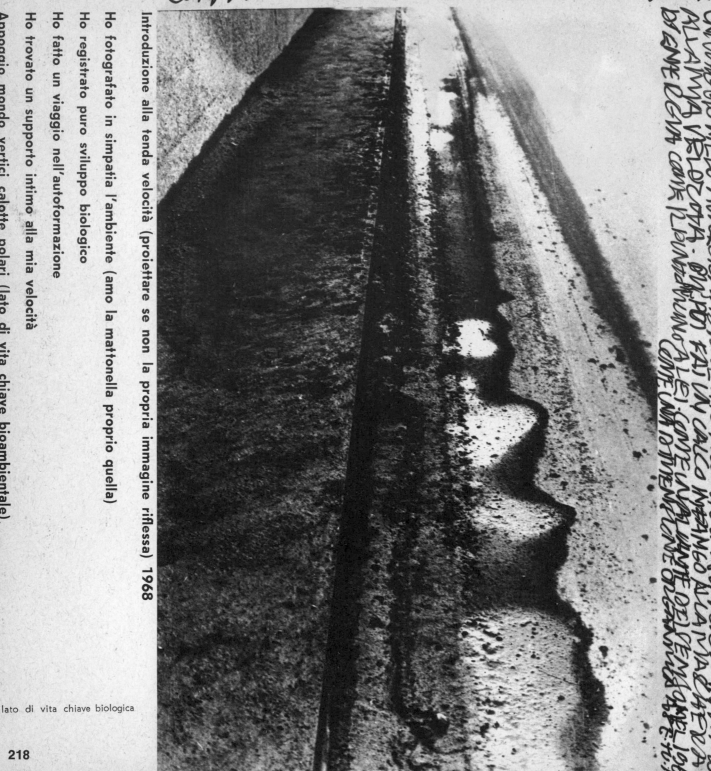

Introduzione alla tenda velocità (proiettare se non la propria immagine riflessa) 1968

Ho fotografato in simpatia l'ambiente (amo la mattonella proprio quella)

Ho registrato puro sviluppo biologico

Ho fatto un viaggio nell'autoformazione

Ho trovato un supporto intimo alla mia velocità

Appoggio mondo vertici calotte polari (lato di vita chiave bioambientale).

lato di vita chiave biologica

218

I just thought I'd stop off for a beer.

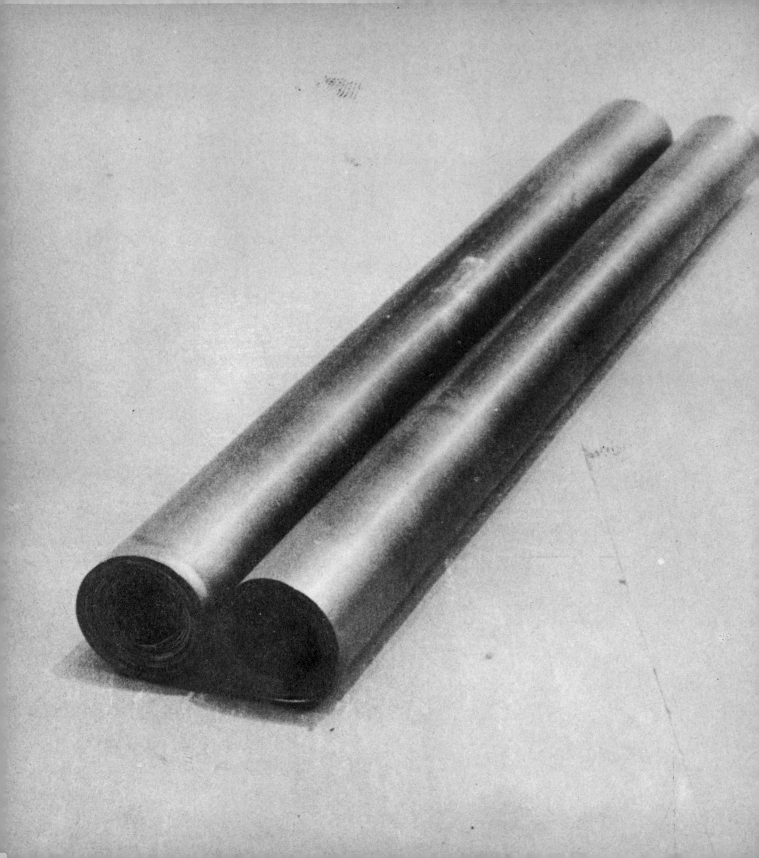

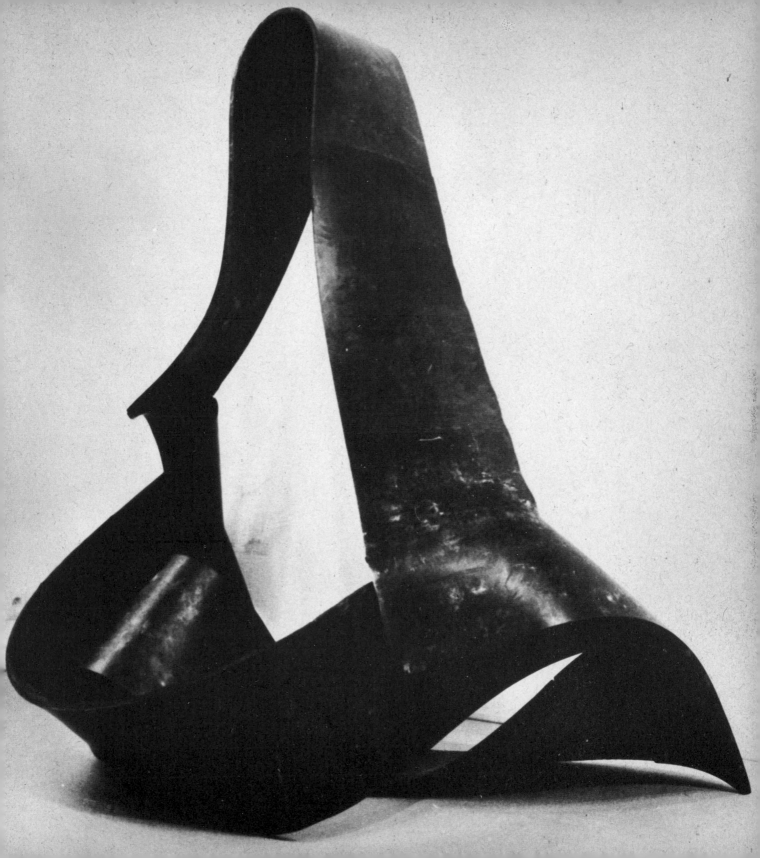

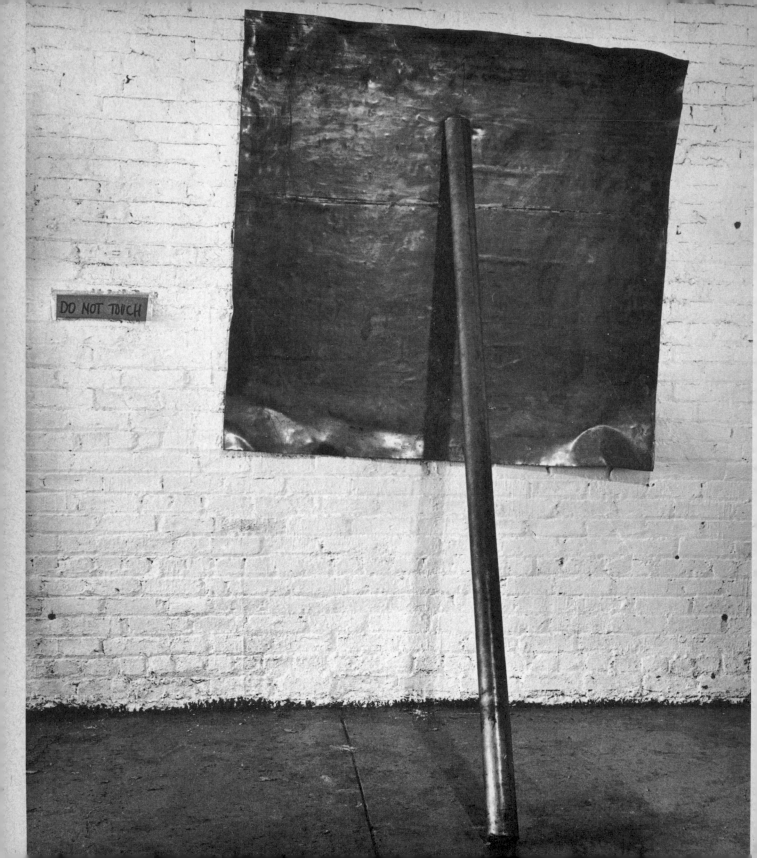

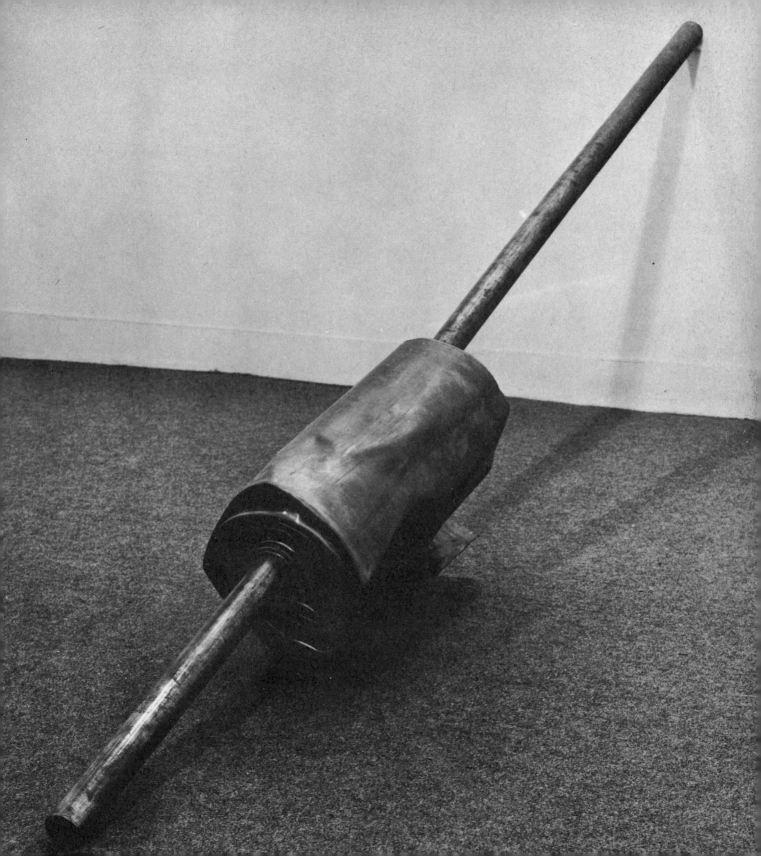

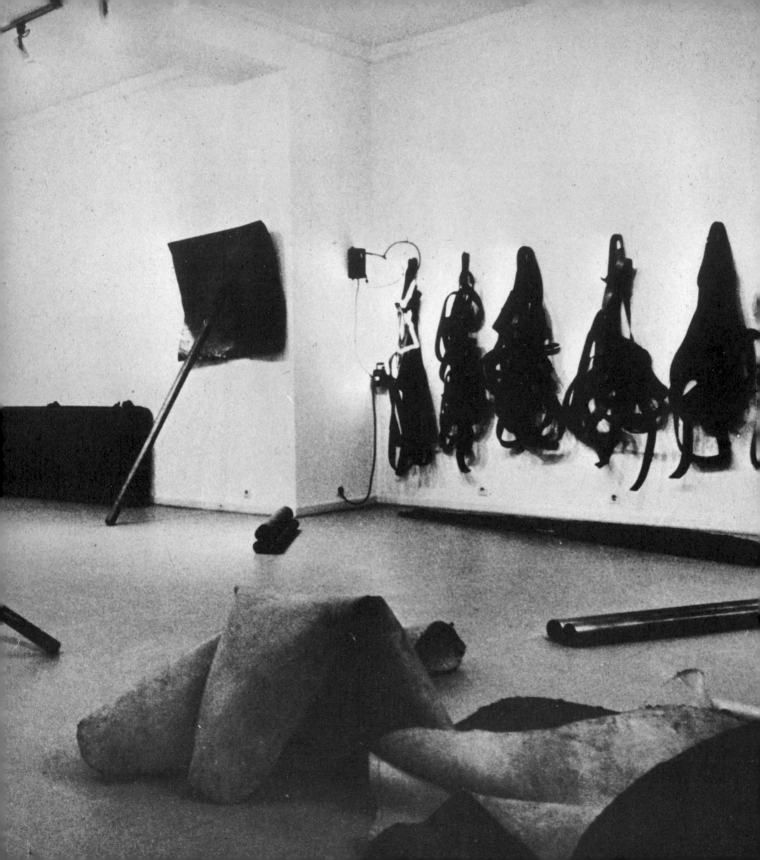

Animals, vegetables and minerals take part in the world of art. The artist feels attracted by their physical, chemical and biological possibilities, and he begins again to feel the need to make things of the world, not only as animated beings, but as a producer of magic and marvelous deeds. The artist-alchemist organizes living and vegetable matter into magic things, working to discover the root of things, in order to re-find them and extol them. His work, however, does include in its scope the use of the simplest material and natural elements (copper, zinc, earth, water, rivers, land, snow, fire, grass, air, stone, electricity, uranium, sky, weight, gravity, height, growth, etc.) for a description or representation of nature. What interests him instead is the discovery, the exposition, the insurrection of the magic and marvelous value of natural elements. Like an organism of simple structure, the artist mixes himself with the environment, camouflages himself, he enlarges his threshold of things. What the artist comes in contact with is not re-elaborated; he does not express a judgement on it, he does not seek a moral or social judgement, he does not manipulate it. He leaves it uncovered and striking, he draws from the substance of the natural event — that of the growth of a plant, the chemical reaction of a mineral, the movement of a river, of snow, grass and land, the fall of a weight — he identifies with them in order to live the marvelous organization of living things.

Among living things he discovers also himself, his body, his memory, his gestures — all that which directly lives and thus begins again to carry out the sense of life and of nature, a sense that implies, according to Dewey, numerous subjects: the sensory, sensational, sensitive, impressionable and sensuous.

He has chosen to live within direct experience, no longer the representative — the source of pop artists — he aspires to live, not to see. He immerses himself in individuality because he feels the necessity of leaving intact the value of the existence of things, of plants or animals; he wants to take part in the oneness of every minute in order to possess above all the « autonomy » both of his own identity and the individuality of things. He wants to feel his vitality in order not to feel that he is a solitary vital individual.

Consequently, all of his work tends towards the dilation of the sphere of impression; it does not offer itself as an assertion, an indication of values, a model for behaviour, but as an experiment with contingent existence. His works are often without a title: almost a way to establish a physical memorial testimony, and not an analysis of the successive development of an experiment.

Life, as the events that make it up, in this way, turns out to be a moment of expectant anxiety, in which the objects accomplished do not present themselves under the form of inert things but as stimulating subject matter — a part of the world in an established and determinate moment — subjective actions that one leans upon in which animals, plants, minerals and men move themselves in an autonomous way.

It is clear, however, that as long as one considers the descriptive aspect, man, minerals and animals have little in common: even though all of these systems function in a similar way, tied as they are to a common process of transformation. For this reason the artist, as well as others from the ecologist to the scientist, is interested in the behaviour of that which is animate and inanimate. He does not accept description and representation of the exterior aspects of nature and life (also they are mass-media) and takes into consideration the special aspect — also those offered by micro-organisms (not very striking but very active). He is interested in placing in the right perspective the minor biomorphic and ecological facts, that can be compared with those that are bigger, more striking, but relatively inert; and with the apparent banality of natural and vital facts, he returns to the marvelous. Thus, he rediscovers the magic (of chemical composition and reaction), the inexorableness (of vegetable growth), the precariousness (of material), the falseness (of senses), the realness (of a natural desert, a forgotten lake, the sea, the snow, the forest) — the instability of a biophysical reaction — thus become discovered as an instrument of consciousness in relation to a larger comprehensive acquisition of nature.

At the same time he rediscovers his interest in himself. He abandons linguistic intervention in order to live hazardously in an uncertain space. He finds it insupportable to consider art as a threshold of anticipated values and he uses it for his self-discovery. He does not accept the role of the « prophet » because he does not trust cultural control (artistic, intellectual, etc.) that suggests slavishness (spectator, public, etc.) as a pattern of values. He comes from the closed spaces of the galleries and the museums (at times, notwithstanding all, he goes back there); he goes down to the public places, crosses forests, deserts,

fields of snow, to appraise a participating intervention. He destroys his social « function » because he no longer believes in cultural goods. He denies the moralistic, fallaciousness of artistic production, the creators of the illusionistic dimension of life and reality. He believes only in his own personal experience, while his relationship with the world does not take place any more through analyzed and manipulated images (comic books, films, photographs, etc.) and the things used for discussion (material « for », gesture « for », action « for ») but with the images of things. He identifies himself with them, to the point of making them a part of himself, and their biological offshoots. Thus his availability to all is total. He accumulates continuously desire and lack of desire, choice and lack of choice; that is, he finds himself in a type of life that overcomes the formulation of thousands of experiences. Assuming for himself that unique instrument of questioning and stimulation, he inserts himself in order not to be assimilated, he makes a jump from « naturalness » and escapes continuously from the acquisitive dimension.

He abolishes his role of being an artist, intellectual, painter or writer and learns again to perceive, to feel, to breathe, to walk, to understand, to make himself a man. Naturally, to learn to move oneself, and to re-find one's own existence does not mean to admire or to recite, to perform new movements, but to make up continuously mouldable material.

What follows is: impossibility to believe in discussion for imagery, in the communication of new explanatory and didactic information, in the structure that imposes regularity, behaviour, synthesis that leans upon a moralistic, industrial subject; estrangement, therefore, from the existing archetype and continuous renewal of himself; total aversion for discussion and aspiration towards continuity, towards aphasia, towards immobility, for a progressive identification of consciousness and praxis. The first discoveries of this dispossession are the finite and infinite moments of life; the work of art and work that identifies itself with life; the dimension of life as lasting without end; immobility as a possibility of leaving contingent circumstances in order to plunge into time; the explosion of the individual dimension as an aesthetic and feeling communion with nature; unconsciousness as a method of consciousness of the world; the search of psycho-physical disturbances plurally sensitive and steadfast; the loss of identity with himself, for an abandonment of reassuring recognition that is continually imposed upon him by others and by the social system; the object-subject as physical presence continuously changing, as a trial of existence that becomes continuous, chaotic, spatial and differs temporally. «Art comes», states Cage, «from a kind of experimental condition in which one experiments with the living». To create art, then,

one identifies with life and to exist takes on the meaning of re-inventing at every moment a new fantasy, pattern of behaviour, aestheticism, etc. of one's own life. What is important is not to justify it or to reflect it in the work or in the product, but to live it as work, to be surprised in knowing the world, to be available to all of the facts of life (death, illogic, madness, casualness, nature, infinite, real, unreal, symbiosis). In fact, accepting the ideology of life one can exalt both its infiniteness and its contingency, one can live and kill life, reason about madness and go mad from reasoning. To think and to perceive, to fix figures and to present, to feel and to exhaust the sensation of an event, in a fact, an idea an action — everything can then become language and being, with its gestures, its actions, its body, its territory, its memory, its daily and fantastic reality. To communicate with persons and things means then to be in aesthetic and participating communion with the world, without posing the problem if the communication of values, of art, is a cosmic living.

Thus, art begins creating to place itself as a possibility in material (vegetable, animal, mineral and mental); its own dimension that identifies itself with knowledge and perception, becomes « living in art », that fantastic existence continually at variance with daily reality that opposes the building of art, that resulting from the place of art — from visual research to pop art, from minimal to funk art. A work of art — that of pop, op, minimal and funk artists — that is ready not for an intervention but for an interpretation of reality, a discussion on the images that tend towards a clarification and a criticism of the methods of communication (comic books, photographs, mass-media, technologically produced objects, micro-perceptive structures, etc.). To create art as a critic of popular and optical images that collaborate for the clarification of the social system, but block the crushing energy of life, nature, the world of things and do away with the sensory significance of any kind of work; to create as an intervention that is carried out by means of the intellectual scheme of critical-historical literature, photographic advertising, imaginary, objective means, structurally psychological, perceptive, in order to domesticate in prefixed schemes the vitality of real daily life; to create art that moves itself within the linguistic systems in order to remain language, an act to live by means of continual isolation; to create art as cultural kleptomania that lives on the assumption of the destructive charges of other languages (politics, sociology and technology); finally to create art as a separate language that speculates on codes and on instruments of communication in order to live in a dimension of exclusiveness and recognition that makes it an aristocratic and class question, an action that scratches at the whole of the superstructure without blunting the natural structure of the world.

On the other hand, the asystematic procedure of life that becomes contemporaneously, time, experience, love, art, work, politics, thought, action, science, daily living — poor in choices and assumptions — if not contingent and necessary; a life as an expression of creative existence, working, mental politics. There it creates work, art, thought, love, politics and complex living that lets itself be used by the connexions of the system; here a living in work, in art, in thought, in politics deprived of recognizable, disoriented, infinite, undiscussible constancy, given the uncertainty of the evolutionary cycle of daily reality. To live in work, in art, in politics, in science as a free design of itself, tying itself to the rhythm of life for an exhaustion, immediate and contingent, of real life in action, in facts and in thought.

In the first case, being, living, working makes art and politics « rich », interrupting the chain of the casual in order to maintain in life the manipulation of the world, an attempt to conserve also « the man well endowed when faced with nature »; in the second case, life, work, art, politics, behaviour, thought « poveri », employed in the inseparableness of experience and consciousness with the political and mental event, with contingency, with the infinite, with the ahistorical, with the chain of individual and social motivation, with man, with environment, with space, with time, with the social situation... The declared intention of doing away with every discussion, misunderstanding and coherence (coherence is in fact a characteristic of concatenation of the system), the need of feeling life continually going on, the necessity, dictated by nature itself, to advance at jumps, without having to collect with exactness the confines that govern modifications. Yesterday, therefore, life, art, existence, manifestation of oneself, manipulation, political beings, involved because based on a scientific and technological imagination, on the highly specialized superstructure of communication, on marked moments; a life, an art, a manifestation in itself, a manipulation, categorical and class-conscious, that — separating itself from the real, as speculative actions — isolates artistic, political and behavioural art with the aim of placing it in a competitive position with life: a life, an art, a policy, a manifestation of itself, a metamorphic manipulation, that through agglomeration and collation, reduces reality to fantasy; a life, an art, a behaviour, a manipulation, frustrated — as a receptacle of all of the real and intellectual impotence of daily life — a life, an art, a moralistic policy, in which judgement is contradictory, imitating and passing the real, to the real itself, with a transgression of the intellectual aspect in that which is really needed. Today, in life or art or politics one finds in the anarchy and in the continuousness of nomadic behaviour, the greatest level of liberty for a vital and fantastic expression; life or art or politics, as a stimulus to verify

continuously its own level of mental and physical existence, as urgency of a presence that eliminates the manipulation of life, in order to bring about again the individuality of every human and natural action; an innocent art, or a marvelousness of life, more political spontaneity since it precedes knowledge, reasoning, culture, not justifying itself, but lives in the continuous enchantment or horror of daily reality — a daily reality that is more like stupefying, horrible poetic entity, like changing physical presence, and never allusive to alienation.

Thus, art, life, politics « poveri » are not apparent or theoretical, they do not believe in «putting themselves on show», they do not abandon themselves in their definition, not believing in art, life, politics « poveri », they do not have as an objective the process of the representation of life; they want only to feel, know, perform that which is real, understanding that what is important is not life, work, action, but the condition in which life, work and action develop themselves.

It is a moment that tends towards deculturization, regression, primitiveness and repression, towards the pre-logical and pre-iconographic stage, towards elementary and spontaneous politics, a tendency towards the basic element in nature (land, sea, snow, minerals, heat, animals) and in life (body, memory, thought), and in behaviour (family, spontaneous action, class struggle, violence, environment).

The reality, in which one participates every day, is in its dull absurdity a political deed. It is more real than any intellectually recognizable element. Thus, art, politics and life « poveri », as reality do not send back or postpone, but they offer themselves as self representatives, presenting themselves in the state of essence.

We do not work as spectators, we ourselves are actors and spectators, fabricators and con-
sumers; between us, who manage to work together, there is a direct, perceptive and instan-
taneous relation, there is no judgement « a posteriori » and no criticism « a posteriori ».
When you see, feel and scent a spectacle presented by the Zoo, what you believe yourself
to understand will only be the rind, the covering, you will never know what has happened
unless you are actors and spectators on the other side of the bars.

To conclude we want to say that it is useless to predict the end of art. Art was done with
fifty years ago. Enough of this lamentation, art is a word.

Art means to be able to make things, those who know how to make are, for some time past,
the architects, the designers, the technicians and the politicians. We are not artists and
that's all. We can subsitute the word art by qua-qua (in a guttural voice, like imitating
geese), like this. Because we were together, ten of us, and while we were discussing the
discourse began to slide away and sink into the mud, we all started to utter qua-qua-qua,
and if somebody will ask us what we are doing (unless it won't become a fashion), we
will answer that we are doing qua-qua-qua.